LA
PASSIONE

HOW ITALY
SEDUCED
THE WORLD

LA
PASSIONE

DIANNE HALES

CROWN
ARCHETYPE
NEW YORK

Library of Congress Cataloging-in-Publication Data
Names: Hales, Dianne R., 1950– author.
Title: La passione : how Italy seduced the world / Dianne Hales.
Description: First edition. | New York : Crown Archetype, [2018]
Identifiers: LCCN 2018033072 (print) | LCCN 2018053796 (ebook) |
 ISBN 9780451499189 (ebook) | ISBN 9780451499165 (hardcover) |
 ISBN 9780451499172 (trade pbk.) | ISBN 9780451499189 (ebk.)
Subjects: LCSH: Italy—Description and travel. | Italy—Social life and
 customs. | Italy—Civilization. | Rome—Civilization. | Civilization,
 Western—Italian influences. | Italy—History. | Rome—History.
Classification: LCC DG430.2 (ebook) | LCC DG430.2 .H35 2018
 (print) | DDC 945—dc23
LC record available at https://lccn.loc.gov/2018033072

ISBN 978-0-451-49916-5
Ebook ISBN 978-0-451-49918-9

Printed in the United States of America

Book design: Jen Valero
Interior art: (leaves) istock.com/VenThePooh; (city) istock.com/Booblgum
Jacket design: Elena Giavaldi and Alane Gianetti
Jacket illustration: Gary Redford/Meiklejohn

10 9 8 7 6 5 4 3 2 1

First Edition

A tutti gli italiani che mi hanno ispirata con la loro passione

To all the Italians who have inspired me
with their passion

CONTENTS

LA
PASSIONE

INTRODUCTION

CONFESSIONS OF
AN *APPASSIONATA*

I n the gleaming kitchen of her culinary academy in Florence, I ask
an architect-turned-chef-turned-restaurateur about the passions
that changed her life: How did she know that she was choosing
the right one to follow?

She sighs. *"Ah, signora,* we do not choose our passion. Passion
chooses us."

I understand. Italy chose me.

More than thirty years ago, shivering in a frigid Swiss station
after a talk in Gstaad, I impetuously switched trains and headed
south to a sun-kissed country I'd never visited. I had no reserva-
tions, no itinerary, no inkling of what I might discover. The last
thing I expected was to fall in love—but I did.

Day by day, sometimes hour by hour, Italy seduced me with
tastes, sounds, scents, and sensations I'd never encountered before.
With every morsel and marvel, I yearned for more. I was far from

the first person to succumb to Italy's charms. Countless others have swooned for its food, wine, incomparable art, or breathtaking scenery—as will many more in the centuries to come.

I fell for the Italians. Old and young, flirtatious men and gracious women, they drew me in, not just with their easy smiles and effortless charm, but with a magnetic intensity that pulled me ever closer. With scarcely a shred of their language, I yearned to communicate with these intriguing strangers—"more marvelous than the land," as the British author E. M. Forster so aptly said.

At the least, I longed to decipher the tsunami of words that washed over me on that first semisilent journey. After I returned to the United States, I immersed myself in Italian classes, movies, and conversation groups. My linguistic infatuation eventually inspired a book, *La Bella Lingua: My Love Affair with Italian, the World's Most Enchanting Language*.

Kindred Italophiles embraced my labor of love, which garnered a spot on the *New York Times'* bestseller list and won for me the great honor of an Italian knighthood, with the title of Cavaliere dell'Ordine della Stella della Solidarietà Italiana (Knight of the Order of the Star of Italian Solidarity). Yet even after *La Bella Lingua's* success, Italy didn't loosen its grip on me.

Through Italian friends and friends of friends, I became captivated by the real woman immortalized by Leonardo in his *Mona Lisa*. Over the course of several years, I walked the streets in Florence where she lived, knelt in the chapel where she prayed, ventured into the long-abandoned convent where she died—and wrote *Mona Lisa: A Life Discovered*. It too found a warm welcome among lovers of art, Italy, or both.

"So are you done with Italy?" asked a man at one of my readings.

"God, no!" I exclaimed. He was asking the wrong question, just as I had done in Florence. The very notion seemed unthinkable—and impossible. Italy wasn't done with me.

AT FIRST, ITALY'S SYMPHONY of chaos had simply swept over me. Every time I emerged from a train station—in Milan, Florence, Venice, Rome—I longed for more eyes to see, more ears to listen, more neurons to process the sensations bombarding me. As I returned year after year, Italy tugged me deeper into its explosive energy. Passion poured into my soul like a river.

Dianne—wife, mother, journalist, serious and sensible— morphed into Diana, dancing barefoot under the Tuscan moon and delighting in everything from fresh-fried *fiori di zucca* (zucchini flowers) to tart and tingly limoncello. Without realizing exactly how, I became *appassionata,* a word that dates back to the fourteenth century and translates as "taken by passion." I didn't fight this sweet seduction. I indulged it, embraced it, delighted in it.

When I described my quasi obsession to a sophisticated Roman, she pegged it immediately as *una passione italiana.* "There are two types," she said with the seen-done-tried-that worldliness of the Eternal City. "There is the passion that you take to bed, but beyond children, what does it get you? Then there are the passions that create something, that take you beyond yourself and outlast you."

I chose to pursue the latter—on my own or with my often-bemused but endlessly supportive husband. Searching for the sources and secrets of *la passione italiana* became my passion. I pursued its trail north to the Dolomites and south to Sicily, from Sardinia's rugged western coast to Venice's labyrinth of canals. As I homed in on specific passions, I visited Florence for its art, Rome for its antiquities, Assisi for its saints, Piedmont for its wines, Milan for its fashion, Emilia-Romagna for its food and fast cars.

Every destination led to a dozen detours, each one a revelation. I trekked through pagan temples, ancient ruins, medieval chapels, glass furnaces, silk mills, fashion salons, restaurants, workshops, studios, concert halls, street markets, vineyards, wine cellars, olive groves, movie sets, and museums of every ilk. Back in the United States, I devoured histories, biographies, memoirs, diaries, novels, poems, and travelogues.

I focused on the passions that have left indelible fingerprints on culture, but to a great extent, the ones in this book, just like other passions, chose me. What intrigued me most were the stories of passionate Italians—famous, unknown, legendary, actual, historical, contemporary. You will meet many in these pages. Yet every profile is a mere "for instance," with a dozen alternatives that I could have included instead.

La Passione, a portrait more of a spirit than a nation, reflects my experiences as an outsider, an explorer, and an unabashed *donna sedotta.* This phrase literally translates as a "seduced woman" and usually refers to someone who's been led astray. You could say that Italy has had its way with me, but I've been a willing, enthusiastic partner.

Italians, born to the peal of church bells and the bite of pasta al dente (literally, "to the tooth"), inhabit a more complex and confounding country than the one I've come to love. But my perspective enables me to notice what they may take for granted. In Parma, at the end of an interview with a young man named Stefano in—of all places—his family's prosciutto processing plant, my guide, who had been listening from a few feet away, walked over and hugged me. A bit taken aback by this unexpected gesture, I looked at him quizzically.

"La nostra bellezza!" (Our beauty!), he exclaimed. "You have seen what we cannot see because we live inside it. The things we Italians do—yes, it's work, but you realize that what gives it mean-

ing is passion. You didn't ask Stefano what he does but what it means to him. And maybe for the first time in his life, he recognized that what he feels for this place, for this work, is passion."

MOST OF THE TIME, I was the one experiencing an epiphany. In an archaeology archive in Rome, I cradled the oldest objects I'd ever touched—shards of vases and statues dating back almost three thousand years—and appreciated as never before the ancient roots of *la passione italiana*. In a rustic chapel encased within a grand cathedral in Assisi, I felt the sacred passion that had inspired an infinity of prayers. In a "piazza," the unofficial name for a sprawling glassmaking furnace room, on a Venetian island, I watched maestri use centuries-old techniques to capture a timeless passion for beauty in a vase as exquisite as any of the flowers it would ever hold.

At every stop, I tasted scrumptious foods and sipped robust wines that could only be produced with Italian passion. I heard music and watched films that took me inside this ephemeral force. Most of all I talked with Italians—artists and artisans, chefs and vintners, historians and film directors. And wherever I went, I continued to be surprised—and seduced.

Crisscrossing Italy over the last few years, I've spent hours in airports. In several I came across grand pianos—at first, I assumed only for display. Then I read the sign perched atop one: SUONAMI! (Play me!). Passengers, pausing as they slogged to and from airline gates, did just that.

While waiting for a flight from Rome to Palermo, I listened to a young girl tentatively finger the melody of "Volare." Two teenagers giggled through a fast-paced pop song. Then a wiry, curly-haired man in his thirties stopped, took off his jacket, sat down, and launched into a sonata that stopped passersby in their tracks. Eyes

closed, fingers never slowing, oblivious to flight announcements and the gathering crowd, he played with utter concentration, his music echoing through the crowded terminal.

I didn't recognize the piece, but I knew what I was hearing: *una passione italiana.*

LA PASSIONE
ITALIANA

magine a world without Italy: Painting without Leonardo. Sculpture without Michelangelo. Literature without Dante. No Verdi choruses or Puccini arias. No Fellini films or Ferrari roar. Heavens uncharted, vines unplanted, tables bereft of pasta, pizza, and a Sicilian cake so divine that its bakers swore it could make the dead breathe again.

Western civilization would surely have sprouted elsewhere, but the planet would have been a paler place, a rainbow stripped of its most vibrant hues: Raphael's luminous blue, Valentino's luscious red, espresso's inky black. More than a country, Italy embodies a culture that has transformed art and architecture, language and music, food and fashion.

Its borders contain more of UNESCO's designated cultural treasures than any other nation. Its inhabitants created the first

universities, banks, public libraries, and law and medical schools; mapped the moon (in 1651); split the atom; produced the first modern histories, satires, sonnets, and travelogues; invented the first working compass, battery, barometer, microscope, radio, and thermometer; garnered twenty Nobel Prizes; and bestowed upon the world the eternal gift of music.

Humanity, Mussolini bragged, is indebted to Italy and its people "for the majority of its accomplishments." For once, he wasn't exaggerating.

But why Italy? How did a scrawny peninsula smaller than California, home to less than 1 percent of the world's population, leave such an outsize imprint on Western culture? Why did geniuses sprout like wildflowers through thirty centuries of history? What sparked endless innovations and inspired a multitude of masterpieces? Was it a miracle? Serendipity? Luck? Destiny?

After decades of up-close but admittedly unscientific observation, I credit *la passione italiana.* This fierce drive, three millennia in the making, stems from an insatiable hunger to explore, discover, create, pursue beauty, feel deeply, love and live with every fiber of one's being. It blazes to life in the Sistine Chapel, surges through a Rossini aria, preens in Bulgari jewels, deepens a vintage Brunello, spices a tangy *penne all'arrabbiata* (pasta with an "angry" sauce seasoned with chile peppers).

Of course, passion can bloom anywhere. Think of France, with its culinary cathedrals; Spain, with its torrid bullfights; Argentina, with its sultry tango; half the globe, inflamed with soccer fever. In every country, individuals of every age, race, and nationality devote endless hours to microbrewing, gaming, extreme sports, gardening, digital dating. Yet these pursuits strike me, as poets have said of love anywhere else, as mere imitations.

How could it be otherwise? The original was made in Italy.

-ᵂᵛ⁄ᵘ-

THE WORD *PASSIONE* DATES BACK to ancient Rome. Newly minted Christians in the first century AD, constructing a vocabulary for their fledgling religion, chose the term *passio* for the agony that Jesus endured to redeem a world of sinners. Etymologists trace its roots to the Latin *passus,* past participle of *pati* (to suffer). The martyrs who died for their faith also endured *una passione* that cleansed, fortified, and transformed them, an agony leading to rebirth. Healers appropriated the word for various maladies, such as "passion of the liver"—a diagnosis that conjures an organ engorged with rage.

The medieval wordsmith Dante, father of the Italian language, recognized romantic love as *una passione* so compelling that it could not be resisted. While he damned pursuers of dark passions—from lust to gluttony to greed—in his *Inferno,* he also denounced the passionless. "Drearies," he called them, unworthy of heaven and unwanted even in hell, "whining wraiths who never truly lived at all, the lukewarm, who are as hateful to God as to his enemies" (from Thomas Cahill's translation).

The Renaissance extended the definition of *la passione* to an all-consuming dedication to a worthy pursuit, most often beauty in its infinite variety. Its passionate artists and artisans unleashed the greatest creative flowering the world had ever seen. A few centuries later the Romantics yearned to become impassioned and quiver with the intensity of their ardor. Jurists blamed "crimes of passion" on high-octane emotions that exploded into acts of unspeakable violence.

Although modern English-language dictionaries acknowledge the religious roots of "passion," they define it as a state or an

outburst of strong emotion, intense sexual love, or deep desire or enthusiasm. *La passione italiana* is all these—and much more.

The *Dizionario affettivo della lingua italiana* (Emotional Dictionary of the Italian Language) describes *la passione* as a flammable material—volatile and dangerous. When it possesses you, it causes infinitesimal, voracious particles to pulsate in the blood. You risk burning like a torch, flaming bright, and then disintegrating into embers. When you are inside *la passione,* nothing else can enter your mind. When it flees, you search desperately for more.

Passion—and passion alone—lifts us above the ordinary. Without passion, there would be no literature, no art, no music, no romance, perhaps none of the wonders Italians have wrought. Beyond sentiment or emotion, *la passione italiana* qualifies as a primal force of nature that cannot be ignored or denied.

"When a passion chooses you, there's nothing else you can do," says a friend whose family produces wine and olive oil in Umbria. "Whatever happens in your life, that fire inside you is always burning. You need to follow it. It's like betraying yourself if you try not to, and the price for betraying yourself is very, very high."

LA PASSIONE ITALIANA DATES BACK to a time before time when a geologic frenzy carved a boot in the middle of the Mediterranean. Convulsing and colliding, tectonic plates thrust an ancient seabed so high that tiny crustaceans were trapped and fossilized in the Italian Alps. Lava seething within the earth boiled and bubbled to form a chain of volcanic cones stretching from central Italy to what would become the island of Sicily.

Even today the Italian earth trembles. The Apennines, running like a spine through the peninsula, still undulate, sometimes with devastating consequences. Europe's only active volcanoes—Vesuvius, Stromboli, and Etna—rumble and spew.

Eons of natural sculpting formed a countryside that Renaissance artists considered the most magnificent of masterpieces, a mosaic of wind-blasted rocks, hills pleated with valleys, and mountains cresting into boundless blue. In the splendid Val d'Orcia, a plaque pays tribute to Italy's first artists: the *contadini* (farmworkers) who tilled fields, terraced hills, and left behind rows of slender green cypresses climbing to crenellated towers silhouetted like paper cutouts pasted on an azure sky.

The symbiosis between the land and its people forms a bond as strong as blood—and older than Italy itself. At Selinunte, an ancient Greek settlement on Sicily's western coast, my guide—a tiny, ponytailed dynamo named Pina—presses my palm against the sun-warmed column of a temple built five hundred years before the birth of Christ.

"You can feel the passion of the people who built this place," she says. "It's in the stones!" In Florence, a street artist tells me to breathe deeply and inhale the heady oxygen that stimulated the genius of Renaissance masters. A Venetian glassblower talks of the water flowing like blood through the veins of an improbable city that seems spun out of fantasy. An olive grower in Campania gently sifts a fistful of soil through his fingers as he describes the land that nurtured the souls of his forefathers.

On a shuttle in Chianti, our driver suddenly pulls to the side of the road. I step out to view a titanic sunset not so much painted as carved, great cloud masses of deep rose, purple, and mauve, coupling and uncoupling as golden rays silhouette their shoulders.

"Sentite!" he commands, exhorting us not just to look but to take in this heavenly spectacle with every sense. And I do, lingering before this twilight tango until the darkness deepens into night.

"What mysterious emptiness in their souls is filled by merely standing on Italian soil?" the Italian writer Luigi Barzini mused in

his classic *The Italians*. Perhaps the answer lies, at least in part, in the skies above and the earth below.

ITALY'S HISTORY MATCHES THE DRAMA of its geography. In the course of three thousand years, everything that could happen to a people or a country has happened in Italy. Against all odds, a feisty band of misfits raised a new city on the Tiber and conquered the known world. Vesuvius erupted. Barbarians pillaged. The seemingly invincible Roman Empire crumbled. City-states warred. Plagues ravaged. Foreign armies invaded.

Unified in the nineteenth century, Italy faced yet more turmoil in the twentieth. Fascism strutted into power. World War II claimed hundreds of thousands of Italian lives and devastated cities and countryside. In its wake, governments rose and toppled. Terrorists bloodied the streets. Crises and corruption battered the economy.

Time and again *la passione* saved Italy. A passion for power and glory propelled the ancient Romans to defeat the most ferocious armies of their day. A passion for a new faith and its promise of eternal life sustained the early Christians through horrific persecutions. After the silence of the Dark Ages, a passion for the people's vernacular inspired poets to craft a lyrical new language.

When the Black Death decimated Italy in the Middle Ages, its people, responding with life-affirming exuberance, embraced worldly passions—sex, food, drink, song—as the best possible antidotes. In the Renaissance, Italy's passion for classical works spread like a rich dye through all of Europe. A passion for freedom brought the people of Italy's regions together into a single nation in 1861. More recently a passion for contemporary art forms—movies, cars, fashion—revived the spirit of a country shattered by oppression and war.

Living on the brink of catastrophe, Italians have borne witness to every possible experience and have responded with every tremor of emotion. Yet after each calamity, Italy has flickered back to life—not despite these upheavals but because of the resilience forged by them. Its people learned fully and deeply what it means to be human—creatures of body, mind, and soul, rooted in the past but seizing the present and reimagining the future.

THE ITALIANS WHOSE PASSIONS SHAPED Western culture lived and loved as intensely as they pursued power, adventure, or acclaim. Julius Caesar, as the historian Will Durant commented, never "let his victories in the field outnumber his conquests in love." Before his triumphant return to Rome, his troops riotously sang out, "Husbands, guard your wives. We bring you the bald adulterer!"

"Let's live and love!" entreated Catullus, the first Roman writer to translate erotic passion into poetry. His florid verses to a woman who ultimately spurned him remain a literary milestone. Ovid, author of the monumental *Metamorphoses,* continued the tradition as a self-acclaimed "professor of love" offering randy advice for would-be seducers.

In the Middle Ages, the three crowns of Italian letters—Dante, Petrarch, and Boccaccio—raised romantic passion to a new height. Smitten since childhood by an untouchable beauty named Beatrice, Dante journeyed from hell to heaven in his *Divine Comedy* on a quest for "the love that moves the universe." Petrarch spent a lifetime polishing 366 verses—a leap year's worth of tributes to his idealized Laura—to express the unrequited "love for which there was no cure." Boccaccio captured passion's earthier side in his rollicking *Decameron,* tales of often-ribald vitality told by a "merry brigade" of young Florentines seeking refuge from the plague in a Tuscan villa.

In their lust for beauty, Renaissance artists infused everything they touched with full-hearted zest and unabashed sensuality. Michelangelo carved a Bacchus so sinuously suggestive that a contemporary sniped, "Buonarroti could not have sinned more with a chisel." Donatello's *David,* the first freestanding nude since ancient times, preened in knee-high boots an art critic described as "pornographic." Raphael and Caravaggio portrayed Madonnas with the features of their mistresses. Titian painted naked beauties so voluptuous that simply gazing upon them seemed an occasion of sin.

In the most quintessentially Italian of arts, emotions billowed into operatic anthems. "Passion! Passion!" Giuseppe Verdi thundered to his librettists. "Never mind which, just passion!" Giacomo Puccini, his life as tempestuous as his music, transported listeners, as a musicologist put it, "into that place where erotic passion, sensuality, tenderness, pathos, and despair meet and fuse."

Enzo Ferrari, whose brand embodies speed, power, and glamour, viewed his passion for cars as "a kind of love, which I can only describe in almost a sensual or sexual way." In his autobiography, Giorgio Armani, who revolutionized modern dress, described the surge of adrenaline he gets from designing as "better than any hallucination or artificial high . . . a kind of orgasm, a passion, a moment of dialogue with myself."

BUT *LA PASSIONE* isn't a prerogative only of the privileged. In casual conversations, Italians from all sorts of backgrounds spontaneously describe passions they can't resist. A psychologist who treats terminal cancer patients tangoes in competitions from Rome to Buenos Aires and beyond. The owner of a stationery store paints huge abstract canvases in his backroom studio. A scriptwriter with scores of movies to her credit rhapsodizes about olive oils from different regions of Italy—which she can differentiate with a single sniff.

In a country awash in tangible delights, anyone can see, hear, touch, caress, sip, smell, and bite into *la passione italiana*. Even everyday foods sizzle with its erotic electricity. A plebeian ham sandwich vamps into "a *panino* sinning with a slice of prosciutto." A Neapolitan vegetable soup becomes *maritata* (married) when a cook adds meat. Markets in Calabria sell *peperoncini,* the spicy peppers nicknamed *diavolicci* ("little devils" in dialect), as "nature's Viagra." According to culinary lore, coffee- and chocolate-laced tiramisù (literally, "pick-me-up") revived prostitutes—and their depleted clients—in Venice.

On the shelves of a grocery in the seaside village of Orbetello, I find espresso flavors named for Italian artists, including Michelangelo, Leonardo, and Botticelli, tantalizingly described as robust, aromatic, intense, satisfying—along with a decaffeinated Tiziano (Titian) for those "who don't want to give up pleasure in any moment of the day." Swept away, I buy all four—only to discover that I can't use any in the Swiss espresso maker in our rented villa.

In an Italian kitchen, passion surpasses any other essential ingredient. "Call it seduction, lust if you will," observed Marcella Hazan, the beloved champion of authentic Italian cooking in the United States. "To cook without this abandonment is to produce food that ends hunger yet does not satisfy."

La passione italiana flows from shops and kitchens into fields, groves, and vineyards. Waves of golden wheat sway languidly in the summer breeze. Just-picked peaches seem to bleed juice. Fire-red tomatoes radiate light. A winemaker in Lazio invites engaged couples to help in the annual harvest to instill the intensity of their love into his grapes. Others serenade vines with ballads or pick grapes by the light of a full moon.

YEARS AGO, in an impromptu interview on Dante, one of his great passions, the director and actor Roberto Benigni explained the great poet's genius to me as the ability to make a miracle of language out of anything, even the lowest, basest parts of life—*"pipi e merda"* (urine and excrement), he offered as examples. Whatever form it takes, *la passione italiana* shares this magical alchemy, transforming the ordinary into the extraordinary, the banal into the beautiful, food into feasts, sounds into songs, moments into movies.

But what makes it unique?

At lunch on via Margutta, the Roman lane that still evokes the spirit of the artists, writers, and actors who've lived there, I put this question to Marco Spagnoli, a prizewinning film director and critic as well as an astute cultural observer.

"First of all, Italian passion is always personal," he begins, noting that external measures of success, like money or fame, matter less than an internal spark. The goal can be grand or modest—a multimedia spectacular or a family video, a new restaurant or a perfect re-creation of a great-grandmother's *lasagne.*

Its significance stems from a deep commitment that rises from within—and from an ancient culture that Italians feel in their blood. "We grow up seeing something very old and very beautiful—a church, a statue, a bridge—every day," Spagnoli explains, "so we feel a duty, a compulsion to continue the tradition."

Once unleashed, *la passione italiana* takes on a life of its own. "It becomes almost an obsession. It doesn't matter how hard we have to work, how many hours it takes. We cannot stop. The old cliché of lazy Italians doesn't apply—to modern Italy or to people who do things. Fortunately, we like to get our hands dirty."

Although his hands are immaculate, I appreciate what Spagnoli means. Italian passions may begin with a thought or a desire but rarely remain purely cerebral. An almost molecular urge compels

Italians to translate their visions into tangible forms: verses, images, food, wine, cars, jewelry, films, designs. And into everything they create, Italians instill a bit of their own personalities, memories, and dreams.

Competition stokes passion's fire. The great rivalries of the Renaissance spurred its maestri to paint, design, and sculpt as no one ever had before. Opera singers strove to hold notes higher and longer than their peers. Race car drivers rocketed to death-defying speeds to outrun all challengers. "If there is no rival, we find one, even if it's just the bureaucracy," Spagnoli notes. "Ultimately we are competing with ourselves, pushing beyond old limits, daring to do more."

Challenges, setbacks, or downright defeats can't extinguish Italian passion. Through centuries of earthquakes, wars, invasions, and upheavals, *la passione italiana* has repeatedly surged back to life. "When things are at their worst," says Spagnoli, "we rise to our best."

"Even today?" I ask. Italy's economic woes and political wrangling have so shaken the nation that many wonder whether true passion can survive. Spagnoli responds wordlessly, with an utterly Italian jut of the lower lip and lift of the shoulders that conveys hope and doubt, confidence and cynicism.

I AM MORE OPTIMISTIC. Alone among nations, Italy has conquered the world—not once, not twice, but three times. The Roman Empire extended its might over territories spanning a quarter of the globe. Christianity, with Rome as its capital and Italy its cradle, planted the seeds of a religion that now counts 2.3 billion members—about one of every three people on the planet. The Italian Renaissance transformed art, architecture, and philosophy in an explosion of creativity that ushered in the modern age.

Italy has so profoundly permeated our collective unconscious that even if you have never set foot on its soil, you've touched and been touched by its heritage. Musicians everywhere play the do-re-mi notes invented by an Italian monk. Italian paintings, sculptures, and buildings adorn cities on every continent. Italy's food, arguably everybody's favorite, nourishes souls as well as bodies. Its wines soothe and stimulate. Its films, cars, and fashions transport us above the mundane and the mediocre. Leonardo's *Mona Lisa* outranks all other masterpieces as the world's most famous painting. Ferrari's Cavallino Rampante (Prancing Horse) outshines other brands as the most recognized logo.

More than ever, we are living proof that, as Barzini once contended, "in the heart of every man, wherever he is born, whatever his education and tastes, there is one small corner which is Italian." This is the place, often untidy or even unruly, that feeds the desire to live and love fully, to pursue beauty, to cherish family and enjoy the company of kindred spirits, to speak and act with flair, to recognize but not entirely care about the things that matter little, and to care fiercely about those that matter most.

And when it comes to matters of the heart, who could resist *la passione italiana*? Imbued with its fire, we might all become as brave as Italy's gladiators, as eloquent as its poets, as alluring as its beauties, as beguiling as its suitors. At the very least, we can savor more fully the greatest of Italian passions—for life itself.

2

SWIMMING WITH
THE GODS

tai attenta!" (Be careful!), Captain Tonino shouts as I dive from a boat (serendipitously named *Passione*) into the Tyrrhenian Sea off Sicily's northeastern tip. I ignore his warning. The Aeolian islands, ancient playground of the gods, shimmer as irresistibly now as in times long past.

Above me Stromboli, the black-coned volcano locals call Iddu, or "Him," puffs smoke into the sky like a man-mountain with an immense cigar. With each exhalation, pebbles skitter down its sides. Its island "wives" glimmer in the distance. Phallic "sea stacks" called *faraglioni* thrust upward from a turquoise sea. Aeolus, god of wind, ripples the water's surface with the gentlest of breezes.

With no one in sight, I swim into a grotto carved in the volcano's side and enter a deep pool with a bluish-green glow. Droplets of moisture splash gently from the craggy ceiling. Sailors call them *le lacrime delle sirene,* the tears of the mermaids who once tried to

lure Ulysses's men toward these perilous rocks. I follow their trail farther into the cavern.

Suddenly the first lash strikes, then a second burns across my thigh. A large medusa, the jellyfish named for the snake-haired goddess, tightens a tentacle around my waist. I struggle against its grip, but every kick intensifies the pain. Finally breaking free, I escape into the open sea. The stinging subsides within days, but the welts remain livid for weeks, a silent rebuke for incurring the wrath of the gods.

My husband the doctor, anointing my wounds with a soothing lotion, arches an eyebrow when I offer my fanciful explanation of what happened. I counter with a quote from the German writer Johann Wolfgang von Goethe: "If they were great enough to create these myths, we should be great enough to believe them."

IN SICILY IT'S EASY TO BELIEVE. Maybe that's why Goethe loved the Mediterranean's largest island. "To have seen Italy without having seen Sicily is not to have seen Italy at all," he contended, "for Sicily is the clue to everything."

Scoured by thousands of years of wind, water, and volcanic fire, the island defies conventional descriptions. This is the topography of passion, a geographic aphrodisiac of colors, shapes, and textures. A poet called it "a sea petrified," conceived in geologic delirium.

Some 620 miles of coastline—931 if you count its offshore islands—curve, bend, jut, rise, twist, and stretch into salt flats that change color in the setting sun. Tawny wheat fields spill into sweet-scented groves of almonds, oranges, and lemons. Sunbaked hills stretch toward craggy mountains. Towering above looms Mount Etna, Europe's most active volcano, molten lava frozen on its flanks, its peak as barren as a moonscape.

Everywhere on the island abandoned buildings slump, many farmhouses with empty windows, like carcasses of giant beasts with eyes gouged by vultures. When I ask what happened to the residents, Sicilians respond with a shrug. Centuries of invasion and conquest—by Phoenicians and Greeks, Carthaginians and Romans, Goths and Byzantines, Arabs and Normans, Germans, Spaniards, and French—have left their mark on the people as well as the land. I see it in their hooded eyes, arched profiles, and, above all, their passionate intensity. Time takes on new meaning here, as if three centuries of history crystallize in a single moment.

ON A RECENT TRIP to Sicily, after three flights and a voyage of twenty-eight hours, I arrive near midnight in Agrigento's Valley of the Temples, among the best preserved of ancient Greek monuments. In my room at the Villa Athena, I throw open the shutters to behold the Temple of Concordia glimmering in floodlights, all but outshining the full moon above it.

Here the settlers of Magna Grecia worshipped all-powerful Zeus, brave Apollo, and the demigod Eracle (Hercules) in temples even larger than those in their native Greece. At sunset the following day, I stroll among stately columns and mammoth altars with Lorenzo Capraro, a local guide who grew up playing among these ruins. The first citizens of the thriving town of Agrigento, he tells me, cherished one deity above all others: the earth mother Demeter, goddess of all that grows, who bequeathed on this favored land the riches of fertile fields.

Demeter doted on her daughter Persephone, whose loveliness captivated Hades, the god of the underworld. One day, as she gathered blossoms on the shore of Lake Pergusa near Enna, he lured the girl near with some blooms of rare beauty, then snatched her into

his subterranean realm. Frantic with fear, Demeter searched everywhere for her child. When she learned of Persephone's abduction, she furiously condemned Sicily to total sterility.

Without Demeter's benevolent grace, the seasons halted, vines withered, and fields turned brown. To save the starving people, Zeus intervened and decreed that Persephone return to her mother. But since the girl had eaten some of the pomegranate seeds Hades had offered her, she would have to return to his lair for part of each year. During these bleak months, Sicily grieves with Demeter.

Every spring, the island welcomes Persephone's return with floral fireworks. While snow still caps Mount Etna, almond trees—a mythological symbol of fertility—burst into white blossoms. Wildflowers riot along the roadways and poke vibrant petals through the ruins at Selinunte, a major port that flourished as a center of trade and art for centuries until its destruction by its Carthaginian foes in 409 BC.

I scramble with Pina, another local guide, around broken pillars and huge blocks of stone to a perch above the slate-blue sea. Pina counts herself lucky to have been among the last generation that worked the nearby fields. As a young girl, she would run across her grandparents' farm "totally free." Her grandfather plowed with a donkey. Her grandmother bartered her garden crops for household necessities. "We didn't need money. We didn't need anyone else. We had the earth."

Even today this passion for the soil, this profound appreciation for Demeter and her gifts, endures. "I am proud to be a child of the people who came here and conquered and survived," Pina tells me. "This sea was their sea, and it is mine. This land was their land, and it is mine. I feel their passion in my veins."

Could she imagine ever living anywhere else?

Her dark eyes well up, and she shakes her head. We sit in si-

lence, amid the fallen gods and their temples, listening to the wind and the waves.

ANOTHER DAY, ANOTHER MYTH, this one born of an earthy passion of a different type.

In a cosmic coup, Cronus, son of the mythic god of the sky, castrated his despotic father. Uranus's testicles fell into the sea, which gave birth to a fully formed woman who floated upon a wave that swept a magic mountain to the northwest tip of Sicily. In a temple atop this cliff, perched between sky and sea, the earliest tribes worshipped the Mediterranean Mother; the Greeks, Aphrodite; the Romans, Venus.

Here in the village of Erice, named for a son of the goddess of love, beautiful maidens served as her priestesses. Night and day, winter and summer, they lit torches in a high tower visible to ships from every direction. Landing in the port of Trapani, sailors clambered almost 2,500 feet up the steep mountainside to worship at the shrine—although more for passion than piety.

In a ritual delicately referred to as "embracing the goddess," the men lay with Venus's lissome handmaidens, who granted their lovers protection from the perils of the sea. The sailors left as their parting gifts the children who would populate the land.

On the day that I visit, Venus's temple, wreathed in mist, seems suspended in a cloud. Although many structures have toppled, the "cleansing pool" where the priestesses bathed still stands, as does a dovecote. Every August, according to legend, the maidens would morph into doves and fly to a sister shrine in Africa for a nine-day festival, returning with red-winged Venus in the lead.

Long after the temple's destruction, the tradition of "sacred prostitutes" providing comfort to sailors from afar continued. In

time, Venus gave way to the Madonna, and a Christian church rose above the pagan temple. Devout young women still trekked to Erice, but to serve in a totally different capacity, dedicating their lives to the worship of God as cloistered nuns.

To support themselves and the orphans they sheltered, the nuns created heavenly sweets with cheese, nuts, and other local crops. A large horizontal wheel carried these mouthwatering treats from the convent's darkness to customers, who deposited money and carried off the delicacies without ever glimpsing the nuns' faces.

On Erice's main street, I step into a former orphanage that now houses the bakery of Maria Grammatico, who learned how to make *pasta di mandorle* (an almond paste similar to marzipan) as a girl. In a Dickensian workhouse, she rose before dawn to fire the ovens, scour pots, and shell and crush almonds. With no dolls or toys, the girls worked every day except Christmas and Easter (when they attended church), their only treats an ice cream on Ferragosto (August 15) and an occasional piece of fruit. Yet out of this bleakness emerged sublime confections.

After leaving the orphanage in 1963, Maria opened a *confetteria* that produces sweets eagerly devoured by tourists. I buy an assortment—*sospiri e desideri* (sighs and desires), *genovesi* (known elsewhere as *minni di virgini* or virgins' breasts), *panzerotti* (little bellies)—and sit on a bench overlooking the bay where Trapani stretches its long breakwaters into the surging sea. Surrounded by all the female spirits who lived amid the mists of Erice, I savor the timeless blend of the decadent and the divine, passion transfigured into the taste of bliss.

"ERICE MAKES MY DARKNESS TREMBLE," said D. H. Lawrence, who wrote *Lady Chatterley's Lover,* the most erotic novel of its day, in Sicily. I can understand his reaction. However, he found his true

soul mates in the Etruscans, an ancient people who settled in central Italy in the eighth century BC.

"The first time I consciously saw Etruscan things," Lawrence wrote, "I was instinctively attracted to them. And it seems to be that way. Either there is instant sympathy or instant contempt or indifference." I too felt an immediate affinity with the Etruscans, whom I got to know over several decades of annual stays in Etruria, the heartland of Etruscan territory that now encompasses Tuscany, Umbria, and Lazio.

At their height, according to the Roman historian Livy, the loose confederacy of Etruscan city-states, with a shared language, religion, and customs, "filled the whole length of Italy from the Alps to the Sicilian strait with the fame of her name." Rather than villages of mud and straw, the Etruscans built walled towns with geometrically laid-out streets and massive gates—one with designated "in" and "out" lanes is still in use in Cortona. Among pre-Roman civilizations, only the Greeks compared in wealth, power, and influence.

Etruria's sailors (and pirates) established dominion over the Mediterranean. Its engineers, renowned for road and bridge building, constructed ramparts so colossal that they seemed "piled by the hands of giants for god-like kings." Praised by the Greeks as "very good-looking because they live luxuriously," the "plump Etruscans" inspired fashions other countries envied and emulated.

Jewelers hammered gold and gems into finely wrought pendants, earrings, and bracelets. Shoemakers cobbled lace-up boots with pointed toes and sandals with buckles that clicked like castanets, which the Greeks imported by the thousands. Dentists molded ox and calf teeth into soft gold to form bridges for human mouths that set a standard unmatched until the late nineteenth century.

Yet the Etruscans' most enduring gift was an ebullient delight in worldly pleasures. Basking amid fertile fields and vineyards, with

streams that never ran dry and mountains rich in precious ores, the original bons vivants dedicated themselves to enjoying a bountiful existence in the here and now. Both sexes, lavishly dressed, reclined in pairs on elegant couches, served by slaves and entertained by musicians.

"People of dainty and expensive tastes," as the Greek historian Dionysius recorded, they "carried about with them, besides the necessities, costly and artistic articles of all kinds designed for pleasure and luxury."

Although they paid homage to a full pantheon of gods, the Etruscans essentially worshipped life itself. To them, Lawrence wrote, "all was alive: the whole universe lived; and the business of man was himself to live amid it all . . . to draw life into himself, out of the wandering huge vitalities of the world." In the Etruscan belief system, everyone and everything pulsed with a "great furnace-like passion that makes the worlds roll and the sun rise up and makes a man surge with procreative force."

Rome's "naughty neighbors to the north," as Lawrence described them, scandalized their contemporaries. In the fourth century BC, the Greek historian Theopompus described the uninhibited Etruscans stripping off their clothes to exercise in the open air and showing "no shame to be seen committing a sexual act in public." As he breathlessly reported to his countrymen, "they all engage in making love, some watching one another, some isolating themselves with rattan screens set up round the couches, each couple wrapped in one another—courtesans, young boys, even wives."

WAS HE EXAGGERATING? Perhaps, although most of what we know of the Etruscans comes from paintings that portray their passion for life. In vividly colored scenes on the walls of elaborate tombs, muscular men hunt, battle, fight bulls, wrestle, throw javelins, and

race four-horse chariots. Naked boys dive from high cliffs into the sea. Dancers, some also nude, with long-limbed Matisse bodies, spin in sensual abandon to the sound of lyres, zithers, and double flutes. Etruscan women, considered the most beautiful and liberated of their age, appear at their husbands' sides at banquet tables (unthinkable for Greeks). And everywhere—at intersections, in front of houses, in temples—stand phalluses, some huge inscribed pillars, some smaller carved stones.

My favorite Etruscans, a man and a woman, recline in the form of a terra-cotta sarcophagus from the sixth century BC in the Villa Giulia, the National Etruscan Museum in Rome. With almond eyes, a narrow face, neatly trimmed beard, long braided locks, and powerful shoulders, he lies casually, naked to the waist, his arm around her shoulder. She, dressed in a flowing gown, with tiny feet tucked into soft slippers with pointed toes, pours perfume—a ritual act—into his hands. I recognize the languorous look on their faces: utter postcoital contentment.

The future the Etruscans envisioned after death was neither an ecstatic heaven nor a fearsome hell, but a continuation of their sensual life on earth, as if the party simply resumed on the other side. To prepare, they stocked their tombs with jewelry, cosmetics, and elegant robes. This benevolent vision of eternity inspired them to accept all that life offered with unabashed exuberance.

Over time the Etruscans lost this zest. Tombs from the second and third centuries BC depict somber faces and stiff bodies lacking the natural grace of earlier eras. D. H. Lawrence blamed the Romans, who cannibalized Etruscan culture and claimed their engineering and artistic feats as their own.

"Italy today is far more Etruscan in its pulse, than Roman: and will always be so," he wrote in *Sketches of Etruscan Places*. "The Etruscan element is like the grass of the field and the sprouting of corn, in Italy: it will always be so."

As their society merged with that of the Romans, Etruscans would drain the marshes along the Tiber, lay out the first Forum, erect the first temples, create the first racecourse, teach everything from engineering to augury, and transform Rome from an assemblage of huts to a city of wood and brick. Above all else, the Etruscan spirit, hardened in battle, soothed by beauty, and energized by celebration, would endure.

"The Etruscans planted the seeds for all the passions we think of as Italian: music, food, wine, design, beautiful clothes, jewelry," says the archaeologist Lisa Pieraccini, director of the M. Del Chiaro Center for Ancient Italian Studies at the University of California, Berkeley. "The Romans were able to achieve all that they did because they were standing on the shoulders of the Etruscans."

The ancient Romans would never have agreed. They believed with absolute certainty that the gods themselves had destined them for greatness.

DEEP IN MYTHOLOGICAL TIME, Venus (Aphrodite in the Greek pantheon), goddess of love and beauty, spied a handsome prince in the vicinity of Troy. Dressed as an earthly princess, she seduced him and then slipped away. Nine months later Venus presented the Trojan prince with the son they had conceived.

Revealing her true identity, Venus made her lover pledge to keep their secret. (He didn't, and as punishment, her father hobbled him with the strike of a lightning bolt.) She also predicted that their love child, whom she named Aeneas, would sire a race that would someday rule the world.

In the twelfth century BC, after a ten-year siege, Troy fell to the Greeks, who had deployed their infamous "Trojan horse," a mammoth hollow structure with soldiers hidden inside. As the city burned, Aeneas escaped with his lame father on his back and his

young son at his side. Despite detours and dalliances (including a torrid but doomed affair with Carthage's queen Dido), Aeneas made his way to central Italy.

The tribal king of the Latins welcomed Aeneas, who asked to marry his daughter, already betrothed to a local general. Aeneas and his rival squared off, and Venus's son won the princess's hand. In time, Aeneas ascended to the throne of the kingdom of Alba Longa on the Tiber. The crown passed through eight generations until a jealous younger brother overthrew his reigning sibling. To block any rivals, he killed his nephews and confined his niece Rhea Silvia in a temple to the goddess Vesta, where a vow of chastity would prevent her from conceiving an heir.

Mars, the lusty god of war, blithely upended this plan. On a sunny day, he caught a glimpse of the beguiling virgin, who, resting on the banks of a stream, had "opened her bosom to catch of the breeze." Overcome with desire, Mars swooped from the heavens and "left her rich with twins."

When Rhea Silvia gave birth to two boys of uncommon beauty and size, the angry monarch ordered them drowned. But a slave, taking pity on the infants, placed them in a basket in the Tiber that washed ashore at the foot of what is now the Palatine Hill. There they were rescued by a *lupa*—probably not the she-wolf of legend but a woman known by a nickname given prostitutes because, like wolves, their lovemaking "knew no law." She brought them to the cave of a kindly shepherd, where they grew to manhood. Once they learned their true origins, Romulus and Remus overthrew the wicked usurper who had stolen their grandfather's throne.

The twins decided to build a new kingdom of their own on the Tiber, but quarreled over its location. They called for augurs, an Etruscan tradition, to settle their dispute. When six birds appeared above Remus on the Aventine, the hill he preferred, he seemed to

be the winner. But then a dozen birds circled over Romulus on the Palatine, clearly favoring him and his chosen site.

Romulus began marking the perimeter of his *città quadrata* (squared city). Taunting his brother, Remus jumped across the boundary. His outraged twin killed him.

"This," Romulus swore, "will be the fate of any who dare to violate this land." And so, on a date fixed in history as April 21, 753 BC, Rome—conceived in rape and baptized in blood—was born.

ALTHOUGH MUCH OF ROME'S "foundation story," as historians categorize it, may be myth, we know that its first inhabitants honored their divine forefathers. And we know, too, that its ancient site existed—thanks in large part to more than thirty years of research by the archaeologist Clementina Panella at Sapienza University of Rome (La Sapienza to Italians). Inch by painstakingly excavated inch, her team burrowed deep below ground level to uncover what she calls "the first page in this amazing history of humanity."

Above all else, Panella explains when I visit her laboratory, Rome began as a place for the gods, created by Romulus or "the figure or figures he represents" as a temple. The land of his squared city was considered too sacred ever to be violated by battle. Warriors had to lay down their weapons before entering this hallowed zone.

In one corner of the original city, Panella's team uncovered a monumental sanctuary, the Curiae Veteres. Here representatives of every district of Rome, regardless of class or status, gathered to worship, witness ritual sacrifices, and share meals together, as testified by huge mounds of discarded animal bones. This sacred space remained in use for 1,300 years—perhaps, Panella speculates, longer than any other on the planet.

Today thousands of fragments from these distant days fill floor-to-ceiling shelves in the archaeology department at La Sapienza:

Bits of black-glazed Etruscan pottery. A carefully reconstructed pitcher. The head of an emperor, sliced from a statue and used as filler for the foundation of his successor's palace. (The torsos were recycled, with a bust of the new leader cemented on top.)

One artifact in particular intrigues me: an urn about a foot high from the fifth century BC that held the remains of an infant who had died at or shortly after birth. Although Romans routinely exposed newborns who were feeble, defective, or simply unwanted to the elements, this baby was gently wrapped in a cover of sorts and buried under the protective eave of a home.

The researcher who unwraps it for me sighs. *"Povero bambino!"* (Poor baby!) We pause for a moment in silence, touched by the timeless anguish of a child's loss, still fresh after 2,500 years.

This sense of connection explains why the stories of ancient Rome remain more compelling than any we might invent. Although they loom as larger-than-life historical figures, the Romans whose names echo through the ages—Caesar, Mark Antony, Augustus—survive in Italians' imaginations as flesh-and-blood members of their family tree.

THE GODS' FIRST GIFT TO ROME was survival against overwhelming odds. Surrounded by hostile tribes, the new city had no natural resources, no fertile fields, no trained military, no institutions for government or commerce. Its swampy location on the Tiber posed a constant risk of floods and malaria. To populate his city, Romulus welcomed local shepherds and offered sanctuary to exiles, runaway slaves, debtors, thieves, traitors, bandits, even murderers—"the dregs," as a classics professor succinctly described them to me. And yet they would thrive.

Gathering around a deep pit, each of Romulus's renegades threw in a handful of soil or coins from his homeland, a mingling

of their different pasts with their shared future. As the Greek biographer Plutarch recounts, they also tossed in tokens "of all things deemed good according to custom and necessary for human life according to nature." Like seeds, these symbols flowered into the passions that would prove as eternal as the city they founded.

To ensure its future, Rome's first citizens—poor, ragged, hardened by prison, slavery, or years on the run—needed children, and the mothers to bear them. But when Romulus tried to arrange marriages, the leaders of nearby towns scoffed at the notion of marrying their daughters to such riffraff. Some suggested that Rome offer asylum to female fugitives, the only fitting mates for its unsuitable suitors.

Romulus devised an alternative strategy: He invited the local tribes to his new city for a festival. Fathers and brothers, most from the nearby town of Sabina, turned over their weapons and relaxed with their families to enjoy the feast. Then Romulus's men swooped in and carried off the young female guests. Some accounts say thirty teenage virgins were taken; other estimates run as high as six hundred.

Rome's leader justified the kidnapping as motivated by *l'ardore della passione* (the ardor of passion) and assured the terrified girls that they would be treated with respect. As Roman wives, they would do no domestic labor other than spinning; slaves and servants would handle all other chores. No one could speak indecent words in their presence. No man could appear naked before them—or he would risk being punished as severely as a murderer. Their children would wear distinctive jewels and robes and share in a great destiny.

"We do not ask only for your bodies," Romulus emphasized. "We want your hearts as well."

The hearts of the girls' outraged relatives burned for vengeance. Their opportunity came when Tarpeia, the daughter of the commander of the Roman garrison, ventured outside the city walls to

fetch fresh water for a sacred ritual. Some flirtatious Sabines convinced her to help them enter Rome in return for the wrist-to-elbow gold bracelets they wore on their shield arms.

As soon as they burst through the gates, the Sabines crushed Tarpeia with their shields—fitting punishment for a traitor, they declared. (The cliff where she died became known as the Tarpeian Rock. Traitors were hurled to their deaths from its height for centuries after.)

Although the Sabines had the initial advantage of surprise, the Romans quickly armed themselves. As the fighting intensified, the Sabine women—sobbing and shrieking—rushed from their homes, not to escape, but to throw themselves into the fray. Pushing between combatants, they implored their fathers not to kill their husbands and their husbands not to kill their fathers.

"We would rather die ourselves," they cried, "than live without either of you, as widows or as orphans."

"Silence fell," reported the historian Livy. "Not a man moved. A moment later Romulus and the Sabine commander stepped forward to make peace."

The two men shared power until the Sabine king died in a riot in a nearby town several years later. Romulus reigned as Rome's king for more than three decades. His successors would rule a city, then a peninsula, then an empire. Its citizens would shape the building blocks of Western civilization. Its government would survive longer than any in history.

Almost three millennia after Rome's founding, its legacy lives on—in laws rooted in its statutes, cities based on its blueprints, churches and capitols crowned by its cupolas, the "Romance" languages spoken by millions around the world. Although Rome may have been built to honor its gods, *la passione italiana* would transform its citizens and create a city all of humanity can claim as our home.

3

FROM WARRIORS
TO LOVERS

*S*niff!" our guide commands as she thrusts a leaf snipped from
a bush in the Roman Forum under my nose. "What do you
smell?"

I inhale deeply. The aroma is tantalizingly familiar—fresh,
spicy, woodsy, a scent I immediately link to a certain type of alpha
male—but I can't identify its name.

"Glory!" she exclaims.

Wreaths woven of such laurel leaves once crowned Rome's con-
quering generals as they rode in triumph behind twelve attendants
bearing fasces, the long rods and ax symbolizing power over life
and death. At their sides, a slave repeatedly whispered, *"Memento
mori,"* a reminder that despite the adulation they remained mortal,
destined to die. Yet for the moment they could bask in the honor
of extending the rule of Rome, described by the writer Pliny as a
gift "bestowed upon the human race like a second source of light."

On a soft September night, the glories of Rome surround me like the stage set of a majestic historical drama. Jagged columns jut toward the stars. Triumphal arches, pocked by time and thieves, gleam in floodlights. Multimedia spectacles projected onto ancient walls reconstruct the bustle of Caesar's Forum and the grandeur of Augustus's temple. All testify to a long-lost time when every road led to Rome and every nation bowed under its command.

Rome changed everything. Drawing on earlier cultures, it adapted and refined the intellectual and technical heritage of Greece, Carthage, Egypt, and the East. The laws of its Twelve Tables brought order to a tumultuous world. Its government established the separation of powers and served as a model for the American and French Constitutions. Its Roman arch would prove as crucial to architecture as the wheel to transportation. Its sturdy roads, spanning more than fifty thousand miles, carried pilgrims, traders, adventurers, and caravans of exotic goods from every corner of the sprawling empire.

Lives were short (an average of forty-one years for men, twenty-nine for women) and the future uncertain. "Carpe diem!" the poet Horace urged, and so the Romans, masters of the art of living, did—with gusto.

"WERE THEY LIKE US?" I wonder aloud as I survey the still-glorious remnants of the ancient Romans.

Our guide suggests a more salient question: "Are we like them?"

Not at first glance. Rome's was a pagan creed, with a bloodlust that ran deep. Honed into an invincible killing machine, its legions enslaved millions and lined miles of roads with the crucified bodies of enemies. Its citizen-soldiers killed without compunction—and faced the prospect of being killed without complaint.

Even in their private lives, Romans didn't shy away from brutality. Crowds cheered as wild beasts mauled each other and gladiators—the sexiest celebrities of the day—fought to the death. Violence permeated homes as well as arenas. By law a Roman patriarch could kill an unwanted or sickly newborn, a disrespectful slave, or a wife who committed adultery or aborted a child without his consent.

Although the Roman Empire would ultimately crumble and fall, its influence would endure. The passion of its citizens entered the spiritual DNA of their descendants and spread beyond geopolitical borders. Even now, twenty-some centuries later, people around the world still do as the ancient Romans once did.

We prize our families and honor our dead. We take for granted creature comforts that the Romans invented, such as indoor plumbing and heated water. We call the months of the year and the planets in the heavens by their Roman names. We soothe ourselves with music, soak in warm baths, wildly cheer our favorite teams, sip wine, linger over delicious dinners, and laugh at bawdy comics and clowns.

Like the Romans, we garb ourselves in stylish clothes, fancy footwear, and statement jewelry. Modern women experiment with hairstyles (including hair extensions and wigs), fight wrinkles, and apply makeup that is thankfully far less noxious than the "mascara" of ground-up roasted ants favored by Rome's beauties. Men still try to conceal their baldness, but more subtly than with the lampblack their Roman counterparts applied to their scalps (a ruse that worked only across the vast Circus Maximus).

In our pursuit of romance and happiness, observes Alberto Angela, the archaeologist and author of *Amore e sesso nell'antica Roma* (Love and Sex in Ancient Rome), contemporary men and women may be more similar to the ancient Romans than any prior

generation. "No other civilization or culture of past or of recent centuries," he contends, "has ever been closer to them in terms of daily life, love, and sex."

BUT HOW CAN WE RECONCILE the Romans' staggering achievements with their shocking cruelty? How can we comprehend their ability both to kill ruthlessly and to love passionately?

"Think of the gods the Romans worshipped: Mars and Venus," says the archaeologist Livia Galante as we walk among the remains of their temples. As sons of Mars, the Romans were warriors, the fiercest on earth. As sons of Venus, they were lovers who embraced sex as her sweetest gift, to be enjoyed as freely as fine wine, without a twinge of guilt.

Over the arc of their history, the Romans evolved from warriors to lovers. This chapter introduces some emblematic figures from this long transition: Lucretia, a noble wife who would inspire her countrymen's passion for freedom. Caesar, the consummate warrior and lover who would stand astride the ancient world like a colossus. His successor Augustus, who would bestow on Rome the most enduring peace in history.

In time, the sons of Mars would lay down their swords and become statesmen, scholars, and sophisticated lovers of earthly pleasures. Venus would have her day. The Roman Empire, straddling three continents, would bask in a time when, as the historian Edward Gibbon wrote, "the condition of the human race was most happy and prosperous."

Yet pagan Rome never completely shed its blood-drenched past. On an evening tour of "dark Rome," I descend into the depths of the Colosseum, where ravenous beasts once roared from cramped cages and gladiators armed themselves for deadly duels. Its sodden ground turned red with the blood of men and beasts. Animal

carcasses—as many as five thousand in a single day—were hauled away via a special gate. Gripped by a sudden chill, I understand more profoundly that the primal passion that propelled Rome into history was power—in the arena, on the battlefield, and in the bedroom.

LIKE MARS, ROMAN WARRIORS SEIZED whatever—and whomever—they desired. For centuries, a *sessualità di stupro* (sexuality based on rape), as Italian sociologists describe it, permeated Roman society. Sex, like everything else in virile Rome, was about conquest.

Men wrote the rules—and when it came to sex, there was only one: a Roman man must always dominate. Taking rather than providing pleasure, he could couple with a woman, a young boy, or a slave of either sex. Sexuality itself, deemed as natural as any appetite, saturated Rome and its territories.

Graphic sexual images appeared on dinnerware, lanterns, and paintings hung in homes and taverns, in view of women and children as well as men. Both sexes wore jewelry in phallic shapes to ward off malignant spirits. Statues of the ever-erect, hugely endowed god Priapus, the carrier of life and incarnation of male sexual vigor, decorated street corners and gardens, where they helped to frighten off birds.

There was no differentiation—nor even any words—for heterosexual and homosexual, gay and lesbian. "Greek-style" encounters seemed a novel way of experiencing pleasure. Sophisticated Roman men were almost expected to appreciate beauty in a winsome boy's body just as they did in a woman's—as long as they always dominated. Aristocrats (and the occasional emperor) often doted on young male partners, but consensual sex between free adult men was frowned upon as degrading to a citizen of Rome.

The taboo against passive submission extended to every sexual

act. Because the mouth, as the organ of speech, was considered sacred, a man who "dirtied" his by performing oral sex on another man or, even more unthinkably, a woman was betraying the honor of Rome. The passive role in sex with a man seemed the ultimate humiliation, a reason Roman soldiers sometimes sodomized defeated enemies.

While a man was judged for his virility, a woman's greatest virtue was *pudicitia,* sexual purity that demanded chastity before marriage and fidelity after. A girl's lips were expected to be as virginal as her body, untouched by any but her husband. After marriage, a man could assert *il diritto del bacio* (the right of the kiss) to check his wife's breath and see if she had drunk any wine—an offense punishable by death. The legal justification: "A woman greedy for wine closes the door to virtue and opens it to vice."

A ROMAN HUSBAND PROUDLY DISPLAYED a good wife as a trophy enhancing the honor of his family. One evening in 509 BC, Livy records, some young cavalrymen besieging a nearby town drunkenly debated their mates' virtues. Certain that his wife, Lucretia, outshone all others, one of the men, named Collatinus, suggested that they ride the few miles back to Rome to check on their women.

Arriving late in the evening, they found the wives eating and reclining on banquettes—except one. At Collatinus's house, Lucretia was spinning by lamplight alongside her maids. She graciously offered dinner to her husband and his guests.

The charm of this virtuous woman inflamed the son of the reigning king, a despised tyrant known as Tarquin the Proud. A few nights later the prince, burning with what Shakespeare called his "scarlet lust," returned to the house, entered Lucretia's bedroom, and declared his desire for her. When she rebuffed him, he threatened to murder her and leave her in bed next to the naked

body of her African slave. Everyone would think that they had been killed while committing adultery. Horrified at such a disgrace to her family, Lucretia submitted.

The next day, she summoned her father and husband. Struggling for composure, Lucretia told them what had happened. "Only my body was violated, my spirit is innocent," she tearfully recounted. "I will kill myself, and my death will prove it. But promise me that this act will not go unpunished." With a knife hidden in her robes, she stabbed herself in the heart.

The death of Lucretia marked a turning point in Roman history. Her relatives carried her body through the streets to the Senate. Raging against the despotic king, the people forced him to flee. Rome's legislators, determined never again to allow a monarch supreme power, formed the Republic.

Lucretia gained an immortality of her own in paintings by Botticelli and Titian, a narrative poem by Shakespeare in 1594, an opera by Benjamin Britten in 1946—and inclusion in Judy Chicago's 1979 feminist installation, *The Dinner Party,* a tribute to more than a thousand heroines of world history featuring plates that depict female genitals.

MARRIAGE, ALBEIT BY ARRANGEMENT rather than abduction, became a Roman's civic and social duty. The poor paired off in simple rituals, such as placing a woman's hand in a man's and reciting a vow. The upper classes bartered their daughters for the family's political or financial gain. Brides, usually girls between the ages of twelve and sixteen, engaged to grooms twice their age or older, had no say in the matter. As a business transaction, marriage was too important to allow either love or passion to enter the negotiations.

The marriage bed was reserved for reproduction, not recreation. Erotic desire, viewed with suspicion as irrational and

uncontrollable, was discouraged, if not actually forbidden, in marriage. "He who loves his wife with too much passion," a statesman warned, "commits adultery." Husbands could readily indulge carnal desires elsewhere—and indulge they did.

Prostitutes, wearing thigh-high togas and bright red, orange, or blue wigs, sold their bodies and skills under bridges or in the shadows of the Forum. *Lupanaria* (wolves' dens, or brothels) offered a range of services for prices that ranged from less than the cost of a glass of wine to as much as a soldier's daily salary for specialized items on a crudely drawn "menu" of sexual positions. Men with money and influence could find more options among actresses, dancers, beauticians, masseuses, and workers at the public baths, considered by the nature of their trades to be amenable to sexual overtures.

AS ROME EXPANDED ITS BOUNDARIES and increased its wealth, political and social tensions threatened to tear the Republic apart. By the second century BC, the plebes, or common people, were clamoring for reform, while the aristocratic elite clung to power and wealth. Civil wars erupted, with violent street fights and rioting in Rome. In these perilous times, a man emerged to tower above all others: Gaius Julius Caesar (100–44 BC), who proudly traced his bloodline to Venus and her son Aeneas.

"Veni, vidi, vici" (I came, I saw, I conquered), he declared after one victory. These three words summarize his passion: Caesar lived to conquer—by sword, word, or seduction.

While still in his teens, Caesar plotted a brilliant political career, beginning with marriage to Cornelia, a daughter of Rome's political leader. Two years later a civil war swept the dictator Sulla, a rival of Caesar's father-in-law, to power. He demanded that Caesar divorce Cornelia and wed his stepdaughter. When he refused,

Caesar was condemned to death. Fleeing into the countryside, he contracted malaria. His mother persuaded the Vestal Virgins, the most influential women in Rome, to plead for her son's life. Sulla relented, and Caesar returned to Rome—not yet twenty but a survivor of political and personal peril.

While fulfilling his military service, Caesar was dispatched to serve the king of Bithynia (the northern coast of modern Turkey). Rumors circulated that the homosexual monarch welcomed Caesar to his bed as well as his court. For the rest of his career, Caesar would be mocked as the "queen of Bithynia" for his passive role in the alleged affair. He brushed aside the gossip and repeatedly proved his macho mettle.

Captured by pirates while sailing across the Aegean Sea, Caesar dispatched servants to bring a hefty ransom and passed his six-week captivity taunting the crew with his plans to kill the lot of them. They thought he was joking. As soon as he was freed, Caesar engaged armed vessels, retrieved his money, captured the pirates, and crucified them all—cutting their throats first as an act of clemency.

By age thirty, Caesar had proven himself a fearless commander, a gifted orator, a dutiful husband to an impeccably virtuous wife, and a loving father to their daughter. When Cornelia died in labor the following year, he buried her in a grand public funeral, the first for a woman so young.

Then as now, ambitious men needed money to fuel their passion for power. Pompeia, granddaughter of the dictator Sulla, brought plenty to her marriage to Caesar. Her enormous inheritance subsidized his lavish spending on favors to influential allies, dinner parties, and gladiator games—one with a record 320 pairs of fighters in ornate silvered armor.

Caesar's extravagance paved his way up the ladder of political offices, but charm helped him woo and win scores of lovers, many

married to his colleagues and enemies. His longest relationship was with a noblewoman named Servilia, mother of Brutus, whom Caesar came to love as a son.

"The husband of all the wives," said Caesar's admirers. "And the wife of all the husbands," jeered his enemies. Yet all agreed that, as the historian Adrian Goldsworthy reports, the "sheer scale of his activities stood out in Roman society, which at this time did not lack adulterers or rakes."

CAESAR'S MILITARY CONQUESTS CARVED OUT vast new territories for Rome, including most of modern France, Switzerland, Belgium, southern Holland, western Germany, and the British Isles. During his campaigns, his legions—a battle-hardened army that, as he put it, "could storm the very heavens"—captured eight hundred cities, towns, and forts and killed or enslaved, by his account, millions of their residents.

Wary of Caesar's growing power and popularity, in 49 BC the Senate issued an ultimatum demanding surrender of his command. Instead, Caesar broke a long-standing tenet of Roman law and led one of his legions—some five thousand men—across the Rubicon River and into Italy. In a brilliant blitzkrieg, he swept through Italy, with town after town opening its gates in surrender.

In two months, with almost no bloodshed, Caesar gained full control of Rome's military and treasury. He initiated a program of social and governmental reforms, introduced the twelve-month "Julian" calendar, centralized the Republic's bureaucracy, and won designation as "dictator in perpetuity." With each new role and responsibility, the brilliant tactician and unscrupulous politician evolved into a more astute statesman and governor.

When Caesar pursued his remaining enemies to Egypt, local allies delivered the mummified head of his longtime rival Pompey.

In true Roman fashion, the warrior quickly turned into a lover—this time of Egypt's twenty-two-year-old queen Cleopatra. Historians still debate who seduced whom.

Striking if not conventionally beautiful, Cleopatra may have stirred Caesar's passion with her quick mind and nubile body. Even more seductively, she came to him as his equal, queen of an opulent realm and soon the mother of his only son. Although Caesar would never marry her, he presented his Egyptian prize to Rome, where he scandalized its residents by placing a statue of Cleopatra next to Venus's in the goddess's temple.

Caesar's foes feared that the overreaching ruler would soon declare himself emperor. In 44 BC, on the fifteenth, or ides, of March, a gaggle of senators ambushed him on his way to the Senate. Stabbed again and again, he fought back with his metal stylus. But when Brutus raised his dagger, Caesar cried out, "You too, child!" (not the oft-quoted *"Et tu, Brute?"*), and collapsed, bleeding to death from twenty-three wounds.

THE WORLD AS ROME KNEW IT turned upside down. Full-scale civil war erupted. Brutus and some of the other conspirators fled. Gaius Octavius (Octavian; 63 BC–AD 14), Caesar's eighteen-year-old grandnephew, adopted son, and chief heir, and his loyal lieutenant Marcus Antonius (Mark Antony; 83–30 BC) emerged as corulers and pursued Caesar's assassins. Then passions again changed the course of history.

Mark Antony had always been more of a lover than a warrior—not just of women, but of wine, revelry, and the demimonde of the theater. In 40 BC, he married for the fourth time, choosing Octavian's sister to reinforce his alliance with Caesar's heir. Then he left to rule over Rome's distant provinces, including Egypt.

Soon he fell under the spell of its siren queen, who would bear

three of his children. Sinking ever deeper into the decadence of the desert kingdom, Antony seemed to forget he had half an empire to rule—and a formidable young rival watching and waiting in Rome.

Violating sacred taboos, Octavian broke into the temple of the Vestal Virgins to retrieve Mark Antony's will. This secret document spelled out his plan to give conquered territories as kingdoms to his sons with Cleopatra. The Roman plebes turned against him. In 32 BC, the Senate declared war on Egypt. After more than a year of naval battles and sieges, Octavian defeated the combined forces of Antony and Cleopatra in 30 BC.

When he realized that all was lost, Antony threw himself on his sword. Cleopatra, by means of a poisonous asp, also took her fate into her own hands. Warriors and lovers, they ended their lives on their terms, determined—as Shakespeare has Cleopatra say—to "make death proud to take us."

MANY DOUBTED THAT YOUNG OCTAVIAN could hold on to power. He proved them wrong, ruling longer and bringing Rome greater glory than any of its emperors. This seemed his destiny—especially when the Senate, three years after Caesar's assassination in 44 BC, took an unheard-of step and declared the deceased ruler a god.

The twenty-one-year-old princeling, who began identifying himself as *divi filius* (son of gods), quickly learned that descendants of deities could claim whatever they desired. And from their first meeting in 39 BC, he desired Livia Drusilla, a woman from an illustrious family whom the poet Ovid described as having the features of Venus and the mettle of Juno, the formidable queen of the gods.

At the time, both Octavian and Livia happened to be married. Octavian's much older wife, Scribonia, whom he had wed to ce-

ment a political alliance, was carrying their first child. Livia was pregnant with her second child by a husband who had twice allied himself against Octavian—first with Caesar's assassins and then with Mark Antony.

The existence of two spouses and two unborn children proved to be trivial obstacles. On the day their daughter Giulia (Julia; 39 BC–AD 14) was born, Octavian sent his wife a letter informing her of their divorce and taking the newborn into his custody. Just as perfunctorily, Livia's husband was "persuaded," perhaps with financial or political inducements, to divorce his wife.

Within days of giving birth, Livia married Octavian. The couple's erotic passion evolved over time, with Livia personally selecting the nubile virgins her husband enjoyed deflowering. However, their shared passion for imperial power endured in a union that lasted for more than fifty years.

Declared "first among citizens," Octavian proved a shrewd and often ruthless leader, who adroitly eliminated enemies, bolstered alliances, and wove together a fragile coalition. In 27 BC, he restored the Republic—but only in name. Rather than calling himself "Caesar," he accepted the title "Augustus" for his role as a mediator between mere mortals and his godly peers and pursued the Roman passions for power and glory in a new way.

"Augustus was the first to use art and architecture for the sake of propaganda, for sending the message, 'I am in charge,'" says the archaeologist Livia Galante, who notes that he proudly declared, *"Feci, refeci, perfeci"* (Latin for "I made, I restored, I completed"). At the end of his life, the mortal "god" would remind Romans that he had "found a city of brick and left behind a city of marble."

With less success, Augustus tried to rein in his subjects' wilder passions (though unable to restrain his own). The Romans never forgave him. He retained their admiration but lost their affection after a series of decrees declared marriage a civic obligation,

raised taxes on unmarried citizens, and imposed harsh penalties to discourage extramarital affairs. Rather than dealing with a wife's adultery within the family, as in the past, the new laws required a husband to report an unfaithful spouse and meted out severe punishments.

Yet even an official edict did not restrain his rebellious daughter Giulia.

WALKING THROUGH THE RUINS of Augustus's splendid palace on the Palatine, I imagine the little girl, snatched from her mother at birth and starved for affection, who grew up amid its regal trappings. Giulia's icy, ever-critical stepmother, Livia, controlled every aspect of her life. To her father, she served mainly, in her biographer's words, as a *"pedina di vetro"* (glass pawn) for his political machinations.

At age two, Giulia was engaged to the ten-year-old son of Mark Antony (whose fall from favor ended the wedding plans). When she was fourteen, Augustus arranged her marriage to his eighteen-year-old nephew, who died just two years later. He chose his great general Agrippa (ca. 63–12 BC) as her next husband.

Giulia would bear five children for a man almost twenty-five years her senior. But as Agrippa governed the vast Eastern provinces, she relished her first taste of freedom, along with the delights of festivals, chariot races—and handsome young suitors who shared her urbane interests.

Rome buzzed with gossip about Giulia's serial affairs, wild parties, and wine-soaked evenings with devotees of Bacchus. "Shameless beyond any taunt of shamelessness," the statesman Seneca thundered, Augustus's daughter "admitted flocks of lovers as she wandered the city in nocturnal revels. . . . The very Forum and ros-

trum from which her father had made known his law on adultery suited his daughter for fornication."

When a pundit observed that her children, rather remarkably, all looked like Agrippa, Giulia retorted, "I never take a passenger on board unless the ship's hold has a full cargo." The plebes adored her. Augustus, amused by her sunny gaiety, quipped that he had two somewhat wayward daughters: the Roman Republic and Giulia.

Agrippa never indicated any awareness of his wife's extramarital escapades before his death of a sudden illness in 12 BC. All three of their sons, designated as Augustus's heirs, died young. Livia, an adroit behind-the-scenes manipulator, was suspected of some role in the untimely deaths.

Rome's ambitious First Lady masterminded Giulia's marriage to her son Tiberius, who was happily wed and seemingly devoid of political aspirations. Although neither he nor Giulia wanted the match, both bent to Livia's indomitable will. A brokenhearted Tiberius divorced his beloved (and pregnant) wife, whom he was forbidden to see after following her through the Forum with tears in his eyes. Giulia and he conceived a child, who lived for only ten days, and the couple grew apart. In 6 BC, Tiberius decided to "retire" to Rhodes, in part because of his troubled marriage.

In 2 BC, Giulia became entangled with Iullus Antonius, a son of Mark Antony (her father's archrival) and perhaps the true love of her life, who hatched a plot to murder Augustus and rule Rome with her. When the scheme was uncovered, Iullus killed himself. As part of his official review of the investigation, Augustus, who had long dismissed whispers about Giulia's promiscuity, confronted detailed descriptions of his daughter's transgressions. He was devastated by her betrayal—and furious.

Giulia paid a high price for her passion. Augustus publicly

charged his own daughter with adultery and set in motion a divorce for Tiberius. Refusing to meet or speak with Giulia, Augustus, in essence, buried her alive by exiling her to a small rock of an island in the Tyrrhenian Sea, with no companion other than her mother, no wine, and no comforts of any sort.

After years of public supplication on Giulia's behalf, Augustus allowed her to move to a desolate corner of Reggio Calabria in southern Italy. Despite her repeated pleas, he refused any further mercy. "Would that I had never married or that I had died without offspring," he lamented.

When Tiberius assumed the throne after Augustus's death, he ordered his ex-wife's rations cut so she could quietly "waste away." Giulia died of starvation at age fifty-two—a long life for a woman of her time but one that must have seemed an eternity. Yet, as contemporary historians note, Giulia achieved what the vast majority of Roman women did not: in daring to follow her own passions, she carved a place for herself—albeit a sad one—in Roman history.

THE PAX ROMANA, Augustus's most lasting legacy, endured without major wars for more than two hundred years. During this long season in the sun, Romans changed. But first they would sink to the lowest levels of debauchery as their darkest passions ran their course.

After Tiberius's death in AD 37, the throne passed to twenty-four-year-old Caligula (AD 12–41), so mad and monstrous that his own guards murdered him after a reign of less than four years. They found his lame uncle Claudius (10 BC–AD 54) trembling with fear in the gardens and declared him emperor. Although he had never sought imperial power, Claudius proved a competent administrator until his death, almost certainly by poison.

His successor Nero (AD 37–68)—"a self-obsessed, mother-

killing pyromaniac," in the historian Mary Beard's words—may have arranged the huge fire that incinerated Rome in AD 64 in order to clear land for a vast new palace. After the imperial guards assassinated Nero, the last scion of Caesar's dynasty, political chaos engulfed Rome, with four emperors rising and falling in a single year.

Yet, despite these internal upheavals, the empire grew in wealth, power, and land. At its largest in the year 117, Rome's dominion extended from Scotland to the Sahara, the Iberian coast to the edge of Iran. In a capital teeming with exotic temptations, Romans of every class indulged their every passion.

Sex—never burdened with moral injunctions—became a free-for-all frolic, while marriage, once a pillar of state and society, fell out of fashion. One essayist dubbed it "a necessary evil to be avoided whenever possible." Others derided it as a *seccatura,* a nuisance or "drying up" that sucked the life from a man.

Those who needed an advantageous marriage or wanted legitimate heirs endured the requisite nuptials but then opted for quick-and-easy divorces—so many that the Senate capped the number allowed per citizen at eight. But who needed a wife or series of wives with so many enticing alternatives?

TOTAL FREEDOM FOR THE GANDERS brought some degree of liberation for the geese. According to the sociologist Eva Cantarella, author of *Dammi mille baci* (Give Me a Thousand Kisses), women in the post-Augustan age achieved a degree of independence unmatched until modern times. Breaking free of the stern morality of centuries past, Venus's daughters actively pursued their own passions. One practical reason for their emancipation: women could afford to do as they pleased.

After wars and uprisings killed many of its citizen-soldiers,

Rome's legislators, eager to preserve family wealth, allowed inheritances to pass to daughters as well as sons. Marriage laws changed as well, so that a wife's assets no longer automatically became her husband's property. Widows, divorcées, and orphaned daughters found themselves, ostensibly with the guidance of a "tutor," managing substantial sums, owning properties, and even supervising businesses. More women took the initiative and divorced unfaithful or indifferent husbands. Some resorted to poison as an expedient alternative.

Upper-class women, swathed in diaphanous silk and adorned with gold, studied Greek and philosophy, formed literary salons, and nurtured passions for art, literature, and design. Some wrote erotic verses deemed virtuous because they were addressed to their husbands. Increasingly, wives and ex-wives ventured into public spaces without male escorts, including theaters (the Vestal Virgins had prime seats).

Chariot races and gladiator matches drew throngs of women who wildly cheered their favorites—and bestowed favors of their own. A senator's wife abandoned her children to run off to Egypt to live with a gladiator with a scarred body, a battered face, and a skull dented by blows to his helmet. Perhaps, Rome's gossips murmured, she was more attracted by his sword.

WITH DAYS NUMBERED, death inevitable, and an unknown, unknowable abyss awaiting, the Romans of the post-Augustan age focused on the pleasures of life—yet derived less joy from endless festivals and meaningless hookups. Soldiers' sons and grandsons, no longer required to serve in the military, turned into petty bureaucrats, trapped in interminable meetings and tedious protocols. Spectators rather than competitors in games and sports, Rome's men grew soft.

In the second century AD, physicians diagnosed an epidemic of exhaustion, anxiety, and other signs of what we might call stress among affluent men throughout the empire. The most likely culprit, they concluded, was sex.

According to an influential theory imported from Greece, every ejaculation of semen sapped a man's virility and depleted his vitality. Manly Romans, who had long engaged in sexual exploits to confirm their macho identity, were cautioned to adopt *l'etica della continenza* (the ethic of restraint) to ease their vague malaise. Husbands were advised to curtail or, better yet, entirely avoid sex beyond the marital bed, especially with boys or men.

And so relationships between the sexes changed again. Rather than viewing marriage as a business arrangement or political ploy, brides and grooms began to choose each other on the basis of mutual attraction and affection. Women played a more important role in family and society, but at the same time, they reverted to the oldest Roman values. Like the good wife in the early days of the Republic, a bride was once again expected to arrive at marriage a virgin, remain faithful to her husband, and stay with him until death.

No longer battle-ready warriors or wanton lovers, men took refuge in the home as a sanctuary. Allies could quickly turn into enemies, while a devoted wife remained the one person a man could trust in every circumstance. As part of the new *morale di coppia* (spirit of the couple), mutual fidelity took on greater appeal—as did shared sexual pleasure. Erotic art, featuring women as fully involved—and aroused—partners, appeared on the walls of middle-class homes as well as aristocratic villas.

AMID CATACLYSMS OF EVERY SORT, including the first assaults by barbarians descending from the north, a loving marriage emerged

as the mainstay of personal happiness, nurtured by a passion more profound than mere appetite or lust. The hardened warriors of centuries past began to love in ways that Rome's founders could never have imagined.

How do we know about this emotional metamorphosis?

"The Romans showed us how they felt," says Christopher Hallett, a professor of classics and art history at the University of California, Berkeley. "After centuries of stoic restraint, Romans in the first centuries after Christ began to express real emotions rather than just platitudes of praise." We find their heartfelt words in private notes and diaries, erotic verses, and the funeral inscriptions they left behind.

In a letter to his wife, the magistrate Pliny the Younger wrote, "It is incredible how much I miss you—first of all, because I love you. . . . My feet literally carry me to your rooms. But when I do not find you there, I retreat, lovesick." When his twenty-three-year-old wife died, a young Roman grieved, "She was dearer to me than life." After eighteen "happy years together," another widower declared, "for love of her, I have sworn never to remarry."

We find similar sentiments on the tombs that line the Appian Way. These memorials, the sole claim to immortality for most Romans, once depicted men as valiant warriors or imperious officials of the state. But in the post-Augustan age, Rome's citizens chose to display their tenderness—albeit in idealized form, with their faces superimposed on godly bodies. A husband often appeared as a buff Adonis dying in the arms of a shapely Venus with his wife's features. A widower included both his spouses on their shared tomb—his deceased wife sleeping next to him and her successor, bare to the waist, sitting on the edge of the bed.

THE POST-AUGUSTAN GOLDEN AGE PRODUCED landmark achievements in music, art, architecture, and design—as well as *l'arte di godersela* (the art of enjoying one's self). Citizens and visitors marveled at the gargantuan Colosseum, the largest amphitheater in the world, and the Pantheon, with its gravity-defying dome. Rome's artists infused an earthy realism into classic sculpture and painting. As literacy spread, letters, poems, and pamphlets washed over the city like the Tiber at flood tide. Satirists and historians raised literature to a new level, while cultured ladies penned romantic verses and heartbroken swains wrote tearful odes to lost loves.

Romans also elevated everyday life to a loftier plane, surrounding themselves with the superbly crafted statues, vases, and mosaics we go to museums to admire. Music echoed through their pleasure palaces. Goblets and platters of gold decked their tables. Sumptuous tapestries draped their walls.

"Nothing was purely utilitarian," a historian observed, "for life was not meant to be sordid." This passion for beauty in all things, lost for centuries in the Dark Ages, would blossom again in the resplendent Renaissance.

During the Romans' social evolution, a revolutionary new religion emerged, preaching of unconditional love on earth and everlasting life in heaven. It would pit the entire pantheon of ancient gods against a bloodied man on a cross, cosmic warriors versus a cult of unarmed Jesus lovers. Christ would face Caesar in the arena—and would carry the day.

Glory took on a different scent, and something new dawned with the Roman sun.

4

THE GREATEST LOVE
STORY EVER TOLD

The ancient port of Trapani juts like a sickle into the Mediter-
ranean off the northwest coast of Sicily. According to duel-
ing legends, the curved blade originally belonged either to the
goddess Demeter, who dropped it in her frantic search for her kid-
napped daughter Persephone, or to Cronus, who tossed it into the
sea after castrating his father, Uranus, god of the sky. Trapani has
since won renown for its reincarnation of another family drama:
the suffering and death of Jesus, son of the Christian God.

I come to this ancient port to see *la passione* in its original re-
ligious meaning brought to life in La Festa dei Misteri (the Feast
of the Mysteries), an annual Good Friday procession imported by
Sicily's Spanish conquerors. Over the course of twenty-four hours,
a parade of massive altars, each depicting a scene of Christ's final
days, winds through Trapani's maze of narrow streets.

The altars, fashioned in elaborate detail in the seventeenth and eighteenth centuries, have survived floods, fires, and Allied bombings in World War II. A cortege of flag-bearers, children costumed as angels, and members of a *ceto,* one of the sponsoring trade associations—sailors, fishermen, woodworkers, and such—walk solemnly before each.

Squads of eight to twelve muscular men wearing dark suits or traditional garb grasp one another's shoulders, pressing close into a crosshatch of intertwined arms as they hoist each tableau aloft. Sweating and grimacing, they weave in a wavelike rhythm called the *annacata,* stepping forward and back and side to side. After several minutes of all-out effort, a wooden clacker signals a pause. The porters lay down their heavy loads and catch their breath as a marching band plays haunting dirges.

I take a prime viewing position near the starting point, the piazza in front of the Chiesa delle Anime del Purgatorio, dedicated to the souls in purgatory. Two white-haired widows standing next to me, veterans of dozens of these ecclesiastical marathons, provide a running commentary.

The men move like the sea, surging in and out with the tide, one of my companions explains. The other insists that the rhythmic dance started because the porters drank so much along the route that they staggered, dropping an altar on more than one occasion. When their grandchildren appear in cherub wings, the women rush forward during a break to drop morsels of food into their mouths like mother birds feeding chicks.

As day darkens into dusk, the crowd grows. I find myself swept into the procession, carried along in a crush of humanity. After the passing of the altar displaying Christ's lifeless body encased in a glass casket, I try to break away.

"Guarda! Guarda! Guarda!" (Look! Look! Look!), voices around me shout. Just turning a corner, a little girl, caped in black,

leads a cortege of dozens of mournful women carrying candles and rosaries. Inching its way behind them is yet another altar with a single regal statue: La Madonna Addolorata, the sorrowful mother of Christ, draped in rich black velvet robes.

A silver heart gleams in her chest. Above it—suddenly lit by a ray of the setting sun—flashes a sword, along with six shiny daggers piercing her heart. This is a Sicilian mother, stabbed by grief for her beloved child yet standing strong and resolute. Tears run down the cheeks of many onlookers. Almost instinctively, I put my hand over my heart.

LATE INTO THE NIGHT, from a little terrace off my hotel room at the Badia Nuova, I watch the candlelit altars pass through the streets. Parents carry sleepy angels to bed. Musicians and marchers peel off into restaurants. For a few hours, everyone rests.

I wake at dawn on Holy Saturday to follow the turgid music back to the Church of the Souls in Purgatory. In a grand finale, the crowd applauds as each altar disappears into the darkness of the nave. When La Madonna Addolorata arrives, confetti and flower petals flutter from windows and balconies. The parish priest gives thanks to the people of Trapani—for their labor, for their time, and, above all, for their inspiring passion.

On Easter, I once again hear a marching band and rush outdoors. At the end of a sun-dappled street, I behold an altar with the risen Christ, tall and triumphant, surrounded by lilies, carried by a fresh crew of burly porters. The crowd cheers. Steeple bells ring. I breathe in the scent of spring flowers and candle smoke. The faces around me glow with jubilation.

Inside the church, I join the parishioners admiring the altars on display. A young priest, noticing that I am one of the few non-Italians in the crowd, asks what I thought of the procession.

"Bellissima," I say, adding that I am touched to see such beauty inspired by pain and sorrow.

"No, signora," he says gently. "You are mistaken. It is not suffering that we celebrate in the Passion of Christ. It is love." Indeed it is: the great love that conquered the empire that had conquered the world and gave rise to the largest religion in history.

"THIS I COMMAND YOU," Jesus directed. "Love one another, as I love you." The words of the unconventional Hebrew preacher, born in Bethlehem during Augustus's reign, baffled Rome's leaders.

"Who is this Jesus?" they demanded. A nobody, advisers assured them. A carpenter's son with no fortune, no army, no power base. A sorcerer who tricked crowds into believing he could turn water into wine, multiply loaves and fishes, make the blind see and the dead rise from the grave. Yet even crucifixion could not silence his seductive message of eternal life in a kingdom not of this world.

In a city that had seen everything, the Jesus cult began doing the unheard-of. Without reason or reward, Christians rescued abandoned babies, fed the poor, tended the sick, comforted the dying, and welcomed slaves as well as masters, women along with men. Derided by Rome's leaders as fit only for the unwashed and unwanted, the new faith nonetheless spread like wildfire.

Rome countered Christianity's message of unconditional love with savage butchery. In the third century, after sporadic persecutions, the emperor Decius declared all who refused to worship the old Roman gods enemies of the state. Christians who defied the order were flogged, crucified, beheaded, burned alive, or thrown to voracious wild beasts.

A widow with seven sons was whipped, hung for hours by the hair of her head, and then thrown into a river with a large

stone tied around her neck. A bishop was scourged, wrapped in oil-soaked rags, and set aflame as his tormentors pried off strips of his flesh with pincers. A Roman aristocrat's daughter, barely into her teens, was dragged naked and screaming to a brothel in Piazza Navona. Her hair miraculously grew long to cover her nudity, and the men who attempted to rape her were struck blind. When she was bound to a stake, the flames would not catch. A soldier finally killed the girl with his sword.

Ultimately the attempted genocide backfired. Several thousand Christians perished, but their courage inspired tens of thousands more, who praised their *passione* as "a second baptism." The martyrs' deaths seeded the new religion. As missionaries carried the gospel of love to every corner of the Roman Empire, Christianity's soft power proved mightier than any sword.

RATHER THAN DETHRONING the old gods and abolishing cherished traditions, the new "love religion" integrated them, blending pagan and Christian, sensual and sacred. Ancient Roman holidays morphed into holy days. December's freewheeling Saturnalia gave way to the celebration of the birth of Il Bambino Gesù (the Baby Jesus); spring fertility festivals, to Jesus's triumphant resurrection from the dead. Churches rose over temples. Under many altars archaeologists have found ancient amulets, particularly phalluses of every size and sort.

Rather than evoking the wrathful God of the Old Testament, the new faith portrayed his son as a lover. The language of romantic, even erotic passion throbs through early Christian writings. In this cosmic love story, Jesus the suitor beckons the beloved people of earth to "the dance," the fantastic harmony of creation.

"Like a bridegroom Christ went forth from his chamber," Sant'Agostino (Saint Augustine) wrote. "He came to the marriage

bed of the cross and there, in mounting it, consummated his marriage. . . . He lovingly gave himself up to torment in place of his bride, and he joined himself to the woman forever."

The tenderhearted God-man would give his followers his body to eat in the Communion host and his blood to drink in the sanctified wine. Devout women would become brides of Christ, wear his wedding ring, dedicate their chastity to him, and experience "passion" in intimate moments with him.

"Jesus is an irresistible and adorable lover," wrote Santa Gemma Galgani, who welcomed the agony of a mystical crown of thorns placed around her head. "How could one not love Jesus with all one's heart and soul?" Love of the Lord spawned other forms of love: familial love symbolized by Joseph the father, Mary the mother, and the Christ child; filial love showered upon the infant Jesus; maternal love embodied by the Madonna tenderly caring for her son.

In the Basilica of Santa Maria in Trastevere, in Rome, built on the site of a fountain of holy oil that erupted at the moment of Jesus's birth, I stand before a twelfth-century mosaic of Mary, who is dressed like a Byzantine empress with a gold crown, at her son's side in heaven.

"See what Christ is doing!" a docent whispers. "He's hugging his *mamma*!" Indeed, in a first-ever depiction for any deity, a smiling, barefoot Jesus embraces Mary, his hand around her shoulder. If the son of God could hug his mother with obvious affection, Christians too could show love for their mothers—and all others.

"If I have not love, I am nothing," the apostle Paolo (Paul) reminded his followers in the letters he dictated to his distant flocks. "Faith, hope, and love abide, and the greatest of these is love."

Ultimately love triumphed. In 313, the emperor Constantine, who had a cross emblazoned on the shields of his conquering

armies, issued the Edict of Milan, which granted tolerance to all faiths. Christianity became the Roman Empire's sole authorized religion in 380.

THEN DARKNESS DESCENDED. Waves of barbarian tribes (whose incomprehensible languages sounded like "bar-bar-bar" to the Romans) broke through gaps in the empire's defenses and burned fields, razed castles, and plundered towns. By the sixth century, Rome's population shrank to a twentieth of its former size. Civil government ceased to exist. Civilization itself seemed in peril.

Among its saviors was Benedetto (Benedict) of Norcia (480–547), the son of an aristocratic family who left his Umbrian hometown for Rome to further his education. Abandoning his studies, Benedetto withdrew to the wilderness to contemplate Christ's teachings—and to purge his lust for a woman. Unable to stifle his erotic desires, Benedetto began walking toward Rome. Along the road he spied a thick patch of briars, stripped off his clothes, and flung himself naked onto the prickly thorns. Conquering "pleasure through suffering," as Pope Gregory the Great recorded, "his torn and bleeding skin served to drain off the poison of temptation."

Vowing to "fight the devil with pen and ink," Benedetto established a network of monasteries, the largest at Monte Cassino south of Rome. Safe within their walls, Benedictine monks, dedicating their lives to "prayer and work," copied the writings of the ancients, tilled fields, planted vineyards, and cared for the sick and needy. The passion of such holy men preserved for all time the heritage of Greece, Rome, and Christianity. To them, every word they wrote, every lesson they taught, every comfort they provided represented an act of sacred love.

BY THE TURN of the first millennium, a new "age of civilization" was ready to be born. Christianity would serve as its midwife and mainstay. Replacing the Roman Empire as the unifying force in Europe, the Church would influence art, architecture, philosophy, and politics; found schools, universities, and hospitals; and establish a moral code that underlies modern notions of human dignity and rights.

Sacred passion begat a full range of creative passions. Inspired by liturgical chants, an eleventh-century monk named Guido d'Arezzo invented do-re-mi graphic symbols to record musical melodies—and drew the notes on his own hand to teach them to others. Religious hymns, chants, requiems, and melodies for "Passion plays" provided the foundation for classical music and the inspiration for some of its most celebrated works.

In a largely illiterate world, the visual arts educated and uplifted congregations. Churches grew larger and higher, with vaulted roofs, massive columns, and rounded arches. Within their lofty interiors, Italian artists captured the passion of their faith in tributes to God's glory: altarpieces, mosaics, frescoes, statues, crucifixes, stained glass windows, and ceilings that swept worshippers' eyes—and souls—to the heavens. Their talents enriched even small churches in remote Italian villages with medieval masterpieces—and inspired the recognition of individual artists.

In the late thirteenth century, a Florentine artist emerged unlike any who had come before. Cimabue (ca. 1240–ca. 1302) painted a Madonna surrounded by angels for the Basilica of Santa Maria Novella. The large figures, more lifelike than any previous works, so amazed the townspeople that they carried the panel in a jubilant procession through the city streets to the church.

Cimabue's apprentice Giotto di Bondone (ca. 1266–1337), an

even greater talent, soon eclipsed him. Breaking with the stiff Byz-antine style, he introduced the classical technique of drawing ac-curately from life. Within a few years, artists throughout Italy were trying to emulate Giotto's ability to make painted figures breathe. A few centuries later religious masterpieces, such as Leonardo's *Last Supper* and Michelangelo's *Creation of Adam* and *Last Judgment,* would take their beholders' breath away.

CHRIST'S MESSAGE OF LOVE also inspired a literary landmark: an ode to God's creations hailed as the first real "knock-your-socks-off masterpiece" of Italian poetry. Its author—Francesco d'Assisi (Francis of Assisi; 1182–1226), the son of a prosperous textile merchant—seemed an unlikely candidate for piety or poetry. The ringleader of a band of hard-drinking, carousing young men, Fran-cesco set himself apart, as his first biographer Thomas of Celano put it, by surpassing "all his friends in the worthlessness of his pur-suits . . . the first to suggest mischief, a zealot in the cause of folly, [outdoing everyone] in practical jokes, in pranks, in tomfoolery, in idle talk and gossip."

When the city-states of Perugia and Assisi faced off in one of their frequent clashes, the twenty-year-old playboy, dreaming of chivalric glory, volunteered for the fray. But nothing had prepared Francesco for the slaughter he witnessed in battle. Captured by enemy troops, he was tossed into a squalid underground cell in Perugia for a year before his father could arrange a ransom.

The traumatic experience shattered his health and transformed the callow youth. Francesco pulled away from his rowdy gang to meditate in the mountains and pray in the dilapidated chapel of San Damiano in Assisi. One day he heard the figure of Christ on the crucifix above the altar instruct him to "repair my house, which you see is in ruins."

Francesco, taking the instructions literally, hauled bales of precious cloth from his father's shop to a nearby market town to sell and tried to give the proceeds to the pastor. His incensed father charged his son with theft. At a public hearing before the bishop of Assisi, Francesco turned over the money—along with every stitch of clothing he was wearing. As the naked youth explained to the bishop, he now had only a heavenly father.

Francesco also took a "bride," Lady Poverty, and called himself Poverello (Poor Little One). Renouncing all earthly possessions, he formed a new band of "begging brothers," who built simple huts in the forest around a rustic chapel known as the Porziuncola (Little Portion). The grand Basilica of Santa Maria degli Angeli now envelops the tiny church.

Wearing a beggar's rough robe cinched with a rope and crude wooden sandals, Francesco and his brothers preached their gospel of love and peace among paupers, lepers, and other social outcasts. Even animals responded to Francesco's empathy.

Once, he approached a fearsome wolf terrorizing the town of Gubbio. When the beast lunged at him, Francesco stood his ground and entreated him not to eat "Brother Ass" (as he referred to his body). The wolf, curling up at his feet, wordlessly conveyed a promise not to attack the townspeople, who provided food for the animal at the gates of their city for the rest of its life.

Despite debilitating illnesses, Francesco delighted in being a child of the universe. His rapturous "Canticle of the Creatures" praises with unbridled wonder Brother Sun, Sister Moon, Brother Wind, Sister Water, and Brother Fire. Francesco's lyrical verses transformed his spiritual passion into the first major work in the still-evolving Italian language.

Francesco's health deteriorated over two decades of preaching and fasting. At age forty-four, blind (following cauterization of his eyes to treat an infection), emaciated, and racked with pain, he

lay dying in a dark, low cavern near the Porziuncola. One of his brothers read aloud from San Giovanni's (Saint John's) Passion of Christ. Those keeping vigil outside reported that at the moment of Francesco's death, larks sang and flew in circles.

Despite a steady stream of tourists, Francesco's beloved chapel, infused with centuries of heartfelt pleas, remains one of my favorite places to kneel and reflect.

"Your prayers will be answered," a kindly friar tells me on my most recent visit.

"I hope so," I reply.

"I know," he says, explaining that when God asked what he would like in return for his devoted service, Francesco requested only that those who come to this chapel and "pray with a devout heart will obtain what they ask." My prayers for a friend with breast cancer were indeed answered—for which I thank San Francesco, God, and the state-of-the-science care she received.

CATHOLICS EVERYWHERE HONOR FRANCESCO and the legions of saints—as many as ten thousand by some estimates—as inspirational pillars of piety. But in Italy, these blessed men and women, so like us in their human frailty, seem to be family—big brothers and sisters eager to lend a hand.

"Qualche santo ci aiuterà!" (Some saint will help us!), Italians reassure me when a car breaks down or a suitcase goes missing. I imagine these spiritual first responders on speed dial in heaven, jumping into action at a moment's notice. Certain saints have taken various professions under their wing. Veronica looks out for photographers; Antonio Abate (Anthony the Abbot) for pizza makers; Cosma and Damiano (Cosmas and Damian) for doctors; Orso (Ursus) for woodworkers; Francesca Romana (Frances of Rome) for taxi drivers. Even body parts merit celestial guardians:

Agata (Agatha) for breasts, Lucia (Lucy) for eyes, Biagio (Blaise) for throats.

Italians mark the passage of the year with saints—from Silvestro (Sylvester) on New Year's Eve, to Giuseppe (Joseph) on March 19 (Italy's Father's Day), Giovanni on June 24, Lorenzo (Lawrence) on August 10 (the Night of the Shooting Stars), and the entire crowded Catholic pantheon on Ognissanti (All Saints' Day) on November 1. Saints' names adorn Italy's streets, piazzas, neighborhoods, towns, hospitals, prisons, theaters, schools, banks, wines, hams (as in San Daniele prosciutto), and even a season (Saint Martin's Summer, l'Estate di San Martino, a warm spell in early November named for the Christian soldier who cut his cloak in two to share with a shivering beggar).

Villages and cities commemorate their patron saints with festivals that combine solemn processions of statues or relics (believed to be martyrs' bones or teeth) with races, carnival rides, open-air dances, and elaborate fireworks displays. For the feast of San Domenico, who lured away snakes that had invaded the tiny hillside village of Cocullo in Abruzzo, snake handlers called *serpari* march his statue, draped in long, sinewy serpents, through the streets.

To honor its beloved Santa Rosalia, Palermo blazes with thousands of lights during a procession of a great golden galleon. In Naples, crowds sing, pray, and cry to the martyr San Gennaro as they anxiously await the liquefaction of his dried blood and assurance of the continuing well-being of the city and its citizens.

ON MY DESK I keep a calendar the size of a business card identifying the saints honored every day of the year so I can send *auguri* (best wishes) to Italian acquaintances on the appropriate dates. Since my parents called me Dianne after the Roman goddess (with special permission from their parish priest), I have always been an

ecclesiastical orphan, with no *onomastico* (name day) to celebrate as joyously as a birthday. Some friends, insisting that everyone needs *"un santo in paradiso"* to serve as a heavenly "fixer," encourage me to choose a personal favorite.

"Is there a patron saint of passion?" I ask, half-joking. But I get a serious answer: Although she's not officially designated as such, Santa Caterina (Saint Catherine) of Siena (1347–1380) certainly qualifies. Her brief life brimmed with passionate love for God and his Church.

The twenty-fourth child of a cloth dyer, Caterina fell in love with Christ as a young girl during spiritual visions she called "wonder stories." At age fifteen, she declared her desire to pledge her life to God. Her mother insisted that she forget such nonsense and marry. To discourage suitors, Caterina defiantly chopped off her long blond hair and began wearing a veil. Impressed by the sincerity of her piety, her father built a small cell in the lower part of the house, with no furniture except a bench. Caterina spent three years there, fasting and praying in complete isolation.

The defining spiritual moment of Caterina's life came in a vision when the nineteen-year-old became the bride of Christ. Amid an assemblage that included the Virgin Mary and King David, Jesus put a jeweled band of gold on her finger. (In some versions, he used the foreskin from his circumcision.) Although the ring was invisible to others, she claimed that it was always in her sight as a reminder of her mystical union. During this rapturous scene, Caterina's heart stopped, and Christ opened her side and replaced it with his own. He then inserted her revitalized heart in his chest. She became part of his body; his heart beat within her.

In her twenties, Caterina became a member of the *mantellate* (cloaked ones), a lay order of women who consecrated their lives to God but did not live in convents. Without the responsibilities of a wife or the restrictions of a nun, Caterina enjoyed an

extraordinary degree of freedom. As she went about Siena caring for the ill and dying, Caterina's contemporaries described her as "a preternaturally happy woman with exceptional charisma." Dispensing practical advice as well as spiritual counsel, she attracted devout followers known as Caterinati, whom she called "my family."

In 1370, during a four-hour vision of hell, purgatory, and heaven, God called on Caterina to embark on a public life. She had taught herself to read but could not write, so Caterina dictated messages—320 extant letters—to all sorts of people, including popes, princes, and kings.

Her most urgent mission from God was to return the papal court from Avignon, where it had become a corrupt pawn of the French monarchy, to Rome. Worldly clerics had descended into such decadence that she compared them to decaying "flowers who shed a stench that makes the whole world reek." At God's instruction, she wrote to Pope Gregory XI, addressing him as *Babbo* (Daddy) and urging him to be "manly" in his efforts to restore moral order. The pope eventually moved the Church back to Rome, perhaps in part because of her exhortations.

Caterina's religious passion matched her political fervor. Subsisting on bread, water, and bitter herbs—and at times only on a daily Communion wafer—she had frequent "spells," during which she would fall senseless, eyes tightly shut, limbs rigid, hands clenched. (Physicians speculate that she may have suffered from epilepsy.) After a series of strokes, Caterina died at age thirty-three. She was canonized in 1461 and named, along with Francesco, as a patron saint of Italy in 1939.

A FAR MORE OBSERVANT CATHOLIC in Italy than in America, I've attended Sunday Mass in grand basilicas and simple stone churches. Years ago, in an Umbrian chapel permeated with cen-

turies of candle smoke, I puzzled over the priest's stern sermon—a diatribe exhorting against *peccati della carne.*

New to the Italian language, I translated this phrase as "sins of the meat." Confused by the very notion, I glanced around the pews, hoping for some clue. My fellow worshippers kept their eyes down and squirmed uncomfortably. Had they been violating the Friday fast? Overindulging in burgers (certainly a more likely American transgression)?

Later, a friend, bursting into laughter at my confusion, explained that the priest was decrying "sins of the flesh." Yet even these misdeeds seem less damning in Italy, where the devil himself, as a proverb puts it, "is not as ugly as he's painted" and the Ten Commandments seem more suggestions than directives (like red lights in Naples, according to its drivers).

These days, fewer Italians identify themselves as Catholics: 77 percent, according to recent surveys, compared with 88 percent in 2006. Only about 24 percent, down from 39 percent, describe themselves as practicing their faith. Demographers offer multiple explanations for this decline.

Older, more devout generations are dying off. Immigrants have brought new faiths. Secularization continues to spread. The Church, tarnished by scandals, wields far less political influence than in the past. Birth control, abortion, and divorce became legal in Italy decades ago and remain less contentiously debated than in the United States.

Yet faith still lives in the Italian air—literally. Church bells chime—in some cities every quarter hour—from dawn to dusk. Working on a draft of this book on a Sunday morning deep in pastoral Val d'Orcia, I hear bells pealing from an unseen church. Minutes later the breeze carries a hymn that a heavenly host might well be singing.

In Rome, nuns in long habits and priests in black robes remain

so ubiquitous that I position myself next to one for the death-defying challenge of crossing a busy street. Fresh flowers festoon the colorful shrines nestled in niches that I pass along country lanes. And whenever I drop into an Italian church, if only for a respite from the summer sun, I come upon weddings, baptisms, funerals, and silent worshippers fingering rosaries as they kneel.

Although religious practices may have faded, love of God and the saints endures—as do sacred passions powerful enough to take possession of Italian and non-Italian souls alike.

RITA MORGAN RICHARDSON, a French teacher in Nashville, never thought she would spearhead a crusade to save an abandoned chapel in Tuscany. While serving in the military in Naples, her American father met and married a local woman. Although Rita grew up in Georgia, her staunchly Italian mother imparted a strong sense of her Italian heritage.

In 2010, Rita and her husband, Tim, during a visit to their son while he was studying in Cortona, ventured to the nearby hill town of Castiglion Fiorentino. Taken by its picturesque charm, they bought a small home and came back several times a year. Every day, they would walk by a boarded-up church on their pedestrian-only lane. Curious, they discovered that it once housed a group of friars belonging to the Congregation of the Oratory, a religious order founded by San Filippo Neri (Saint Philip Neri; 1515–1595).

"I'm Catholic, but I had never heard of him," says Rita. "The first thing that I learned about him—and that won my heart—was that he is the patron saint of joy."

Filippo Neri, born in Florence, felt a strong calling to religious life. Without money or a plan, he began studying and then preaching in Rome. His friendly nature and ebullient sense of humor

won so many converts that he became known as Rome's "third Apostle," after San Pietro and San Paolo. According to legend, his heart grew so big with God's love that people could see it pounding in his chest.

To attract more converts, Filippo devised a form of religious theater, with performers reproducing biblical scenes set to music. Soon people were flocking to the entertaining shows that took the name of the hospital prayer hall used for the first performances— *oratorio.* His followers built "oratories" across Italy that offered the faithful places to worship and sing together, including one in Castiglion Fiorentino called San Filippino.

"In the 1600s and 1700s, San Filippino was a bustling community center, a place where ordinary people did and experienced extraordinary things," says Rita. "Tim and I wondered why someone wasn't doing something to save a building so rich in history. When we asked, we always heard the same thing: *'Crisi. Niente soldi.'* Economic crisis. No money."

Then an unexpected passion seized Rita. "One day I just knew that the 'someone' to save San Filippino was me—even though I had never attempted anything like this." With the permission of the local archbishop, she and Tim got their first glimpse of the chapel's interior. Inside they found beautifully sculpted cherubs, a hand-painted balcony for the choir, and a wooden coffered ceiling of cobalt blue and gold, perhaps the oldest in the town.

"We were blown away," Rita recalls. Launching a one-woman campaign, she formed the Friends of San Filippino, an official American nonprofit, and reached out to Italian American organizations and Italophiles. Their generosity, along with Rita's passion and perseverance, so impressed the townspeople that they have wholeheartedly embraced the project.

"Sometimes we need foreigners to wake us from our torpor and make us look at things with the eyes of another," says a local teacher

whose students have volunteered as translators. Community members have donated their artworks and auctioned off dinners and stays at local bed-and-breakfasts to raise funds. The ongoing campaign has rekindled a pride in their past and a passion to keep the spirit of San Filippino alive.

"You can feel the love of San Filippino in Castiglion Fiorentino," says Rita. "The world may be full of special places that deserve to be saved, but it's also full of people with an inexplicable passion to do good works that they never knew they had."

Surely somewhere Filippo Neri, the loving, laughing, big-hearted patron saint of joy, is beaming.

THE RISE
OF ROMANCE

What could be more romantic than Valentine's Day in Verona?" I ask my dubious husband as I persuade him to visit the hometown of Shakespeare's Romeo and Juliet for La Festa degli Innamorati (Celebration of Lovers).

"Did Valentine live there?" Bob asks.

"Well, no," I respond.

The original Valentino served as a Catholic priest in third-century Rome. The emperor, believing that bachelors made better fighters, had outlawed marriage for soldiers. Sympathetic to young couples eager to wed, the compassionate cleric defied the decree and continued to perform weddings.

Thrown into prison, Valentino developed a friendship with a young girl—perhaps his jailer's daughter—who came to visit him. Some say they fell in love; others claim that he cured her blindness.

Before his execution, he sent her a note signed, *"Tuo Valentino"* (Your Valentine).

Lovers around the world have been using the phrase ever since. Towns throughout Italy celebrate the saint's day, but the festivities have never morphed into an Americanized card-sending, rose-buying, candy-giving lollapalooza.

ON THE CRISP SUNSHINY DAY, Verona, bedecked in red banners and heart-shaped balloons, bustles with smiling couples. At lunch in the charming Antica Torretta, friends tell the romantic story of how they met. Maurizio Barbacini, who went on to international acclaim as an opera conductor, was accompanying his twin brother, a tenor launching his singing career, on the piano at a music festival in Spoleto. Antonella, a twenty-year-old beauty, was performing the lead in *Madama Butterfly*.

The first time Maurizio saw her, Antonella had a little Pomeranian dog, "red like fire," and a dress of the same intense color. "I thought either she doesn't know how to sing or she's very, very good." The latter proved true. She won top honors in the competition—and an admirer.

Although Antonella brushed off his initial advances, a smitten Maurizio followed her to her next performance in Milan. "I asked, 'What are you doing here?'" Antonella recalls. "Then for the first time, I looked into his eyes, and I realized that they were the most beautiful blue."

Il colpo di fulmine (the lightning bolt of love) struck. They married within a year. After four decades together, Maurizio's blue eyes still light up when Antonella enters a room; she holds his hand as we stroll the cobbled streets that lead to Juliet's home.

When I ask if Juliet and her Romeo had actually lived in Verona, our friends respond, *"Chissà?"* (Who knows?). The ear-

liest account of a pair of star-crossed Italian teens—Mario and Gianozza—was set in Siena. A more sophisticated "history of two noble lovers" named Giulietta and Romeus (later Romeo) in Verona appeared in about 1530. Shakespeare plucked his plot from its English translation, and the Veronese happily adopted the romantic duo as their own.

Juliet's storied balcony, small and low, hunches above a courtyard grimy with spray-painted hearts and lovers' initials. So many tourists fondled the breasts of Juliet's statue (for luck in love) that the original had to be replaced with a copy. Couples squeeze up narrow stairs, pause for a selfie on the balcony, and elbow back down.

We extricate ourselves from the crowd and make our way to a dingy side street and an even more disheartening sight: the forlorn entry to Romeo's house, marked only by a small, rusty plaque. On a bridge crossing Verona's moat, we pass an iron gate so laden with "love locks" that a concrete support has collapsed, spilling dozens of these tokens of undying commitment across the pavement.

So much for happily ever after.

ROMANCE, AS ITALIANS HAVE ALWAYS KNOWN, requires more than red hearts and flowers. Like every passion worth pursuing and possessing, it demands a price. Even at its most sublime, romantic love remains, as Umberto Eco defined it, a state of "devastatingly unhappy happiness," part affection and part affliction.

At grand rounds at the University of Pisa, my husband, a professor of psychiatry, hears reports of agitated young men brought to emergency rooms by their worried parents. The youths cannot focus to study or work, nor can they sleep or eat. Many babble incoherently and pace restlessly.

When Bob suggests possible diagnoses, such as mania or drug

abuse, his Italian colleagues inform him that these tormented souls are usually suffering the symptoms of love. Asked if he has seen many such cases in the United States, he shakes his head.

"Not a single one."

Perhaps *la passione italiana,* with its unique willingness to surrender wholly without hesitation or reservation, makes Italian hearts more vulnerable. In English a heart "breaks" just like a dish, but Italian provides a specific word for its shattering: *spezzare.* When I ask a friend how he feels after his longtime girlfriend left him, he says, *"Mi piange il cuore."* My heart weeps.

Heartbreak, as Italian cardiologists have documented, can prove fatal if it fulminates into the *sindrome da crepacuore* (syndrome of death by heartbreak). Victims develop symptoms similar to a heart attack, such as chest pain and shortness of breath. Most recover without lasting damage to their hearts, but about 5 percent go into cardiac arrest and die.

TRIBULATIONS OF THE HEART may be as old as time, but Roman writers were the first to document their course and create a true literature of love. In the first century BC, a young man from a provincial town ventured to the Big City, fell in with a fast crowd, swooned for a sophisticated lady, and suffered devastating heartache.

His name was Gaius Valerius Catullus (ca. 84–ca. 53 BC), born into a wealthy family in Verona. Shortly after arriving in Rome at about age twenty, Catullus glanced across a crowded terrace and beheld Clodia Metelli, the noble, smart, bewitching thirty-something wife of a powerful consul. To the infatuated youth, this elegant Romana combined "in one woman the charms of all charming women." He dubbed her "Lesbia" as a literary tribute to Lesbos, the island where the Greek poet Sappho had rhapsodized about her love for another woman.

"Dammi mille baci!" (Give me a thousand kisses!), Catullus begged. "Then a hundred / Then another thousand, then a second hundred / Then—don't stop—another thousand, then a hundred . . ." Yearning to give this beauty as many kisses as there are grains of sand or stars in the sky, Catullus trembled to think of her touch.

"Let's live, my Lesbia," he entreated. "Let's live and love!" When his "shining goddess" yielded, Catullus all but exploded in ecstasy. But he seethed with jealousy of her husband—who conveniently died of unknown causes in his home on the Palatine Hill. As rumors spread that his cheating wife had poisoned him, Catullus fantasized that he and his beloved could live together at last. But she demurred.

"I love, and I hate," he wrote as Clodia took another lover—several, Catullus contended, fanning his rejection into outrage with images of her in the arms of hundreds of men. "The Lesbia that Catullus loved more than himself and all he owned," he sniped, "now hangs around the highways and byways jerking off the lordly scions of Remus." His language may have been coarse, but his insights into love's delights and disappointments rang true.

Catullus found solace with other lovers, including a comely teenage boy with plump lips to whom he yearned to give three hundred thousand kisses, all tastier than honey—along with other specific sexual favors that he graphically described in verse. His poems inspired a new generation of love-struck writers who immortalized their own romantic escapades.

Although they didn't explicitly use the word *passione*, these young poets recognized love's price and pain. Describing themselves as "wounded," "wretched," or "enslaved," they compared losing your heart to "having your bone marrow on fire."

With Rome's fall, Catullus's works disappeared for almost a thousand years. In the fourteenth century, a single manuscript

containing about a hundred of his verses was discovered stopping up a wine barrel—in Verona, which I've come to think of as Italy's literary *nido d'amore* (love nest).

ONE OF CATULLUS'S ADMIRERS, Publius Ovidius Naso, whom we know as Ovid (43 BC–AD ca. 17), followed his provocative path. His literary masterpiece, *Metamorphoses,* retells some 250 tales of mythological gods whose passions shattered the lives of hapless mortal victims, such as the virginal nymph Daphne, transformed by her father into a tree to protect her from Apollo's lust.

For decades, Ovid's own love life paralleled the randy adventures of his literary creations. Married three times and divorced twice, the sophisticated storyteller eventually settled down at age forty-six to a happy domestic life. Styling himself a "professor of love," Ovid drew on his own experiences as well as keen observations of his fellow Romans to pen an urbane manual for seduction, *Ars amatoria* (*The Art of Love*).

A prototypical advice columnist, he offered practical tips for picking up women (Go to the chariot races and remove an imagined errant thread from an attractive lady's cloak), enhancing a flat chest (Stuff the band worn around the breasts with soft fabric), and faking an orgasm (Flail! Gasp! Moan!).

The book became the talk of a town that loved talking about love and a field guide to Rome's age of excess. Ovid's salacious writings also drew Augustus's ire. As part of his campaign to curb his citizens' erotic indulgences, the imperial ruler banned Ovid's books—which naturally sparked even greater interest in them—and exiled the poet.

Banished to semibarbarous Tomis (in present-day Romania) on the Black Sea, Ovid wept his life away, consoling himself with the

reassurance that his words would make him immortal. And so they did. Ovid's writings, along with those of Catullus, inspired the Tuscan poets of the Middle Ages to create a new genre of romantic verse.

THESE LOVE-STRUCK WRITERS diagnosed themselves with a heart-stopping condition that they called *sbigottimento,* a state of stupefaction caused by contemplation of one's beloved. With no hope for a cure, they sought relief in lilting verses inspired by the amorous ballads of traveling French troubadours. Their *dolce stil novo* (sweet new style) for poetry reveled in the thrill and torment of losing one's heart, regardless of the risks of this delicious but dangerous passion.

The early romantics idolized a pair of thirteenth-century lovers named Paolo and Francesca, who once lived in a kingdom by the sea. After years of bloody conflict, the lord of Ravenna had sealed a truce by marrying his fair daughter Francesca to a son of the fearsome warrior clan called the Malatesta (literally, "bad" or "evil head") in nearby Rimini on the Adriatic coast.

According to some accounts, handsome Paolo, Malatesta's younger son, came to Ravenna to negotiate the nuptial contract. Not until her wedding in or around 1275 did Francesca realize that her groom would be his older lame and brutish brother Gianciotto ("crippled" Johnny).

With Gianciotto away at battle, Paolo, a husband and father, provided protection and companionship for his young sister-in-law. To pass the time, the two "charmed the hours away" by reading together about Galeotto, who had acted as the go-between for the knight Lancelot and Queen Guinevere, wife of King Arthur, in the fantasy kingdom of Camelot. When they reached the description of that pair's first, adulterous embrace, Paolo breathed "the tremor

of his kiss" on Francesca's welcoming mouth. "That day we read no more," she would demurely recall.

The liaison continued for several years, until Gianciotto returned unannounced and pounded at the locked bedroom door. Paolo hastily ran for cover, but his cloak snagged, and he couldn't escape. Not realizing this, Francesca let Gianciotto enter. As he lunged at his brother with his sword, Francesca threw herself between the two men and was killed instantly. Gianciotto pulled his bloody sword from her body and ran it through his brother. The lovers were buried in a single tomb.

We meet the pair in Canto V of Dante's *Divine Comedy*. Like other lustful sinners, they whip endlessly around the second circle of the Inferno, propelled by winds as fierce as the passions that buffeted them on earth. Francesca, tethered to Paolo for eternity, describes the desire that overcame her as *"amor, ch'a nullo amato amar perdona"* (love that permits no one not to love in return). Just about every Italian woman I know recalls a suitor from her youth, often a tongue-tied teen, repeating these words to win her heart.

With his lyrical depiction of Paolo and Francesca, Dante cemented into the hearts of Italians the romantic concept of a love so compelling that it cannot be blocked by ramparts or contained by walls. Like the ancient gods struck by Cupid's arrows, mortal lovers were powerless in passion's thrall, which alternately plunged them into despair and raised them up to rapture.

Dante understood this condition well: he lived under its spell.

LOVE'S LIGHTNING BOLT STRUCK Dante (1265–1321) when he was just nine years old. In a neighborhood church in Florence, he beheld a pretty younger girl named Beatrice, a daughter of a distinguished family.

"At that moment," he remembered, "the spirit of life that hath

its dwelling in the most secret chambers of the heart began to beat so violently that the smallest pulses of my body shook." Although the two seldom saw each other and barely spoke, Dante developed an unrequited yet undying passion.

As was the custom of the time, both Dante and Beatrice entered arranged marriages. Dante's wife, Gemma, bore at least three children, but neither she nor their offspring merit a single mention in his works. His adored Beatrice died in 1290, a few weeks before her twenty-fifth birthday, probably in childbirth. In La Badia, the sweet little chapel where she is buried, young lovers still leave flowers and notes at her tomb.

Drawn to Florence's tumultuous politics, Dante was serving as a town prior, a sort of councilman, when civil war ripped the city apart in 1301. Along with other members of his party, Dante was exiled and his house razed. If he were ever to return to his family and the town of his birth, he could be burned alive. The native Florentine found himself penniless, friendless, homeless—as he put it, "a ship without sails or rudder, driven to various harbors and shores by the parching wind that blows from pinching poverty."

All that sustained Dante was his passion for Beatrice. Unable to touch her in life, the poet believed he could "attain" his unattainable beloved for eternity by "loving her more deeply than most lovers can claim." With words his only resource, Dante swore "to write of her what has never been written of another woman." In doing so, he created a template for romantic passion that became an ideal of lovers everywhere.

LONG AFTER I BEGAN STUDYING Italian, I resisted Dante, whose frowning face glared at me from portraits and statues throughout Italy. I assumed his works would be as off-putting as his dour visage. But when, as essential research for *La Bella Lingua,* I finally

read lyrical translations of his work, I learned that behind the scowl beat the heart of an incorrigible romantic.

Asked to identify his credentials as a poet, Dante once replied, "I'm just someone who takes notes when love inspires me." These "notes" flowered into 14,233 eleven-syllable lines organized into one hundred cantos in three volumes of his *Divine Comedy: Inferno* (Hell), *Purgatorio* (Purgatory), and *Paradiso* (Paradise). Beatrice gleams at the heart of this passion-filled opus.

Every wrought syllable was written, rewritten, polished, and perfected for her. Her eyes, radiant like suns, lead the pilgrim Dante to Paradise, where he discovers the essence of the universe, a divine love more powerful and profound than any earthly imitation. This, as the final line of the *Divine Comedy* (so named for its happy ending) proclaims, is "the Love that moves the sun and the other stars."

With this epic, Dante spun Tuscany's lusty, lively vernacular— the people's tongue—into literary gold: a gleaming new language second to none in its power and profundity, the linguistic base of modern Italian. *"Dante vive!"* proclaim graffiti in Florence. Dante lives!

He undoubtedly does. More than seven centuries after the bard's birth, Bruce Springsteen, Patti Smith, and bands like Radiohead and Nirvana cite Dante as an inspiration. They join an exalted chorus of famous fans, including William Shakespeare, John Milton, William Butler Yeats, James Joyce, Samuel Beckett, and Ezra Pound. No other single piece of literature has generated more research, analysis, commentary, interpretations, or adaptations— all of which keep proliferating "at an alarming rate," clucks *The Cambridge History of Italian Literature.*

-๛-

ROMANTIC PASSION CLAIMED ANOTHER HEART in 1327. In a church in Avignon, where his family fled after the same purge that forced Dante into exile, young Francesco Petrarca, known as Petrarch (1304–1374), beheld the woman who became his muse. Infatuated by nineteen-year-old Laura, whose eyes melted him "as the sun does the snow," he expressed in his *Canzoniere,* a book of 366 sonnets, "the boundless love for which there was no cure."

A natural athlete and voracious scholar, Petrarch traveled and studied throughout Europe. Like many men without inherited wealth, he opted for a career in the Church and took "minor" vows that prohibited marriage. Nonetheless, a series of women streamed through his life, and he fathered at least two children. Like Dante's family, none of Petrarch's consorts or children appear in his writings. His heart belonged only to Laura.

Physical love had nothing to do with this platonic passion. Already married when Petrarch first glimpsed her, Laura remained forever beyond his touch—or even his gaze. He seemed almost relieved when she died of the plague around 1348, saying that he no longer had to struggle with "an overwhelming but pure love affair." A simmering sexual attraction evolved into a spiritual enlightenment that would lead him beyond grief to redemption.

To express the loftiest of emotions, Petrarch and his legions of imitators embroidered eloquent phrases in which water became "liquid crystal" and a beloved an ethereal object of adoration ("the candid rose, thorn-encompassed"). Petrarch continued to polish what he dismissively called his "little songs" throughout his life, transforming them into literary gems.

His contemporaries hailed his verses—far too saccharine and contrived for modern taste—as "pure linguistic oxygen." Migrating as quickly as quill could copy them, they made all of Europe, in a commentator's phrase, "sonnet-mad." Poetry became such a popular passion that Petrarch complained that lawyers, theologians,

and even his valet had taken to rhyming and that soon "the very cattle would begin to low in verse."

Petrarch's most enduring contribution comes from his translations and commentary on manuscripts from ancient Rome and Greece, which shifted the way people thought about life itself. Rather than seeing earthly existence as a mere way station to eternity, he espoused a fuller view of human dignity and potential. Historians laud the acclaimed thinker as the intellectual father of the Renaissance.

Although contemporary Italian echoes with more "Englishisms" than lyrical turns of phrase, Petrarch's linguistic influence survives in seductive guises. Once, at the opening of a gallery in Florence, a silver-haired gentleman complimented me in typically Petrarchan style—which I totally misunderstood.

"Che begli occhi!" (What beautiful eyes!), he crooned, lifting my hand almost but not quite to his lips. As he rhapsodized about their green color and mused about whether they were more *giada* (jade) or *smeraldo* (emerald), I got lost in his Italian soliloquy. When he seemed to imply that I had an artificial eye, I protested.

"No, signora," he explained. What he had said was that my eyes seemed made of porcelain, created by an artist greater than any in his native city.

ALTHOUGH MORE WOMEN GAINED LITERACY in the Renaissance, few had an opportunity to write, and even fewer dared to rhapsodize about romance. An outstanding exception, Gaspara Stampa (ca. 1523–1554), considered one of the finest poets of the sixteenth century, broke the stereotype of women as passive recipients of adulation.

Classically educated, Gaspara and her sibling, Cassandra, gained fame in Venice as a sister act, appearing in literary salons

to sing, play the lute, and improvise poetry to a medley of tunes. A portrait depicts a young beauty with a laurel wreath on her luxuriant brown hair and a book in her arms, her velvet dress cut low to display creamy shoulders and décolletage.

Writing as the lover rather than the beloved, Gaspara writhed with unrequited passion, just like her male counterparts. The subject of her literary tributes, written in Petrarch's highly embellished style, was a certain Count Collaltino di Collalto. In 220 poems, she exalts his chiseled visage, praises his noble soul, and delights in the way he filled a room with his aura. Although we don't know if the two became lovers, Gaspara freely embraces sexual passion in her writing.

"If any woman ever so enjoyed the fire and ice of love, it's me," she declares, refusing to hide such intimate feelings. "My delight, my desire, is to live ablaze yet not feel the pain." Even the torment of her beloved's indifference brings her bittersweet pleasure, the kind that blues singers understand.

"Reading her poems," comments Kathleen Gonzalez, author of *A Beautiful Woman in Venice,* "is like listening to Billie Holiday sing of her love for a man who betrays and leaves her."

Although the Stampa sisters won praise as talented *virtuose,* simply performing as entertainers called their reputations—and virtue—into question. Gaspara's growing recognition fanned the envy of the Venetian equivalent of venomous Internet trolls, who attacked her as an unmarried woman shamelessly writing about sex. A fellow member of her literary academy wrote a vulgar poem calling her a whore and musing about which of the Stampa sisters might be better in bed.

Gaspara's health began deteriorating in 1553. The following year, she spiked a high fever and developed a racking cough. Fifteen days later, at age thirty-one, she died. Several months after Gaspara's death, her sister published her poems. Retracting their

previous rants, critics hailed the poet as "unique among others," a woman who extolled an earthbound love that unified body and soul.

IF POETS ALONE HAD THEIR SAY, romantic love might have been mummified in elaborate rhyming schemes. But Giovanni Boccaccio (1313–1375), the great raconteur who inspired storytellers from Chaucer to Dickens to Twain, never let passion stray far from its earthy roots. The illegitimate son of a Florentine merchant, he tried but failed at careers in banking and law. All that he wanted was to write, eat, and chase women.

While living in Naples, Boccaccio fell for a spirited coquette he called Fiammetta (Little Flame), who ran through his limited funds before leaving him for a richer suitor. He went on to father several illegitimate children and eat his way to an enormous girth. "If anyone ever needed compassion or appreciated it or delighted in it, I'm the guy," Boccaccio wrote.

In 1348, shortly after his return to Florence from Naples, the Great Pestilence killed a quarter of the townspeople, including Boccaccio's stepmother and numerous friends. His antidote to this horror was the *Decameron,* Italian's first great prose narrative, hailed as "an ode to and of passion in all its sweaty, sexy fullness . . . a book of the love of life." In the midst of the greatest disaster that had befallen Italy in a thousand years, Boccaccio managed to find beauty, humor, and goodness.

In this rousing work, a "merry brigade" of seven young women and three young men take refuge in a country villa to escape the plague and swap one hundred tales of love, lust, mischief, and treachery. As they demonstrate, the omnipresent threat of death intensifies a passion for enjoying life to the fullest—drinking, singing, gratifying all cravings, and delighting in sensual joys.

Scamps and schemers, greedy merchants and unrepentant adulterers, gluttonous priests and sex-crazed nuns flit through Boccaccio's pages. Contrary to the common assumption, only about a quarter of his tales have bawdy themes, but these sparkle with lusty vitality. In one spicy story, a young hermit, instructing a naive young girl, convinces her that she could best serve God by putting the devil, springing to life in his penis, into "hell," her dark and warm vagina. In a typically *boccaccesco* spin, the girl becomes so devoted to this form of worship that she wears the poor man out.

BOCCACCIO'S ZESTY STORIES SPREAD as swiftly as the contagion that inspired them. After the guilt-ridden Middle Ages, readers were delighted by his bemused acceptance of all-too-human failings. Who could blame his shameless sinners? As one of his lascivious abbesses declares to justify her transgressions, "It is impossible to defend oneself against the promptings of the flesh." So why even try?

Yet Boccaccio also appreciated the softer side of romance. In his most poignant tale, a young Florentine named Federigo, whose greatest pride is his noble falcon, spends his entire fortune trying to win the heart of a wealthy married woman, the virtuous Monna Giovanna. After her husband dies, the widow's young son becomes grievously ill and entreats her for the one thing he thinks would make him well—Federigo's prized bird.

Monna Giovanna, planning to beg for the falcon, arrives at Federigo's house at lunchtime. In a twist that foreshadows O. Henry's "The Gift of the Magi," Federigo, embarrassed that he has no food to offer, kills his cherished pet, roasts it on a spit, and serves it to his guest. Monna Giovanna's son dies, but, moved by Federigo's selfless deed, she marries the young man, rewarding his sacrifice with both wealth and happiness.

Boccaccio never found a love so true. After two marriages and countless liaisons, his love life soured to such an extent that he derided all women in a misogynist rant. His weight ballooned, and his health deteriorated. Scorning his *Decameron* and Italian itself, he wrote turgid tomes in Latin and considered burning his works and his library. Petrarch stopped him—and in his will left the impoverished author money to buy himself a warm winter dressing gown.

NOT EVEN THE CHARACTERS in Boccaccio's raciest tales could match the sexual exploits of the Venetian Giacomo Casanova (1725–1798), whose name became a synonym for seduction. His mother, a popular actress, left her firstborn son with his grandmother and various caretakers as she toured Europe in a traveling theatrical troupe. The odd, sickly child, who didn't speak until age eight, spent a lifetime searching for love—and found it in the arms of women of encyclopedic variety.

Casanova's résumé included stints in a seminary (expelled), a post as a secretary to a Spanish cardinal in Rome (fired), and a law degree (never put to use). "The chief business" of his life, he declared, consisted of "cultivating whatever gave pleasure to my senses." Seduction, which he described as a "thrilling, sometimes dangerous sport played by both sexes," intrigued him most.

A champion at the game, Casanova could slither his way under any skirt. Like a predatory animal with an omnivorous sexual appetite, he pursued women of every age, status, and size: ladies and chambermaids, girls and grandmothers, tarts and spinsters, nuns and nobles—by some reports, a thirteen-year-old niece and his own illegitimate adult daughter as well.

In time, Casanova's gambling and whoring tested even Venice's tolerance, and he was denounced as a Freemason, an atheist, and a

dabbler in black magic—serious crimes that landed him in prison. After fifteen months of plotting, he pulled off a seemingly impossible jail break and escaped to Paris.

The clever con artist won a commission from the French government to organize a state lottery, still in existence, based on the Venetian model. This enterprise, along with a silk manufacturing business, proved so lucrative that Casanova acquired a luxurious house, servants, horses, carriages, and a reported twenty mistresses, each ensconced in an apartment of her own.

Although he declared passion for several women, Casanova viewed love as "a kind of madness" and marriage as "the tomb of love." He preferred to remain footloose. For decades, he hobnobbed with intellectuals, mingled with royals at the British and Russian courts, skipped around Europe (often in flight from debtors or police), fought numerous duels, and once reportedly lost the equivalent of a million dollars in a single night of high-stakes gambling.

Arrested and jailed repeatedly, Casanova returned to Venice a broken man. For a while, he worked as an informer for the Venetian secret police, but a pamphlet he wrote, a vicious satire of the city's leading citizens, provoked such a scandal that he had to flee again. Homeless and penniless, Casanova became, as a Frenchman who once admired him put it, "a glorious butterfly transformed into a worm." A charitable friend gave the lonely exile a sinecure as the librarian in his dreary castle in Bohemia.

His health and vitality failing, Casanova suffered from gout, edema, and hemorrhoids as well as severe bladder infections, the legacy of sexually transmitted diseases. His vitality and bravado drained, he began writing his memoirs in 1790 and kept revising drafts until he died eight years later.

"I am writing *The Story of My Life* as the only remedy to keep from going mad or dying of grief," he said. His autobiography, stretching over nearly four thousand handwritten pages, along

with his little dog, served as Casanova's only solaces in a wretched old age.

JUST AS I WAS ABOUT to conclude that Italian romances and romancers inevitably end sadly, I came across a story that changed my mind. According to a reputedly historical account, a young woman in fourteenth-century Florence "lived twice"—thanks to the power of true love.

Ginevra degli Amieri, the pretty, spirited nineteen-year-old daughter of a rich merchant, loved and was loved by the commoner Antonio Rondinelli. Her family, according to the custom of the time, arranged a marriage to a well-born and well-to-do Florentine. After her wedding, Ginevra fell into a deep depression, stopped eating, and lost energy and weight.

One morning her husband found his young wife lying motionless in bed, eyes closed, unresponsive to everything around her. Fearing the plague, he quickly had Ginevra's lifeless body carried to the parish church, where her parents garbed her in white and sobbed through her funeral.

In the dark, cold damp of the family tomb, Ginevra suddenly awakened and called out for help. No one heard her. Somehow, she freed herself from the grisly vault. Dressed only in her flimsy shroud, she staggered to her house and called out to her husband. He opened a window and thought he was seeing a ghost. Terrified, he shouted that he would buy more Masses for her soul and ordered the servants to bolt the shutters.

Ginevra crept to her parents' home, where her mother sat weeping by the hearth. Certain that a phantom had appeared before them, her sorrowful parents bid the sad little wraith to rest in peace and locked the door.

Summoning what little strength was left in her wasted body,

Ginevra dragged herself to the house of the young man she had loved and called his name. At the sound of her voice, Antonio rushed outside and carried her, almost frozen, to his bed. With his tireless care, Ginevra slowly regained her health.

When her husband learned of Ginevra's return to life, he demanded restitution of his rightful "property." Antonio, determined never to lose his beloved again, pleaded their case before an ecclesiastical court. Since death had ended her first marriage, the vicar ruled, Ginevra was free to marry the man she loved.

Like Dante, Ginevra lives on. According to local legend, on the first Tuesday of every month, her ghost, dressed in white, rises from her tomb. In the dark of night, she retraces her path as she wanders from the family crypt to her husband's window and then to her parents' door before finally reaching Antonio's home.

There, once more, she finds comfort in her beloved's arms— providing romantics with the happy ending we crave and proving for all time that the passion of true love can triumph over church, state, narrow minds, and stone cold hearts.

6

PASSIONS
IN BLOOM

Drums beat. Trumpets blare. Hundreds of Florentines squeeze onto benches set up along Piazza Santa Croce; others crane from the windows of the surrounding buildings. On a crisp February day in 1468, the richest city-state in Europe hosts a celebratory joust in honor of a military victory and the engagement of their ruler's son, Lorenzo de' Medici (1449–1492), to a noble Roman girl.

Young men from the town's leading families canter slowly into the piazza on horses festooned with a king's ransom of precious stones, silk, velvet, and ermine, a display so brilliant that the radiance seemed to one observer "enough to block out the sun." A thick layer of white sand covers the great rectangle, divided lengthwise with wooden rails so galloping horsemen can thrust lances at each other at breakneck speed.

A white charger enters, bearing the unmistakable figure of

nineteen-year-old Lorenzo, supremely yet seductively ugly, with a jutting chin and a massive, curiously upturned nose. The broad-shouldered athlete wears a white silk mantle bordered in scarlet. Atop his black locks perches a velvet cap encrusted with rubies and pearls. At the center of his shield gleams the famous Medici diamond known as Il Libro (the Book), reportedly valued at the equivalent of a million dollars. The red Medici *palle* (balls) wave on a banner from his lance, along with the standard of his married mistress. Unseating every opponent, Lorenzo wins the day.

Two years later, when the twenty-one-year-old succeeded his father, the citizens of Florence exultantly hailed Lorenzo as their prince of passions. This Renaissance ruler governed the state, negotiated a delicate international peace, managed the family business, composed love poems and lusty ballads, mingled easily with philosophers and peasants, and was hailed throughout Europe as the greatest and noblest Italian of his time. Throughout his life, he also remained, as Niccolò Machiavelli duly noted in his history of the family, "amazingly involved in sensual affairs."

Although Magnifico was a title given to many lords in those days, Lorenzo became Il Magnifico, the most magnificent of all. In the seize-the-day spirit of his time, he raised celebration almost to the level of art with torchlit parades, masquerades, "lion-hunts" in the Piazza della Signoria, and high-speed horse races from one city gate to another.

"Who would be happy, let him be," Lorenzo wrote in his most famous verse. "Of tomorrow we cannot be certain."

In these Camelot years, Florentines, giddy with their own good fortune, reveled in the glorious moment. Besotted with beauty, they elevated everything in their lives—a shoe's turned-up toe, a sleeve's jewel-bright lining, a dagger's hand-carved sheath—into an adornment. Like the ancient Romans, they seized the day and lived each moment with a gusto unseen in centuries.

FLORENTINES CALLED THE MOVEMENT that transformed the Western world La Rinascita (the Rebirth), a jubilant resurrection of classicism after a thousand years of darkness. Although historians differ on precise dates for its beginning and end, the Renaissance (from the French for "rebirth") marked not so much a period of time as a revolutionary change in thinking, acting, and living in the world. With the discovery of Roman and Greek artifacts, extricated from crumbling ruins and remote monasteries, everything very old became new again. Italians felt their connection to their glorious past more strongly than ever before; ancient passions stirred back to life.

The scholars who translated and expounded on classical works came to be known as humanists, for their dedication to the manmade enterprises of art, literature, and language. "If we are to call any age golden," the philosopher Marsilio Ficino wrote, "it must certainly be our age, which . . . has restored to life the liberal arts that were almost extinct: poetry, painting, sculpture, architecture, music."

All exalted the glory of the human body, the agility of the human mind, and the grandeur within the human spirit. Man (and to a much lesser extent woman) became the measure of all things, and the pursuit of beauty, a manifestation of love and virtue, the noblest goal.

Artists emerged as the rock stars of their day. Giorgio Vasari, the father of art history, hailed them as heroic *artefici,* creators of miracles like God himself, endowed with a unique capacity to stretch beyond the banal and touch the sublime. Overcoming seemingly impossible technical challenges, they defined the visual language of Western culture, forever changing our concepts of beauty. Their goal was to inspire *meraviglia,* a sense of marvel and extraordinary

delight, and *stupore,* defined as "the state resulting from the perception of a thing that exceeded the limits of the senses."

By the late fifteenth century, artists were pursuing this passion like a drug. Luca della Robbia, a goldsmith's apprentice, became so engrossed in sculpting that he did nothing but chisel. When his feet grew cold, he warmed them in a basket of carpenters' wood shavings so he could continue his work. Paolo Uccello labored through the night, searching for the vanishing points of perspective. When his wife would call him to bed, he protested that he couldn't bear to leave his "sweet mistress."

Yet the yearnings of the human heart remained the same. The painter Sandro Botticelli, for example, like Dante and Petrarch before him, became hopelessly enraptured with an unattainable woman. Simonetta Vespucci (1453–1476) charmed all of Florence with her strawberry blond curls and delicate features when she arrived from Liguria to wed a local banker. After winning a joust in her honor, the smitten Giuliano de' Medici, brother of Il Magnifico, crowned her "Queen of Beauty."

Simonetta's reign was brief. She died, probably of tuberculosis, at age twenty-two. Devastated by her loss, Botticelli took to resurrecting her image again and again in paintings of unsurpassed elegance—as Venus rising from the sea, a springtime nymph dancing amid blossoms, a series of haunting Madonnas. The painter outlived his muse by thirty-four years. At his death, Florence honored his final request and buried him at the foot of Simonetta's tomb in the Church of Ognissanti (All Saints). The two lie there still, united for eternity.

REGARDLESS OF THE PASSION and talent of its artists, the Renaissance would never have come into full bloom without money—a great deal of it. Fortunately, Florence, once a sleepy wool town

on the Arno, had grown into the prosperous economic and cultural center of Europe, second only to Paris in population and prominence. Traders transporting silks, spices, salt, and other prized commodities from the Middle East brought currencies to be changed into florins, the coin that became the preeminent currency of Europe. Florentine banks loaned millions to kings and princes (at profitable interest rates). While many banking families grew rich, the Medici emerged as the most successful of these dynasties.

Called God's bankers because they collected taxes from every country in Europe on behalf of the papacy, generations of Medici ruled Florence with the power, but not the title, of monarchs. With Cosimo, as historians record, the Renaissance lifted its head. Under his grandson Lorenzo, it reached its peak of excellence. Under his great-grandson, who became Pope Leo X, it conquered Rome and the Christian world.

I got to know Medici country, the neighborhood surrounding the Basilica of San Lorenzo, when I was researching the life of Mona (Madame) Lisa Gherardini. The merchant's wife portrayed by Leonardo da Vinci lived with her family just a few blocks from the Medici palazzo, completed in 1484 after decades of construction. Deliberately choosing a relatively modest, fortresslike design, the family patriarch Cosimo de' Medici filled his home with treasures from the past—coins, sculptures, maps, scrolls—and works by innovative local artists.

In the center of its garden he placed a sculpture that foreshadowed the Renaissance in all its sensual splendor: the shepherd boy David, the first freestanding nude since antiquity, sculpted by Donato di Niccolò di Betto Bardi (ca. 1386–1466), known as Donatello, his childhood nickname. Unlike medieval artists, who had wrapped angels in wings and saints in mantles, he carved an androgynous adolescent with long locks, delicate features, and a slim

torso, garbed only in a rakish hat and boots, with a cocky swagger in his hips and Goliath's head under his foot.

Prodigiously productive, Donatello didn't differentiate between art and craft, lucrative commissions or whimsical projects. "Because he took delight in all things," wrote Vasari, Donatello set his hand to doing everything "without considering whether it was insignificant or prestigious." This was characteristic of Renaissance—and indeed continues to be a part of Italian—passion: the conviction that anything that human hands create should rise to the highest possible level of excellence.

Rivalries, sometimes jocular, sometimes savage, fanned by the outspoken Florentines, goaded artists' ambition. The constant carping and competitiveness in his hometown, Donatello claimed, inspired him to ever greater accomplishments. The sculptor churned out so many fine works so quickly that a merchant once refused to pay the agreed-upon fee for a life-size bronze head completed in only a month. Outraged, Donatello declared that he would destroy in one moment what it had taken a month to make. He carried through on his threat: with a shove, he knocked the bust from a parapet, shattering it to bits.

In daily life, money meant so little to the sculptor that he kept his earnings in a basket suspended from the ceiling of his studio and invited workers and friends to take what they needed. When the lifelong bachelor fell into poverty in old age, the Medici family supported him. At his request, he was buried in the Basilica of San Lorenzo, near his patron Cosimo.

WHILE DONATELLO POURED all his energy into art, often-conflicting passions for painting and women consumed another Medici favorite. Filippo Lippi (ca. 1406–1469) was orphaned at age two. An

impoverished aunt struggled to care for the boy, but she wearily consigned him to a monastery when he was eight.

An indifferent student, young Lippi spent all his time drawing in the margins of his books. When no punishment deterred him, a teacher sent him to the Brancacci Chapel in Florence's Church of Santa Maria del Carmine. On my first visit, I understood why. The painter known as Masaccio ("messy" Tom for his disregard for everything but art) had frescoed the walls with paintings—including an anguished Adam and Eve, wailing their way from Paradise—that infused raw emotions into recognizable human figures. Soon the youth could duplicate Masaccio perfectly.

At eighteen, Lippi ran away—only to be kidnapped by pirates as he sailed the Adriatic. With no relative or patron to provide a ransom, he remained in chains on the Barbary Coast for two years. One day, grabbing a burnt coal from the fire, Lippi sketched the pirate leader in typical Moorish clothes full length on a white wall—a feat his amazed captors thought was magic. In time, he painted his way to freedom and back to Tuscany, where Cosimo de' Medici recognized and rewarded his talent.

Much to Cosimo's frustration, however, Lippi couldn't resist pursuing love wherever he found beauty. When he spied an attractive woman, he single-mindedly wooed her, offering all he possessed for a night in her arms. If she refused, he cooled his ardor by talking to himself while painting her portrait, often as the Madonna. Then he would return to the chase.

Determined to curtail Lippi's amorous wanderings, Cosimo locked him inside the Medici palazzo to finish a project. After two days his "animal desires," as Vasari termed them, drove the painter "to seize a pair of scissors, make a rope from his bedsheets, and escape through a window to pursue his own pleasures for days on end." When he finally returned, Cosimo, conceding that "rare

geniuses are celestial forms" requiring freedom, granted him liberty to come and go, keeping him close with only "bonds of affection."

While painting a fresco for a convent in Prato, Lippi spied yet another striking young woman, Lucrezia Buti, either a ward or a novice in the cloister. He entreated the nuns for permission to model his Virgin Mary on the lovely girl. Each sitting further inflamed his desire. One day, as Lucrezia traveled on a pilgrimage to a nearby shrine, he carried her off—without any known protest on her part. Defying the prioress and her father, Lucrezia remained with Lippi, modeled for several Madonnas, and gave birth to a son, who would gain his own renown as the painter Filippino Lippi.

At Cosimo's behest, the pope released the senior Lippi from his vows so that he could marry Lucrezia, but to everyone's surprise, the painter balked. Instead, Vasari reports, he continued "to spend lavish amounts on his love affairs." In 1469, while working on frescoes in the Spoleto cathedral, Lippi died suddenly. According to local rumors, the relatives of a woman he had seduced poisoned him.

SUCH WAS THE PRICE of living, as the hypersexual humanists did, in the heat of seemingly perpetual erotic arousal, determined to suck all the marrow out of life. To them, sex seemed an imperative rather than an indulgence. Why else would nature have designed the body in such a way that touching the genitals triggered greater delight than any other stimulation? Yet theirs was not mere lust. The humanists pursued erotic passion as a way of expanding their experiences, stimulating their senses, and elevating their souls to a loftier plane.

Considered both the most creative and the most passionate of humans, artists pushed to the edge of what Vasari called "madness and wildness." This dangerous tendency, besides rendering them

"unmindful and eccentric," revealed "the shadow and darkness of vices." Like Lippi, the painter Raphael of Urbino (1483–1520), talented, affable, and drop-dead gorgeous, served as another case in point.

Capable of reproducing any master's style, Raphael copied the innovations of his talented contemporaries, who didn't always view imitation as a form of flattery. "All that Raphael knows of art, he got from me," Michelangelo once groused. Raphael, for his part, described his temperamental critic as "lonely as a hangman."

As a papal favorite and the toast of Rome, Raphael lived like a prince, showered with lucrative commissions. This "very amorous man," as Vasari delicately puts it, "was fond of women . . . and always quick to serve them." When an infatuation distracted Raphael from completing a commission in a cardinal's home, his patron moved the painter's mistress on-site.

Ultimately Raphael's sexual indulgence—which he tried to conceal—proved his undoing. As Vasari records, exhausted by pursuing "his amorous pleasures beyond all moderation," one night he happened to be "even more immoderate than usual" and returned home with a very high fever. The painter didn't reveal "the excesses he had committed," and doctors bled him in such a way that he became progressively weaker and died.

The thirty-seven-year-old was buried with sorrow and ceremony in the Pantheon. When I visit the temple-turned-church-turned-tourist-attraction, I never fail to pause at his tomb and read the poignant epitaph:

"Here lies Raphael, by whom nature herself feared to be outdone while he lived, and when he died, feared that she herself would die."

WHILE ROME AND FLORENCE BOASTED Madonnas of great beauty, Venice, named for the goddess of love, inspired the most seductive genre of Renaissance art: the voluptuous nude, the embodiment of the city's erotically charged atmosphere. Its unsurpassed master, Tiziano Vecellio, known as Titian (ca. 1490–1576), outshone all others as the brilliant "sun among smaller stars."

Although Titian savored the pleasures of living *alla veneziana* (in Venetian style), we know little of his private life. He fathered two sons with a woman named Cecilia, possibly his housekeeper. When she became grievously ill in 1525, he married her to ensure the legitimacy of their children. Cecilia recovered and survived another five years. In the mid-1530s, Titian married again. We know little about his second wife other than that she gave birth to a daughter.

In a career that spanned more than six prolific decades, the indefatigable painter produced hundreds of works, including grand-scale religious paintings, massive mythological scenes, and portraits of Europe's uppermost crust. None rivaled his tantalizing nudes— his *poesie* (poems), as he called them.

Titian wasn't the first artist to paint naked women, observes his biographer Sheila Hale, but he pioneered the use of live models. With milk-white breasts, ample thighs, and honey-colored hair, these beauties often posed lying down, exuding "an overt sexuality that had never before been seen in painting." The women, with faces recognizable to Venetians of the time, remain "as real to us today as when his contemporaries thought they saw the blood pulsing beneath their trembling flesh."

Several of Titian's paintings showcase the mythological beauty Danaë. After a prophet predicted his death at the hand of her son, Danaë's father imprisoned his daughter in a bronze tower where no man could ever reach her. Wily Jupiter outsmarted him. In Titian's depictions, a nearly naked Danaë reclines on an unmade bed in ob-

vious sexual rapture as a shower of the god's golden sperm falls in the form of coins between her parted legs. (The son she conceived did accidentally kill his grandfather.)

The goddess of love also appears in several Titian works, most famously the *Venus of Urbino,* which displays the fleshy charms of one of Venice's highest-paid courtesans. In a lushly colored scene, this regal princess of passion reclines on a bed, her soft, rounded body naked except for a bracelet, pearl earrings, and a ring on her pinkie finger. What intrigued me the first time I saw this Venus in Florence's Galleria degli Uffizi was not her fleshy form but her unabashed gaze inviting viewers to enjoy what she proudly revealed.

Compared to this succulent beauty, a writer of the time observed, every other woman who had ever appeared naked on canvas looked "like a nun." A shocked Mark Twain decried the *Venus of Urbino*—"Titian's beast," in his words—as "the foulest, the vilest, the obscenest picture the world possesses."

Imitated by generations of artists, Titian's zaftig beauties still spark debate over whether they are lascivious pornography or elevated art. When I ask a Venetian what she thinks, she grins like her city's sly putti and says, "Maybe a bit of both."

THE WOMEN PAINTED with consummate skill by Renaissance masters intrigue us, not just with their physical allure but with their elegance and dignity. However, even seemingly enlightened humanists, who applauded feminine wit and intelligence, believed that women should remain subservient to men. The philosopher Ficino, an inveterate romancer, relished female charms but dismissed women as "chamber pots," meant "to be pissed in and thrown away."

Despite daunting obstacles, a few women with singular passion did manage to create important works of art. Some were the

daughters of artists who picked up skills in a father's *bottega*. Others found the freedom for creative expression within convents, which mainly took in girls—as many as one in four of Florence's daughters—whose families couldn't afford bridal dowries. Those with lilting voices sang in choirs. Others, with a passion to glorify God with beautiful works, took up their brushes.

At age fourteen, Plautilla Nelli (1524–1588), a merchant's daughter in Florence, entered a local convent and gained a reputation as, in Vasari's description, "the nun who paints." Winning the respect of prominent male painters of the time, she became Florence's first recognized female artist.

"There were so many of her paintings in the houses of gentlemen in Florence," Vasari reports, "that it would be tedious to mention them all." One of the first artists of either gender to sign her works, Nelli set up a studio to train other nuns to paint.

Her most remarkable composition represents a first in the history of women's art: a massive *Last Supper,* almost twenty-three feet long, for her convent's dining hall. Thanks to a crowdfunding campaign by the Advancing Women Artists Foundation, a recent restoration has revealed rich colors and subtle details unseen for centuries.

WHEN ALL ELSE FAILED, female artists improvised. A sculptress in Bologna named Properzia de' Rossi (ca. 1490–1530) carved intricately detailed scenes in an odd and challenging medium: the pits of peaches and apricots. Since marble quarries and sculptors' workshops were male territory, off-limits to the "fair sex," she may have had to employ the only material at hand: stone fruit.

On one pit, Properzia carved a detailed *Passion of Christ* that so impressed the city wardens that they commissioned a marble sculpture above a set of doors in Bologna's Basilica of San Petronio.

She chose a scene from the Old Testament in which the wife of the Egyptian pharaoh's chamberlain, burning with lust for their Hebrew slave, strips off his tunic—depicted, as Vasari describes it, with "a womanly grace that defies description."

Vasari interpreted the work as an expression of Properzia's unrequited desire for "a handsome young man, who seemed to care but little for her." This "most beautiful" work brought "great satisfaction" to Properzia, he asserted, by partly quenching "the raging fire of her own passion." Although the Bolognese applauded Properzia's achievement, the feckless nobleman she pined for "spoke ill" of her to the church wardens, and she received "a most beggarly price for her work." Properzia died nearly penniless.

ANOTHER RENAISSANCE WOMAN attained greater success—professionally, financially, and personally. As a girl in Cremona, Sofonisba Anguissola (ca. 1532–1625) produced a drawing called *Laughing Girl* that her father sent to Michelangelo. It made the great maestro smile—and issue a challenge: try painting a more difficult emotion, like crying.

Sofonisba responded in a delightfully original way—with a little boy weeping over his bloodied finger after he plunged his hand into a tray of crayfish. Michelangelo praised its young creator and sent some of his drawings so she could continue honing her skills.

At age eleven, Sofonisba apprenticed herself to one of the few male artists in Cremona willing to accept female students. Vasari writes that she "worked with deeper study and greater grace than any woman of our times at problems of design." At age twenty, Sofonisba completed a portrait of her three sisters playing chess, considered the first realistic depiction of domestic life—a significant departure from grand ceremonies, religious scenes, and mythological dramas.

The young artist, as Donna DiGiuseppe recounts in *Lady in Ermine,* a novel based on Sofonisba's life, won a prestigious appointment to the Spanish court. King Philip II summoned Sofonisba to Madrid to serve as a lady-in-waiting, artist, and art teacher for his Italian wife. Working tirelessly over fourteen busy years, Sofonisba became the first woman to achieve international acclaim as a professional painter.

When she was in her late thirties, King Philip, deciding that Sofonisba should marry, provided a generous dowry and selected a Sicilian nobleman as a suitable husband. The couple settled in Paternò near Catania on the eastern side of the island. En route to Spain in 1579, her husband was killed in a pirate raid on his ship. Two years later Sofonisba, intending to return to her hometown of Bologna, sailed for the Italian mainland, but was shipwrecked on the Tuscan coast.

During this fateful journey, an unexpected passion stole her heart. The middle-aged painter fell in love with the ship's dashing Genoan captain, Orazio Lomellino, and, according to gossip from the time, asked him to marry her. He readily consented. At age forty-five, Sofonisba wed the love of her life, settled in Genoa, and established a school for painters. They lived there until 1615, when, in her eightieth year, the couple moved to Palermo.

Although cataracts had dimmed her vision, Sofonisba continued to tutor young artists. One was the Flemish painter Anthony Van Dyck, who painted the nonogenarian on her deathbed. For the rest of his career, the acclaimed portraitist would say that he had learned more from a sightless old woman in Sicily than from all the master painters of Italy.

IN ANY OTHER TIME, Sofonisba and dozens of her contemporaries would number among Italy's greatest masters. But in the Re-

naissance, even the brightest stars were eclipsed by two blinding supernovas: Leonardo da Vinci (1452–1519) and Michelangelo Buonarroti (1475–1564). Possessed and inspired by a passion to create works unlike any that came before, each left an indelible signature both as an artist and as a larger-than-life personality.

Even before the Florentines sensed the immensity of his genius, Leonardo won over everyone he met with his charm and remarkable good looks. Nothing about this artist and architect, musician and mathematician, scientist and sculptor, engineer and inventor, anatomist and author, geologist and botanist was ever ordinary.

The quintessential Renaissance man sketched, designed, painted, and sculpted like no one else. He looked like no one else, with carefully curled locks in his youth and a prophet's chest-long beard in old age. He wrote like no one else, in an inimitable "mirror script" that filled thousands of pages in his makeshift notebooks. He rode like a champion, so strong that a biographer claimed he could bend a horseshoe with his hands.

Insatiably curious and brimming with passions, Leonardo delved deep into mathematics, physics, and astronomy; calculated the ideal proportions for a human figure; drew plans for gravity-defying "flying machines"; orchestrated breathtaking theatrical spectacles; and brought to painting such remarkable verisimilitude that Christ and his apostles seemed to breathe as they gathered for their last supper together.

I didn't fully appreciate Leonardo's passion for painting until I was researching *Mona Lisa: A Life Discovered,* my biography of the woman he immortalized. After beginning the painting around 1503, he continued to perfect this masterwork until shortly before his death sixteen years later.

Created with thousands upon thousands of tiny brushstrokes, *La Gioconda,* as Italians refer to the portrait, conveys the immediacy of a photograph centuries before the invention of the camera.

Lisa's eyes shimmer, one pupil ever so slightly more dilated, a split second behind the other in adjusting to a change in light. Leonardo's *sfumature* (subtle shadings) blur ambiguously at the corners of her eyes. Her lips curve but stop on the very cusp of a smile that captivates us more than five hundred years after its creation.

"The portrait was painted in a way that would cause every brave artist to tremble and fear," wrote Vasari. Except one: Leonardo's archrival Michelangelo.

AFFABLE LEONARDO CHARMED even casual acquaintances so effortlessly, Vasari writes, "that he stole everyone's heart." No one ever accused Michelangelo of such larceny. Unlike fastidious Leonardo, who dressed in pinks and purples and scented his hands with lavender, Michelangelo wore paint-splattered tunics and often didn't remove his dogskin underboots until they had reached such a state of disrepair that strips of flesh came off with them. His fearsome temper matched his grizzled looks.

Michelangelo liked to say that he had imbibed his fervid passion for stone in the breast milk of his wet nurse, a mason's wife. A short child who never grew tall, Michelangelo was squat and bony, with a low brow set on a large head, coarse curly hair, big ears that jutted from the sides of his skull, and small, searing eyes. His father tried to beat artistic passion out of the boy, but Michelangelo's obvious talent won him an invitation to live and study in the palazzo of Lorenzo il Magnifico, his first and most beloved patron.

After the fall of the Medici, the Florentine Republic, eager to muster popular support, wanted a symbol of civic pride. At age twenty-eight, Michelangelo gave them a shepherd boy carved from a discarded marble slab more than sixteen feet tall.

When his gigantic *David* rolled slowly on a platform of greased logs through the streets in 1503, Florentines gaped in wonder. The

statue flaunted the rules of conventional sculpture: head, hands, and feet too large; thighs too massive; chest too muscled. Yet every element united to embody the strength and nobility of the humanists' ideal man.

Michelangelo's *David* transformed the artist into both a celebrity and, with the receipt of a hefty commission, a rich young man. Not yet thirty, he would soon accumulate more money than Leonardo did in his entire lifetime. Through decades of tumult—uprisings, assassinations, civil wars, sieges, conspiracies, and invasions—Michelangelo worked ceaselessly, producing unequaled masterpieces in painting, sculpture, and architecture and earning the accolade of Il Divino, the divine one.

AFTER FIVE CENTURIES, the passion of these two geniuses still shines. Leonardo's *Mona Lisa* remains the most recognized, analyzed, copied, and admired image on the planet—and beyond. In 2013, NASA, in its first test of a laser system for interplanetary communication, selected an image of the *Mona Lisa* to transmit to the moon and back. Why not? She's been everywhere and done everything else, with her face reproduced in toast, yarn, pasta, jelly beans, jewels, cups, spools, and just about every other conceivable medium.

Michelangelo's *David* also has emerged as a modern meme, toting a guitar or an automatic weapon, wearing swim trunks, jeans, a jock strap, or a Hawaiian shirt. His *Creation of Adam* and *Last Judgment* in the Sistine Chapel draw tens of thousands of tourists a day.

On my most recent visit, I lingered after an evening tour simply to gaze upward at Michelangelo's celestial ceiling. Then I began watching the people entering the chamber. Dressed in everything from saris to jeans, speaking in the tongues of dozens of nations,

each stopped—even if just for a moment—to take in the paintings' majesty.

The historian and poet Benedetto Varchi would have recognized the look on their faces. Writing five centuries ago, he described his reaction as he beheld Michelangelo's works: "I am stupefied, not just astonished and amazed . . . but almost reborn. My pulse trembles, all my blood turns to ice; all my spirits are shocked, my scalp tingles."

The French writer known as Stendhal described an equally intense physical reaction during his 1817 visit to Florence. Viewing the memorials to Michelangelo, Galileo, and Giotto in the Basilica of Santa Croce, he found himself as "in a sort of ecstasy from the idea of being in Florence, close to the great men whose tombs I had seen. Absorbed in the contemplation of sublime beauty . . . I had palpitations of the heart. . . . Life was drained from me. I walked with the fear of falling."

Art lovers remain just as susceptible. In 1979, an Italian psychiatrist documented more than a hundred cases of tourists in Florence stricken by "Stendhal syndrome." Symptoms include dizziness, fainting, panic, and bouts of "outright madness" that can last for several days. Its cause may lie in the brain. According to neuroscientists, artistic masterpieces target the same cerebral regions that trigger strong emotional reactions to intense or traumatic real-life events. With a majority of the world's art treasures, Italy may be the most perilous place on the planet for art-sensitive souls.

Italians, after eons of exposure, seem to have acquired immunity. However, some still succumb to the aphrodisiac allure of great art. In a survey of two thousand Italians, one in five admitted to having an "erotic experience" in a museum. Why?

"People who like to go to museums feel love," explained a junior cultural minister, who confessed to yielding to this impulse

on at least one occasion. "Love for art and love for eroticism are completely compatible and transferable."

Italy's classic artists, who poured passion into their every work, would surely agree. Their creations don't simply hang on walls or pose on pedestals. They reach through time to ignite a passion so intense that it cannot be denied—or, in some cases, even delayed.

SACRED
AND PROFANE

R ome's lyrically named vicolo del Divino Amore (Lane of Divine Love) shows no hint of godliness or affection. Filthy bins overflow with trash. Empty wine and beer bottles line the gutters. The stench of rotting food fouls the air. As I enter from via dei Prefetti, I walk briskly past walls blotched with graffiti and peeling posters. But after several minutes, I notice a difference. With every step, the *vicolo* seems brighter, cleaner, safer. When the street stops at via del Clementino, I turn and retrace my steps.

Almost midway between the lane's two dead ends—one shadowed and dodgy, the other sunshine bright—I find a structure that was once the home and studio of Michelangelo Merisi, known as Caravaggio (the name of his parents' village). His bold use of chiaroscuro, the contrast between dark and light, underscored his passion for daring innovation as a painter. Meanwhile, his personal

life, also oscillating between extremes, pushed him ever nearer to the brink—physically and psychologically.

In 1604, Caravaggio tore half the roof off his second-floor rooms on the vicolo del Divino Amore, then stopped paying rent and never compensated the outraged landlord. In the nearby Church of San Luigi dei Francesi, he painted three stunning scenes from the life of San Matteo (Saint Matthew) that have stirred viewers' souls for centuries. A few blocks away, in a small piazza now choked with cars, the most celebrated, sought-after artist in Rome killed a man and fled for his life. The city offered a bounty for his severed head.

This was Rome in the seventeenth century, the age of the Baroque and its often-dizzying passion for contrasts and extremes. More so than at any time since the heyday of the Roman Empire, the Eternal City preened, in the words of the Venetian ambassador, as "the emporium of the universe" with people "from every direction, in every season, and from all nations" flocking to the "Mistress of the World . . . to gaze upon her magnificence."

The force behind this *magnificenza* was the Catholic Church. Under siege by Protestant reformers, the Vatican fought back—not just with a crackdown on abuses, but with an all-out crusade for Christian souls. The leaders of the Counter-Reformation wanted to inspire, impress, even seduce believers with a renewed vision of God's grandeur, reflected in awe-inducing masterpieces. The ultimate aim of this lavish campaign was to demonstrate through sheer material splendor that Rome remained the cultural center of the world and the Roman Catholic Church the one true religion.

Pilgrims poured into the Eternal City—so many that they outnumbered its one hundred thousand residents during "holy years" that offered absolution of all sins. Yet then as ever, vice vied with virtue. Prostitutes boldly flaunted their lures. Fortunes were won—

and more often lost—in raucous gambling casinos. Gangs clashed in bloody turf wars. Robbery, rape, and murder were everyday occurrences, often unprosecuted and unpunished.

Artists and artisans also flocked to the citywide *bottega* that the capital of Christendom had become. In this most flamboyant of creative eras, Italian maestri merged a passion for redefining art with a passion for pushing beyond legal and moral limits to devour life whole. Breaking free of Renaissance classicism, they unleashed dazzling visual pyrotechnics. They also left a more personal legacy through lives suffused with both the sacred and the profane, darkness as well as light.

CARAVAGGIO (1571–1610), an orphan who had apprenticed with a painter in Milan, arrived in Rome around 1592—young, scrappy, and hungry. He and other artists found themselves competing for the same commissions, drinking in the same taverns, and fighting for the same women.

Desperate for money, Caravaggio initially churned out paintings in the equivalent of an artistic sweatshop while sleeping on a straw mattress in a storage room. A horse's kick landed him in a hospital for the poor for several weeks. One of his early works, *Self-Portrait as Sick Bacchus,* captures his reflection in a mirror—an ashen, gaunt youth with eyes like dark pools.

A cardinal impressed by a Caravaggio painting in a local gallery offered the artist his first lucrative commissions as well as lodging in the imposing Palazzo Madama, now the seat of the Italian Senate. During his six-year stay, a new world opened for the country boy as Rome's art-loving elite clamored for his works.

Yet Caravaggio never abandoned life on the city's often-mean streets. With his band of young toughs, he swaggered through the

Campo Marzio, blade ever at the ready, looking for trouble—or letting trouble find him. In one three-year span, he was arrested and jailed five times.

"Almost everything we know about Caravaggio's personal life comes from police records and tribunals," the art historian Sara Magister tells me as we trace the painter's footsteps through Rome. His barber, testifying in an assault case, described him as "a stocky young man, about 20 or 25 years old, with a thin black beard, thick eyebrows, and black eyes, who goes dressed all in black, in a rather disorderly fashion, wearing black hose that is a little bit threadbare, and who has a thick head of hair, long over his forehead."

Caravaggio's rap sheet included brawling, carrying a forbidden weapon, insulting police officers, and "house-scorning," a rowdy form of vandalism in which a gang threw stones, broke windows, and hurled animal bladders filled with blood or ink at a rival's home. Caravaggio once became so enraged with a waiter over whether artichokes should be prepared in oil or butter (the latter a northern preference derided in Rome) that he flung a plate at the youth, wounded him under the eye, and ended up in jail for assault.

This devil-be-damned attitude bled into Caravaggio's paintings, melding his evocative style with his gritty view of Rome's underbelly. Workers with dirty fingernails and soiled feet appear as apostles and martyrs. Prostitutes in low-cut dresses serve as models for Mary Magdalene and, more blasphemously, the Virgin Mary. An undercurrent of animal ardor sizzles beneath every surface. Pieces of fruit in a still life seem charged with desire. Saintly figures, however devout, exude an erotic energy. Mythic gods, male and female, pulse with ripe sensuality.

A realist in an age of idealism, Caravaggio orchestrated beams of dramatic brightness to make scenes from mythology or the gospels look and feel as if they were happening right here, right now.

"Caravaggio is always telling a story, often of the moment when something happens and everything changes," says Magister.

We see San Paolo sprawled on the ground during his epiphany; San Pietro splayed upside down as the cross is raised for his crucifixion. Caravaggio's chilling portrait of the Medusa catches her frozen scream of horror just after her head's separation from her body. His own haunted features appear on the decapitated head of Goliath, dangling by the hair from the fist of a somber young David.

Astounded by his revolutionary approach, young painters called Caravaggisti imitated his "miracles" of virtuosity and popularized his technique. Although some critics blasted Caravaggio for "seeking out filth and deformity," commissions flooded in. By the turn of the seventeenth century, he reigned as Rome's artistic superstar.

IN MAY 1605, a simmering feud between Caravaggio and a rival gang leader named Ranuccio, reportedly the pimp for one of the painter's models and lovers, culminated in a confrontation in a Roman piazza. Caravaggio attacked, forcing Ranuccio to retreat. When he stumbled and fell, Caravaggio thrust his knife toward Ranuccio's groin—perhaps to castrate rather than kill him. But the blade severed the femoral artery, and blood gushed from the wound. Ranuccio's brother lunged at Caravaggio, slashing his side. His friends rushed the badly wounded artist to safety.

Sentenced to death, with a bounty on his head, Caravaggio fled south to Naples, capital of the Kingdom of the Two Sicilies. In the sprawling city three times the size of Rome, Caravaggio readily found lucrative commissions. Venturing to the island of Malta, he painted portraits and altarpieces and won a knighthood—only to be expelled from the order as a "corrupt and stinking member" and locked in a fetid underground pit. Bribes helped him escape and

sail to Sicily, where he produced brooding masterpieces. Back in Naples, he was bludgeoned so savagely, probably by bounty hunters, that his face became unrecognizable.

After four years on the lam, Caravaggio won a papal pardon through the intercession of an influential cardinal. With a few paintings for his benefactors, he boarded a boat to Italy. A dispute of some sort landed him in jail in a small town on its western coast. Caravaggio bought his freedom, only to discover that the boat had sailed north with his paintings on board.

The artist set out in desperate pursuit, traveling by whatever means he could find, including on foot, in stifling midsummer heat. Pushing beyond exhaustion, Caravaggio collapsed on a beach near the fishing village of Porto Ercole on the Tuscan coast. According to a contemporary, "without the aid of God or man, in a few days he died"—possibly of dysentery after drinking contaminated water. He was thirty-nine years old.

Caravaggio's death is the town's sole claim to historic fame. I know. For almost thirty summers, my husband and I have vacationed in this picturesque port, charming but lacking any distinguished museum, church, or work of art. Yet even here Caravaggio provoked extreme reactions.

A stately column carved with a Medusa, erected in 1973 in tribute to the artist, stands in a sun-dappled grove of pine trees adjacent to the beach where he collapsed, a tranquil place for a troubled soul to rest in peace. A few years ago, Porto Ercole unveiled another memorial, along with a casket containing several bones from the local cemetery that may—or, more likely, may not, according to scholars—belong to his skeleton.

"Where can I find Caravaggio's tomb?" I ask a local.

"Behind the butcher shop," he replies, "where bones like that belong." There a grim stone-and-steel mound of symbols represent-

ing the torment and despair of his final years evokes the darkness that won over the light in Caravaggio's life.

The painting that most dramatically captures these tensions hangs in the grandiose halls of Palazzo Barberini in Rome. *Judith Beheading Holofernes* recounts the Old Testament tale of a Hebrew widow who became both a killer and a heroine. After the Assyrian general's siege had starved her town to the brink of surrender, Judith, in her best jewelry and finest gown, gained entry to his military encampment. Smitten by her beauty, Holofernes invited her to stay and dine with him. Plied with wine, the general fell into a drunken slumber. Judith seized his sword and hacked off his head.

Caravaggio sets the brutal murder in a Roman brothel, with his favorite courtesan-model as Judith. Holofernes lies on rumpled sheets, his mouth gaping in midscream, his head pulled upward by Judith's left hand tugging at his hair. Her placid face frowns in concentration as she presses the blade deep into his neck. Blood jettisons from the dying man's throat in ribbons of bright red as Judith's wizened old servant watches impassively.

Many artists have portrayed the same chilling scene, but only one painting strikes me as superior to Caravaggio's. Its creator was the daughter of a member of his street gang, Orazio Gentileschi, his talented imitator, "fellow swordsman and friend."

CRITICS OF HIS DAY lauded Orazio as a "poet of light" who blended Caravaggio's realism and Raphael's classicism, but it was his daughter who won both notoriety and renown: Artemisia Gentileschi (1593–ca. 1652). Jane Fortune, founder of the Advancing Women Artists Foundation, describes her as "one of history's most influential painters," with a "rich baroque style" strongly influenced by Caravaggio. Artemisia's life, too, turned into a tale of passion

played out against a backdrop of dark and light. And as with Caravaggio, this contrast would shape the way she painted—and the way she lived.

Growing up in the freewheeling artists' quarter at the foot of Rome's Pincio Hill, Artemisia learned how to draw, mix colors, and paint in her father's workshop. After her mother died in childbirth when Artemisia was twelve, the young girl channeled her grief into art. While still in her early teens, she demonstrated such promise that her father hired a colleague named Agostino Tassi to tutor her.

Tassi became obsessed with Artemisia, following her through Rome and intimidating any boy who dared approach her. One afternoon, when her chaperone left them alone, he raped Artemisia, who was sixteen or seventeen at the time. Promising marriage, Tassi continued to force the teenager to have sex with him until her father denounced him to the pope, charging him with *stuprum* (forcible defloration of a virgin).

In 1612, in a sensational seven-month trial, Artemisia described the violent attack. Pinned down on the bed, a handkerchief jammed into her mouth, a knee forcing her thighs open, she fought back. "I scratched his face and pulled his hair. . . . I grasped his penis so tight that I even removed a piece of flesh." Squirming out from under her rapist's weight, she fumbled for a knife in a drawer close by and threatened to kill him. He taunted her by baring his chest. Artemisia lunged. He parried, although she managed to draw blood.

As recorded in the trial transcript, Artemisia spoke with poise and precision. Everything was at stake for the teenage girl: her honor and reputation, her family's social standing, her prospects for marriage, her hopes for a future as an artist. To verify the truthfulness of her accusations, she had to repeat her testimony while undergoing torture with metal rings that squeezed fingers tight enough to leave permanent scars and, in some cases, break bones. Despite the excruciating pain, Artemisia did not waver.

Testimony at the trial revealed that Tassi had a wife (whom he had planned to murder before she ran off with another man) and an adulterous relationship with his sister-in-law. Although convicted, the rapist fled from Rome and never served his sentence of a year as a galley slave.

A month after the trial ended, Artemisia's father married off his "sullied" daughter to a minor artist named Pierantonio Stiattesi. The newlyweds moved to the groom's hometown of Florence.

AT A TIME WHEN respectable women either married or entered a convent, Artemisia managed to live by her paintbrush. In the city-state ruled by Duke Cosimo II de' Medici, she quickly won high-profile and high-paying commissions. The duke and duchess hired her to paint several works, as did Michelangelo Buonarroti the Younger (the artist's nephew).

Although she didn't learn to read and write until adulthood, Artemisia immersed herself in the poetry of Petrarch and Michelangelo and moved easily amid the theatrical, musical, and artistic glitterati at the Tuscan court. In 1616, she became the first woman inducted into Florence's prestigious Accademia delle Arti del Disegno (Academy of the Arts of Drawing). Galileo Galilei, a fellow member, befriended her, and they shared warmly affectionate notes until his death.

Many of Artemisia's paintings reflect both the trauma of rape and the steely determination of a survivor. Of almost sixty known works, most portray women—not as tranquil Madonnas or doleful martyrs, but as the strong, assertive heroines of mythology and the Bible. Several bear a striking resemblance to the artist as she captured her image in self-portraits: intense, full-cheeked, dark-haired, demanding to be taken seriously at a time when most women were not.

Artemisia painted several variations of the Bible's murderous matron Judith. The best known, in the Uffizi's Sala di Caravaggio (Caravaggio Room) in Florence, both ensnares and repels viewers with its graphic violence. Caravaggio presented an intricately staged murder; Artemisia depicts a bloodbath.

Judith has sliced open Holofernes's throat with his sword. Bright red blood spurts from the wound, spilling over the sheets and gushing toward her elegant gold gown. Her young maid holds the flailing general down with her muscular arms. Judith, her face resolute, shows no hesitation or remorse. The painting, commissioned by the grand duke, so distressed his wife that it was hung in one of the Uffizi's remote corners. (It was later moved to a more accessible site, where it was damaged in a 1993 terrorist bombing of the museum.)

ALTHOUGH SHE RETURNED OFTEN to violent subjects, Artemisia also painted sensual nude or nearly nude women, including a sleeping Venus and an enraptured Danaë with Jupiter's gold coins piled between her fleshy thighs. A cache of long-lost letters discovered in 2011 revealed that the artist herself had a passionate secret life. "I am Artemisia," she wrote to a Florentine aristocrat during their decades-long affair, "and I burn with love."

Francesco Maria Maringhi, a nobleman of means and influence, may have entered Artemisia's life as a patron. At some point, the two began a romantic liaison hidden from everyone except Artemisia's husband. In notes scrawled on the backs of Artemisia's letters, he communicated regularly with Francesco, praising his wife's achievements and genially accepting Francesco's role in their life—especially the financial support that came with it.

Artemisia gave birth to four children—two girls and two boys—in Florence. Three died in childhood; only a daughter sur-

vived to adulthood. Despite her hefty income and her lover's generosity, Artemisia and her husband lived wildly beyond their means and struggled constantly with debt. Merchants' account books reveal multiple complaints about overdue payments and a charge of theft against Artemisia, which she furiously denied. Despite her own extramarital entanglement, she refused to pay some of her husband's bills because he "was still with said woman." (We don't know whom.)

A brew of blackmail, jealousy, scandal, and debt forced Artemisia to flee Florence for Rome in 1620. There she set up a busy *bottega*. Somewhere along the way her husband slipped out of the picture, and her lover Francesco joined her and her daughter.

Admirers penned sonnets praising her "amazing miracles" and painted portraits of her, including a black-and-red chalk drawing of her right hand by a besotted Frenchman. Detractors also had their say. "To carve two horns upon my husband's head," one snarked in a sham first-person verse, "I put down the brush and took a chisel instead."

Forced to move to avoid outbreaks of the plague and to acquire new patrons, Artemisia spent extended stays in Venice and Naples. In 1635, King Charles I of England commissioned Orazio and Artemisia, father and daughter, to decorate the queen's house in Greenwich. Orazio, a favorite of the British court, died in London in 1639.

Artemisia, bankrupt and in need of work, returned to Naples. There she promised a prominent collector that she would show him "what a woman can do." She did so in a lush painting of a naked Diana in her bath, which, as she put it, depicted "the spirit of Caesar in the soul of a woman." Artemisia continued painting until about the age of sixty, when the plague claimed her life.

After her death, Artemisia slid into anonymity, with some of her early works attributed to her father. Overlooked for centuries,

she was resurrected in the late twentieth century as a feminist icon who overcame rape and ignominy to gain respect and acclaim. In recent decades, Artemisia has inspired novels, plays, and an Italian television miniseries.

In a novel called *The Passion of Artemisia,* Susan Vreeland writes a dialogue between Artemisia and her father toward the end of his life. "We've been lucky," she tells him. "We've been able to live by what we love. And to *live* painting, as we have, wherever we have, is to live passion and imagination and connection and adoration, all the best of life—to be more alive than the rest." Although the scene is imagined, whenever I encounter Artemisia's work, these words come to mind and ring hauntingly true.

VREELAND, SPEAKING AS ARTEMISIA, deftly captures the essence of Baroque art and architecture. A sense of passionate "aliveness" pulses throughout the period. I feel its seductiveness most in Rome, the dome-capped city of gushing fountains, monumental staircases, and sunlit piazzas.

I didn't realize that many are the gifts of one singular artistic sensation until I rented an apartment a half block from the home and studio of Gian Lorenzo Bernini (1598–1680). After days of walking by this palazzo, I stopped to translate the commemorative plaque on its facade: "Here lived and died Gianlorenzo Bernini, a sovereign of art to whom reverent popes, princes, and peoples bowed."

Who was the uncrowned marvel who inspired such homage? "The Brad Pitt, Jeff Koons, and Frank Gehry of his age, all rolled into one," the author of a website dedicated to the omni-talented genius writes. Over his long career, Bernini emerged as the Michelangelo of his time, a master sculptor, architect, painter, city

planner, draftsman, engraver, playwright, and scenographer who moved effortlessly from sacred to profane in both his personal and professional lives.

The son of a sculptor, Bernini began working with his father in Rome as a boy while diligently sketching the Vatican's master-pieces, one by one. If he didn't return home for dinner, his father knew that his son was indulging his creative passion with his "girl-friends," as he referred to the papal treasures. Early critics called the youngster "a monster of genius."

In his first self-portrait, the "monster" appears slender and hollow-cheeked, with a wide forehead, unruly black hair, dark eyes, sensual red lips, and a rapt expression. Throughout his long career, he would work uninterrupted from dawn to dusk. "Let me be," he'd say to assistants who tried to coax him to pause for a meal, "I am in love." Going to work, he often said, was "like enter-ing a garden of delight."

When Bernini was just twenty, Cardinal Scipione Borghese, an avid art patron, hired him to create sculptures for his ornate villa, now home of the Galleria Borghese. These early works, which include Hades pursuing Persephone, Apollo grasping Daphne, and David confronting Goliath, testify to Bernini's genius for bringing cold hard marble to hot passionate life.

Hades's hand grips Persephone's thigh so tightly that we can see the imprint of his fingers. Transformed into a tree to escape Apollo's lust, the nymph Daphne sprouts bark and branches that seem to grow before our eyes. Bernini portrays boyish David in midthrow, his body wound like a baseball pitcher's, his arm pulled back, his face grimacing in concentration. The youth's features and taut torso belong to the sculptor, reflected in a mirror reportedly held by Cardinal Maffeo Barberini, who would become his greatest patron as Pope Urban VIII.

·ఌఄ·

AS HE GREW OLDER, Bernini expanded his passion for "girlfriends" to flesh-and-blood beauties and quickly earned a reputation as a "sexual wild man." In the mid-1630s, the sculptor took up with Costanza Bonarelli, the wife of one of the artists in his *bottega,* described by a biographer as "a lusty, independent-minded strong-willed woman capable of matching his passion and ardor."

Bernini carved a bust of his lover with her full lips parted, hair tousled, and dress rumpled. A critic described it as "a petrified figment of passion." More than a century would pass before artists would again depict a woman in the throes of such sexual heat.

Bernini's passion blazed to red-hot fury when he discovered that Costanza was also sleeping with his brother. When he spied them kissing, he chased his sibling through the streets of Rome with sword in hand, beat him unconscious, and broke his ribs. The hot-blooded artist paid a servant to slash Costanza's face (a Roman mark of shame for faithless lovers). Her marble bust remained untouched.

Bernini's distraught mother wrote to Pope Urban VIII, pleading with him to corral her volatile son, who believed "that anything he chooses to do is perfectly legitimate, as if over him there were neither masters nor law." Bernini paid a large fine. His henchman was exiled. His brother left Rome for more than a year. The pontiff strongly "suggested" that the sculptor find a wife.

And so, at age forty, Bernini wed a fetching twenty-one-year-old named Caterina, daughter of a respectable family—so perfect, he told the pope, that he could not have "created a better one on his own, had he been able to cut her out of wax." Caterina bore him eleven children in a marriage that lasted for more than three decades.

During his twenty-one-year pontificate, Urban VIII presented Bernini not simply with accolades, but with the Eternal City itself to use as a canvas. "You were made for Rome," he told his "impresario supreme," overseer of art, buildings, fountains, and public works, "and Rome was made for you."

When the pope ordered Bernini to refine his painting skills, he adroitly produced more than 150 works. Directed to master architecture and urban planning, Bernini assembled a small army of subcontractors and transformed the landscape of central Rome. To fill the vast emptiness of St. Peter's Basilica, he combined sculpture and architecture to create the *baldacchino,* a massive bronze canopy that spirals above its high altar. For the adjacent piazza, Bernini created a semicircular colonnade that literally and symbolically wraps the arms of the Catholic Church around the faithful.

With a passion flaring into obsession, Bernini hounded his workers, who trembled in fear of his fury. His glance alone, according to his son, "could instill terror." Yet Bernini drove himself hardest of all. Describing his commitment to a project, he quoted Michelangelo: "I shit blood when I work." His son more poetically described his father as entering "a state of ecstasy, as if he were sending out through his eyes his own spirit in order to give life to his blocks of stone."

AFTER NONSTOP ARTISTIC AND ARCHITECTURAL triumphs, Bernini suffered a humiliating public failure in 1636. A bell tower he had created for St. Peter's developed cracks that some feared might trigger the collapse of the entire facade. Bernini's enemies accused him of jeopardizing Catholicism's Mother Church. His financial assets were seized; he lost major commissions. The devastated artist took to his bed and stopped eating, starving himself almost to the point of death.

But another woman in ecstasy revived his career: Santa Teresa, the founder of the Discalced (shoeless) Carmelite sisters. In 1647, the patriarch of the Cornaro family commissioned Bernini to sculpt her statue for a private chapel in Rome's Church of Santa Maria della Vittoria. Teresa, a stout middle-aged nun plagued with disfiguring maladies, had described mystical unions with God that induced periods of levitation, when she appeared to float in midair.

Bernini captures one such gravity-defying moment, but with considerable artistic license. In his sculpture, a radiant young woman, pierced by the arrow of divine love, trembles in ecstatic response to "the sweetest caressing of the soul by God." Light from a hidden window illuminates her alabaster body—eyes closed, mouth open, arms outspread, a naked foot dangling from beneath the swirling drapery.

The sculptor had done the unthinkable. In the words of one of his contemporaries, he "put a scene of explicit sex inside a church." Critics accused him of creating "an astounding peep show" and transforming the saint into "a Venus who was not only prostrate but prostituted as well."

To modern visitors, the statue seems, as one put it, "almost porn," with Teresa clearly enraptured by a carnal experience. Bernini's defenders argue that the Baroque era unleashed such potent religious passions that physical and spiritual, sacred and profane, melded into one.

BERNINI'S BEST-KNOWN WORK may be his glorious Fountain of the Four Rivers, the centerpiece of Rome's Piazza Navona, designed in 1651. To win the commission from Pope Innocent X, according to an anecdote become legend, Bernini fashioned a small silver model of his design and hung it on a chain carefully calculated to fall between the breasts of a papal favorite during a formal din-

ner. Captivated by the bauble, the pontiff asked to see a larger version. "Anyone who does not want to use Bernini's designs," he concluded, "must simply keep from ever setting his eyes on them."

When the pontiff came to inspect the work in progress, Bernini couldn't resist a prank: After telling the disappointed pope that the pipes weren't ready, he waited until Innocent X had turned to go before signaling his workers to turn on the water full blast. At the sound of gushing streams, the pope turned around in childlike delight. "You have added years to our life!" he shouted to Bernini.

Bernini remained physically and mentally vigorous until 1680, when a series of strokes left his right arm paralyzed. The octogenarian consoled his children that it was only fair to rest an arm that had worked so very hard during its long life—a life that transformed the visual arts in all of Europe.

MY FAVORITE BERNINI SCULPTURES may be the least visited of his works. I came upon them by chance when I rented the apartment kitty-corner from his palazzo and across the street from the Church of Sant'Andrea delle Fratte, literally out in the thrushes when it was built in the seventeenth century.

Inside this architectural gem, two gleaming white angels, standing on either side of the front altar, looked down on me with expressions that seemed hauntingly familiar. One held the crown of thorns placed on Jesus's head; the other, the mocking inscription identifying him as "King of the Jews." I was certain that I had seen them before.

In fact, I had seen copies—along with eight other angels on the bridge that crosses the Tiber to the Castel Sant'Angelo. This formidable fortress, built in the second century AD, served as a tomb for the emperor Hadrian, a military garrison, and a refuge for popes. According to legend, the archangel Michael appeared atop

its tower in 590, sheathing his sword as a sign of the end of a plague that had devastated Rome.

In 1668, Pope Clement IX commissioned Bernini to adorn the bridge with ten grieving angels, each holding a symbol of Christ's Passion. Assistants carved eight of the figures, but the only two statues sculpted by Bernini himself never took their designated places. Copies by lesser artists were installed instead.

How did the "missing" angels end up in Sant'Andrea delle Fratte? The pope, enthralled by the angels' delicate beauty, may have wanted them for his private collection. However, he died soon after their completion, and the angels remained in Bernini's workshop. In 1729, almost half a century after Bernini's death, the artist's nephew donated them to the nearby church.

In Sant'Andrea delle Fratte, an oasis from Rome's ceaseless bustle, the pristine angels remain untouched by wind, weather, or pollution. To me, they embody the "aliveness" of Bernini and the Baroque. Their marble bodies seem to sway ever so gently. Their feathered wings almost flutter. Their lush curls look as if they would be soft to the touch. On their gentle faces, their eyes seem knowing; their mouths curve ever so slightly upward. Created by a man of passion in an age of passion, they honor the sacred as they hint, ever so slyly, at the profane.

8

FATTO A MANO [MADE BY HAND]

I n the early fifteenth century, a Venetian sailor wanted to bring his fiancée a souvenir of his exotic voyages. Too poor to afford a proper gift, he plucked a ruffled sea plant called *Halimeda opuntia* from the waters off Greece and carried it home to the island of Burano in the Venice lagoon.

His beloved, enchanted by the algae's scalloped edges and raised furls, fretted that the memento would soon disintegrate. Determined to create something that would last as long as their love, she picked up a needle used to mend fishing nets. Plying white thread into intricate patterns, she replicated the delicate whorls. The stunning result was "mermaid's lace," an ingenious design that helped launch Burano's lace-making industry.

With this tale in *A Beautiful Woman in Venice*, Kathleen Gonzalez, a sister *appassionata*, tugged me into a world woven of fiber, air, and passion. For centuries, Venetian lace, gossamer as a spider's

web, represented absolute luxury. A single piece required weeks or months of eye-straining labor. Yet other than accenting regal robes, adorning ladies' bosoms, or trimming clerical vestments, it served no practical function. Like the filigreed glass from its sister island of Murano, no one needed Burano's lace—but everyone wanted it.

The price for spun-sugar works of wearable art skyrocketed so high that Venice's rulers, fearing that a lust for lace would bankrupt its stylish citizens, issued sumptuary laws limiting its use on cuffs, collars, or gowns. Unencumbered by such restraints, wealthy customers in other nations bought Venetian lace by the bolt. For his coronation, Louis XIV commissioned a collar that took two years to stitch and cost hundreds of times its weight in gold.

Burano prospered, sparkling as brightly as its vibrantly painted houses and fishing boats. In 1755, as many as 40 percent of the island's women were making lace, bending over pillows that cushioned their needlework as they worked. More women on the Venice lagoon—spinsters, widows, nuns, abandoned wives, retired courtesans—took up their needles to weave new lives for themselves. As the industrious lace makers earned money for dowries, parish priests reported a surge in marriages and a drop in babies born out of wedlock.

The opulent age of lace and luxury ended with the political upheavals that overthrew the French monarchy in the 1790s and rocked Europe for decades. With family fortunes lost, the formerly rich could no longer afford their cherished frills. The market for Venice's delicate handiwork all but disappeared.

THEN CAME THE DISASTROUS WINTER of 1871. Temperatures plummeted so low that the lagoon froze over. With their boats trapped in ice, Burano's fishermen couldn't leave the harbor. Without a daily catch, its residents began to starve. Italians in the recently

unified nation organized benefits to raise money for desperately needed supplies.

The islanders survived the deep freeze, but Italy's Parliament sought a long-term solution for their precarious finances. The brightest hope seemed Burano's famed needlework, but the lace industry had become, as one observer put it, "a very dead Lazarus."

A countess and a princess, with the backing of Italy's recently crowned Queen Margherita, headed a campaign to resurrect it. Ultimately Burano's fate rested on its last lace maker, an illiterate septuagenarian known as Cencia Scarpariola. Although she could not write her own name, Cencia was a living encyclopedia of knots, twirls, loops, and patterns—secrets in danger of dying with her.

The mistress of the girls' school in Burano became Cencia's sole apprentice. Under the old woman's tutelage, the teacher-turned-student mastered every detail of the painstaking process of weaving a fantasy in thread. In 1872, the Scuola dei Merletti (Embroidery School) of Burano, housed in the former governor's palazzo, admitted its first eight students. Stitch by stitch, its passionate lace makers brought the island back to life.

By the turn of the twentieth century, 350 women were working six hours a day—seven in summer's light—in white aprons and oversleeves to keep their work clean. The industry survived two world wars and a global depression. But it could not withstand a flood of cheap imported lace in the 1960s.

The Burano lace-making school closed, only to reopen in 1981. The island inaugurated a lace museum in 2011. Although far fewer locals make their living from lace, tourists throng the island's shops to take home with them, like the long-ago Venetian sailor, a delicate memento of the marvels they have seen.

WHEN SHE WAS SEVEN, Gloria d'Este, a daughter and granddaughter of Burano lace makers, received her first embroidery hoop as a present from her mother and happily spent hours mastering stitches and techniques. When the island could not offer her a career, Gloria found another place in the world of *il filo* (the thread), as a weaver at Tessitura Luigi Bevilacqua, the last traditional textile maker in Venice. Its luxury fabrics hang in the Vatican, royal palaces, museums, and halls of governments around the world.

When we meet in a converted silk mill in Venice's Santa Croce district, Gloria walks me back in time. Here the forefathers of the Bevilacqua family rescued fifteen hand-operated looms after Napoleon shut down the industry to eliminate competition for French workers. Each is almost the size of a piano, with thousands of taut threads suspended in air, their arrangement so intricate that it can take weeks or months to set up a new pattern. Sample books, stacked on floor-to-ceiling shelves, contain more than 3,500 unique designs in the form of "cartoons," similar to the punch cards of early computers.

The workspace, dark and dank, defies every principle of modern ergonomics. Weavers hunch over looms, repeating the same muscle-wearying motions thousands of times a day. With one hand, they pull a heavy wooden lever while the other zips a shuttlecock across the threads. Constantly scanning for a broken thread or missed stitch, they control the rhythm with a hard thrust of the right leg on a foot pedal. For complex patterns in velvet, damask, or brocade, they work at the slower-than-snail's pace of four inches a day.

Bevilacqua also operates a modern textile factory on the "mainland" with automated looms that churn out reams of textiles for export in a fraction of the time. So why do weavers like Gloria dedicate months, even years, to a single commission?

Not for the money, since wages are no higher than at the mod-

ern plant. Gloria prizes the link to all her predecessors who wove their stories into a galaxy of stitches. And the process itself appeals: The threads feel alive, changing when Venice turns cold or warm, wet or dry. So in tune are weavers with their looms that they can predict *acqua alta* (high water) in Piazza San Marco by the way the wood begins to squeak in the changing humidity. One woman tells me that she talks to her loom—cajoling, praising, chiding, occasionally cursing.

Beyond these reasons are pride in crafting something of beauty every day and passion for a great tradition that existed long before and will continue long after. Although machines can mass-produce similar fabrics, they cannot replicate all the stitches or impart the softness and sheen of handwoven cloth.

"Even though the pattern is set, the final product depends on what I see, what I feel," says Gloria. "After months of working on a piece, I almost hate to let it go, because I've lived with it so long that it's become part of me."

FOR MUCH OF ITALY'S HISTORY, artists and artisans, possessed by the same passion to create with their hands, were equals, without words to distinguish between them. In the Middle Ages, *arte* meant "guild," a collection of specialists in a certain field. The seven major *arti* included judges, notaries, cloth weavers, money changers, wool and silk merchants, furriers, and physicians and apothecaries (painters belonged to this group). The fourteen minor guilds encompassed butchers, shoemakers, innkeepers, bakers, and such. Those who literally got their hands dirty—sculptors, blacksmiths, stonemasons, wood-carvers—worked as laborers for low pay and little, if any, recognition.

To prepare for the creative trades, young boys (no girls allowed) trained in a *bottega*, a small art factory that turned out everything

from paintings and statues to gilded baskets, wedding chests, coats of arms, *candelabri,* and church bells. Under the scrutiny of a sharp-eyed maestro, apprentices learned a full range of technical skills: how to whittle a pen from a goose quill, carve wood, hammer metal, grind stone, mold plaster, chisel marble, sculpt clay, select dyes, and mix paints.

Even acclaimed Renaissance artists crafted objects for daily use as well as masterpieces. Michelangelo fashioned an inkwell for the Duke of Urbino and designed reading desks for the Medici library. Leonardo sketched a warping machine; a model based on his design remains in use at the Antico Setificio, the antique silk factory, in Florence. Botticelli's elaborate *intarsio* (inlaid wood) adorns Urbino's Palazzo Ducale. Cellini hammered a saltcellar of gold, ivory, and enamel for the table of the French king Francis I.

What set such marvels of workmanship apart from works of art was their function. Unlike paintings and statues created to inspire faith, recount mythological deeds, or glorify a ruler, they served practical purposes. But in their never-ending passion for beauty, Italian artisans elevated even utilitarian items to a higher aesthetic plane.

CONSIDER THE EVER-SO-HUMBLE PLATE. Gold and silver platters once gleamed on the tables of privileged Etruscans and Romans. In more modest homes, family members served themselves with fingers and rudimentary spoons from a communal platter. In the Middle Ages, terra-cotta or "cooked earth" plates, baked from clay in village kilns, replaced crude metal dishes.

In the thirteenth century, an Arabian technique for glazing rough clay with gleaming white enamel made its way, via the Spanish island of Majorca, to Italy. The Umbrian town of Deruta, with rich clay lining its riverbanks and plentiful brush to fire the hungry

kilns, embellished *maiolica* (majolica) with colorful designs baked into the glaze during a second firing. By the fourteenth century, Deruta, crammed with busy potters, was paying its taxes in vases and shipping a thousand plates in a single order to nearby Assisi, deluged with pilgrims to the shrine of San Francesco.

The Renaissance brought new inspiration to Italy's ceramicists. Fascinated by classical art, the painter Raphael had himself lowered into excavations, called *grotte,* in Rome. He replicated "grotesque" images of flowers, plants, animals, and whimsical shapes in the papal chambers within the Vatican. When copies circulated throughout Italy, Deruta's potters quickly adapted the colorful designs into the *"raffaellesco"* patterns that remain popular to this day.

About forty miles away, in the mountainside village of Gubbio, a potter named Mastro Giorgio Andreoli (ca. 1465–1555) became intrigued with another Arabian form of alchemy that turned clay plates into gold—or at least made them shimmer like the precious metal. The key was a "third firing" of an already twice-baked ceramic in a specially constructed oven called a *muffola* that produced an intensely smoky blaze.

If the fire was neither too hot nor too cool and burned just long enough, the carbon in the smoke combined with salts in the metallic pigments to form a thin coating that, with vigorous polishing, imparted a gleaming sheen. Noble families immediately clamored for this *lustro* (luster), and potters throughout Italy sent their best pieces to Mastro Giorgio for his finishing touch.

In the tumultuous centuries that followed the Renaissance, Italy became a battleground for warring nations. The *muffola* ovens were abandoned. The secrets of *lustro* died with its masters. But the Italian passion for beauty in all its radiant glory did not.

WHEN ITALY EMERGED as an independent state in 1861, its artists and artisans recognized that the new nation, long divided and dominated by foreign states, needed a unifying cultural foundation. A movement, called Cinquecentismo (from *cinquecento*—the five hundreds—which translates as "the 1500s" in English), looked to the Renaissance for inspiration.

Paolo Rubboli (1838–1890), descended from generations of ceramicists, found a treasure in his family's workshop—a book, written in 1583, that described, step by step, the technique for producing *lustro* ceramics. He was convinced that he could re-create this dazzling finish—if he could build a specialized *muffola* oven. But this would require the support of an entire village. He found it in postcard-pretty Gualdo Tadino near the mountainous border between Umbria and Marche.

"It wasn't just about art," Maurizio Tittarelli Rubboli says as he shows me the letter his great-grandfather wrote to the village's governing council. "It was about bringing back to life an art that would bring glory to the new nation."

Even though it had no ceramic traditions of its own, Gualdo Tadino welcomed Paolo and his wife, Daria, also an accomplished ceramicist. In the 1880s, they constructed a specialized *muffola* oven and, through endless hours of trial and error, mastered the painstaking *lustro* technique. Gualdo Tadino gained such renown for "the miracle of iridescence" that dozens of potters moved to the village to set up their own kilns, gain access to the Rubboli *muffola*, and add a "blaze of glory" to their works.

When Paolo died unexpectedly at age fifty-two, many artisans wanted to move the *lustro* oven to another town. But Daria refused and continued her husband's tradition for thirty years, expanding its range to tea services and *belle donne* vases painted with pretty women.

"Think of her passion!" says Maurizio, a soft-spoken and

thoughtful artisan and teacher, with blackberry eyes that sparkle in admiration. "She was a woman with three young children, on her own and running a business in a remote mountain village."

In 1889, Daria submitted several works to a major design exposition—and won the top prize. The certificate, which Maurizio proudly displays, is made out to "Signor Dario," rather than "Signora Daria," because the judges didn't believe a woman could produce such work. An art catalog from the time lauded her as *"La maestra"* (the mistress) of the third firing.

At its peak in the 1920s, some sixty ceramicists filled the Rubboli studio, working upstairs and down and spilling outside in the summer months. As Gualdo Tadino ceramics gained international recognition, the village prospered—until the devastation of the Second World War and the collapse of Italy's economy.

"My uncles and their daughters made beautiful works with the highest level of craftsmanship, but there was no market for them," says Maurizio. In 1955, they were forced to close the business. Their studio, the Fabbrica Rubboli, fell into ruin, the old kiln built by his great-grandparents abandoned, their molds and tools heaped in corners.

YET THEIR PASSION LIVED ON. Maurizio, a prizewinning ceramicist featured in the prestigious *Il libro d'oro dell'eccellenza artigiana italiana* (*The Golden Book of Italian Artisanal Excellence*), was determined not to let his family's legacy fade away. "I became a ceramicist for reasons tied to my past and my family, but also to this art, however intense and exhausting it may be," he says. After working tirelessly to raise the needed funds, he opened the doors of the restored Museo Opificio Rubboli in 2015.

As we walk through its gracious rooms, Maurizio shows me a self-portrait of his great-grandfather Paolo, with classic features

similar to his own portrayed on a glazed plate. I marvel at bowls, platters, pitchers, cups, vases, and jewelry boxes from the last hundred years. Then we enter the soot-blackened chamber that houses the *muffola,* the last remaining oven of its type in the world.

Maurizio talks me through the steps he follows to re-create his great-grandfather's *difficilissima* technique: Donning baggy, flame-resistant overalls and a mask to protect himself from smoke and burning embers, he places a twice-baked piece of pottery inside the circular oven and ignites bundles of *ginestra* (similar to Scotch broom) to create a smoky fire no hotter than 650 degrees Fahrenheit. Heeding his mother's instruction to always "let the *muffola* breathe," he waits as each batch of twigs burns itself out. With no precise gauge, he relies on experience and periodic peeks through various "spy holes" to determine when the firing is complete. Then he clears the embers, leaves the ceramic in the oven overnight— and waits.

The next morning, Maurizio removes a dark, ash-covered blob and starts polishing. Like Aladdin with his magic lamp, he rubs and rubs until the ceramic glows as if sprinkled with stardust. Although modern methods such as resins can produce shiny finishes, none equals the Rubboli *lustro* that gleams as brightly today as it did centuries ago. A critic, proffering what he undoubtedly thought was high praise, commented that Maurizio's creations are of such extraordinary beauty that "one forgets that they also serve a practical function."

So are they works of fine art or of skilled craftsmanship? I can't imagine eating from one of Maurizio's glistening plates—although I certainly can appreciate the sheer visual delight of looking at one every day. The same question applies to Venice's hand-carved oarlocks, created for gondolas but now mainly purchased as decorations, and Sardinia's engraved shepherd's knives, prized by collectors who've never ventured onto a sheep ranch. Should we evaluate

them on the basis of their functionality or their aesthetic appeal? And what of their creators—are they artisans or artists?

The debate rages on, but I agree with the categorization that San Francesco d'Assisi offered centuries ago: "He who works with his hands is a laborer. He who works with his hands and his head is an artisan. He who works with his hands and his head and his heart is an artist."

This distinction came to life for me in a fifteenth-century palazzo in Perugia that has served as home and studio for five generations of passionate Italians determined to elevate an abandoned craft to the realm of art.

AFTER SOARING TO SPLENDOR in the twelfth and thirteenth centuries, "staining" glass was eclipsed in the Renaissance. While brilliant innovations transformed other arts, glass painters continued to decorate windows with the same techniques passed on by previous generations.

Francesco Moretti (1833–1917), convinced that stained glass could and should rise to the level of true art, broke with tradition. Although you may not know his name, if you've visited the grand churches of Umbria—San Domenico in Perugia, Santa Maria degli Angeli in Assisi, the cathedrals of Orvieto and Todi—and looked up, you've seen windows he either restored or created.

A sculpted bust of the man behind these works greets me in the reception room of Perugia's Museo Laboratorio di Vetrate Artistiche Moretti Caselli. Every inch the Victorian gentleman, Moretti stares intently through rimless pince-nez glasses, one hand stroking his thick, chest-length beard, the other holding a book. If he were to return to life, he could get right back to work in this combination of Geppetto's workshop, chemist's laboratory, and artist's studio.

Jars of pigments, blotched with faded colors, fill the cupboards. Centuries-old books and technical journals cram the shelves. Stacks of sketches, drawings, clippings, and photographs occupy every surface. Mounted on the walls are tools for several trades, all essential for stained glass: a painter's brushes, a smithy's tongs, a sculptor's mallet. Along one wall stands a potter's kiln, used to "bake" the colors in repeated firings.

Beyond the laborious technique, stained glass requires its own special alchemy—the mixing of color and light to bring to life a work that can express itself fully only in a ray of sunshine. By tireless experimenting, Moretti expanded the glass painter's palette from a few basic colors to shades of every hue, as nuanced as Leonardo's oils. With resolute passion, he set out to demonstrate to the world that a true masterpiece could be made with glass and lead, not just with paint and canvas.

MORETTI PROVED HIS PREMISE in 1881 with a single work—not a religious or mythological scene, but an almost life-size depiction of the most important Italian woman of the day: Queen Margherita. At first glance of this portrait in glass, I, like many visitors, assume it must be a painting or even a photograph. The face seems too dynamic, the elaborate gown with its layers of ruffles too detailed, the colors, especially the range of intense blues, too vibrant to be anything else.

Most remarkably, there are almost no visible traces of lead—or so I think until Maddalena Forenza, Moretti's great-grandniece, points out very thin borders tucked under the regent's arms and along her sides. Backlit by the sun, the enameled glass glows with a brilliance no other medium could capture. As Maddalena says quietly, *"La regina vive!"* (The queen lives!).

She calls my attention to a gold bracelet gleaming on the royal

wrist. "It's not possible to paint gold on glass," Maddalena explains, "so Moretti created a base, then added a little yellow, then dots of blue that make a shadow and create gold when the light shines on it." This level of perfection, she notes, marks his *Portrait of Queen Margaret of Savoy* as a true work of art.

Exhibited only three times—in Rome (where the queen herself admired it), Milan, and London—the fragile glass panel has remained in Moretti's studio. "Transporting it is very risky," Maddalena says. "It's like thinking of moving *The Last Supper* from Milan."

Moretti passed on his craft to his nephew, Maddalena's great-grandfather, who instructed his two daughters, who in turn taught the art of glass painting to their niece, her mother. While still in the womb, Maddalena comments with a smile, she absorbed her mother's passion for staining glass. As soon as she grew tall enough to reach a worktable, she began "helping."

Now the primary keeper of the family flame and an accomplished artist in her own right, Maddalena, with finely etched Modigliani features and dark hair spinning into cherub curls, juggles her own commissions, motherhood, and coordination of the efforts to maintain Moretti's legacy.

"There is never enough time," she says, "but the most important thing I want to do is to pass on my family's passion for this art and this place so people understand it, maintain it, and hold it dear."

THE ITALIAN CITY most closely tied to the history of glass—and a passion for it—is Venice, where glassmakers perfected its fragile beauty. Kings wanted Venetian glass for their palaces; bishops and cardinals, for their altars; nobles, for their weddings and banquets. African and Asian countries used Venetian beads for currency.

Columbus reportedly bought safe passage through treacherous waters with the city's prized *rosetta* beads.

On a gray winter morning, I motor in a water taxi to the Venetian island of Murano, home of the Venetian glass furnaces since the thirteenth century. The doge chose this isolated location to protect citizens from fires sparked by the blazing kilns and to safeguard the secrets of the trade, so valuable that revealing them was punishable by death.

In the "piazza," or furnace room, of Seguso Vetri d'Arte, a family enterprise that has been manufacturing glass since 1397, I watch master craftsmen weave wordlessly to and fro like the nimble members of a corps de ballet. Amid clangs, whirs, and a high-pitched shriek, they heat blobs of red-hot glass at the end of long poles, then twirl them into curlicues, threads, leaves, and shells.

"Why glass?" I ask.

"Il vetro è come Venezia" (Glass is like Venice), one of the workers explains, a city surrounded by water, built on sand, with fire in its soul, filled with color and beauty. In glass, these elements come together in splendid equilibrium—the fire balancing the water, the sand mixing with the air.

In the years after Napoleon's conquest and again after each world war, Venice's glass industry seemed doomed, but it always sprang back to life. Although far fewer in number, today's glassmakers display their works in major museums and teach classes throughout the world. Among these modern maestri, one stands apart.

"So you are looking for passion," says my guide Cristina Gregorin, a font of Venetian history and culture, as we duck into a narrow lane off Murano's main street to the workshop of Lucio Bubacco. "Here is Venice's premier erotic glass artist!"

-❦-

IN THE FIRST DIZZYING MOMENTS inside Bubacco's studio, I feel that I have been transported into Casanova's psyche. Everywhere I look—tables, shelves, walls, ceiling—I see vibrant colors, delicate forms, astounding complexity. Clutching my purse to avert any collisions, I realize that I am surrounded by glass variations of Venetian nudes.

Unlike Titian's reclining goddesses, Bubacco's uninhibited men and women—many just a few inches tall—dance, leap, and pirouette, heads flung back, legs floating in air, arms outstretched ecstatically. Some sprout devil ears, tails, and pitchforks; others flutter with angel wings and halos. Revelers grasp goblets of wine with tiny crystal drops splashing from the rim. An openmouthed swan's head tops the torso of a bosomy woman. These fantastical creatures exude a carnal energy, a dynamism that flows from within. This, I realize, is Bubacco's genius: he has breathed sensual passion into glass.

Burly and broad-shouldered, with gray hair slicked back, eyeglasses dangling on a cord around his neck, and a ready laugh, Bubacco tells me that he became a glassmaker like his father *"per caso"* (by chance). Every exquisite cornice or column he saw as a boy rowing in the lagoon, every story he read in Dante and Boccaccio, every exuberant Etruscan wall painting he studied was seared into his imagination. To transmute these visions into tangible forms, he had to develop entirely new ways of working with "soft" glass.

Rather than the roaring oven in the "piazza," Bubacco uses a lamp worker's handheld torch, pincers, scissors, and other simple tools. At his workbench, he deftly wields a 1,500-degree flame to melt a gob of red-hot glass into a torso.

"You have to tame the glass as if it were an animal," he explains. "You control it with the flame and take it where you want it to go." With deft turns of glowing glass, thighs lengthen into legs. Arms stretch outward. Breasts sprout. Buttocks curve into

apple roundness. With a few snips of the pincer, hands extend into graceful fingers. A shapeless mound turns into a head with a pert nose, full lips, and a beaded necklace. The entire process seems organic, as if energy is flowing directly from artist to flame to figure, from the rhythmic act of creation to the work itself.

Despite his international success, Bubacco bristles at those who dismiss his florid style as overly graphic (some say pornographic), kitsch, or craft. "I could earn much more money making abstract forms in glass, but I do not do this for money. I have to do this to express what is inside me, to make real the visions that are inside my head."

"So you do it for passion?" I ask.

"Certo," he replies. "I want the people who see my art to have a real encounter—to touch it, caress it, understand the shapes and movements. I want them to experience what I feel for my art: passion and love."

That evening, at dinner at Ristorante da Ivo, tucked into Venice's warren of waterways, I recognize a familiar object displayed under a spotlight. An unmistakable Lucio Bubacco glass sculpture, radiant in shades of blue and white, captures the ebullience of dancers—naked, of course—frolicking in uninhibited delight. Walking into the night, I feel the same energy in the Carnevale revelers who twirl around me in capes and masks.

AS I'VE WATCHED MAESTRI of glass, clay, silk, and other media work, I've come to think of them as Italy's unsung cultural heroes. Spending time in their studios has changed my view of the world. As if borrowing their eyes, I now look at the simplest things—a slab of wood, a clump of clay, a skein of thread—and see new possibilities.

"It's a labor of love," says Francesca Trubbianelli, a jeweler in Assisi, who shows me drawers of leaves and jars of pebbles she col-

lects in the nearby woods as inspiration for her creations. "Each piece is unique, with its own character, smell, organic makeup. It's gratifying to touch the things of the earth and feel them take on new life in my hands."

In the Museo Atelier Giuditta Brozzetti, in Perugia's repurposed Church of San Francesco delle Donne, Marta Cucchia, a fourth-generation weaver, sits at an antique loom like a virtuoso at a piano, working the lever and threads like a keyboard.

"A passion? Yes—but more," she says in response to my question. "Work like this is about identity, about our role in the universe. Crafts are part of Italy's patrimony. If we lose them, we lose part of our soul."

I think of Italian souls whenever I see or touch the many objects made by Italian hands in our California home, each imbued with memories: a polished black-and-tan marble globe from a windswept mountain above Carrara. A lighter-than-air necklace of clear glass beads fashioned by Susanna and Marina Sent, daughters of a Venetian glassblower. A collection of inlaid wooden boxes from the Italian lakes. A ceramic trinket from a young woman whose mother created classic Deruta designs. Obsidian earrings from the Aeolian islands.

A recent gift, an exquisite hand-printed book with sketches of the flora of Tuscany, takes me back to a hillside in the Val d'Orcia where I spent a day with a true Renaissance man. A chemist by training, Annibale Parisi has expressed his artistic passions in paintings, collages, sculptures, pipes of wood and cork, and entire rooms of furniture. In his home library, a sculpted wooden "tree" covers a wall with branches holding hand-carved "books" that open—like Joseph Cornell boxes—to reveal leaves, nuts, seeds, nests, and bark from particular trees.

Annibale's latest passion combines art and wine. For each of the five thousand bottles of Brunello wines produced every year

by his NostraVita winery in Montalcino, he hand-paints a unique label. As I watch, he grasps a brush to create an abstract image in four symbolic colors, explaining the meaning of each as he works: ruddy brown, for the earth; black, for working and "getting your hands dirty"; shimmering white, for the illumination of the sun; and deep red, for passion. And this, he reminds me, regardless of what one makes, is always the most crucial element of all.

I think of the phrase *il filo rosso,* which Italians use for "the red thread" that pulls together many different things with a unifying theme. This is indeed what the artisanal form of *la passione italiana* does. Italy's craftspeople reach back to the past to preserve ancient traditions, enrich the present with their creations, and light the way to the future with their innovations, all in the oldest of ways— with their hands.

9

THE FLAVORS
OF ITALY

I n a small culinary *laboratorio* in the Umbrian village of Sant'Enea, I bite into a candy as elegantly crafted as a jewel. The chocolate glazing—not too sweet, not at all bitter—feels almost buttery on my lips. With a crunch into its center, delectable flavors—cacao, hazelnut, a luscious cream—cascade into my mouth. Every taste bud thrills to attention. Waves of delight ripple along my tongue. The pleasure centers in my brain exult. In utter amazement, I gaze at the creator of this divine morsel.

Luisa Spagnoli beams.

"What's inside?" I ask.

"Tutto," she answers. Everything: A passion passed from generation to generation over a hundred years of making chocolate. Every challenge her family faced. Every lesson her father, a tough taskmaster, taught her. Every memory of her great-grandmother, the celebrated Luisa Spagnoli (1877–1935) for whom she was named,

a woman who brimmed with passion for her sublime confections, her progressive ideas, her children—and the man she defied all conventions to love.

I "meet" this iconic woman, known throughout Italy for the Perugina chocolates she created and the clothing stores that bear her name, in an oversize album of faded black-and-white photographs. Sitting next to me on a couch in her sunlit home, her great-granddaughter turns its pages and transports me back to the Perugia where Luisa Sargentini was born in the late nineteenth century.

LUISA'S FATHER DIED before her first birthday, and her mother struggled to care for her and her two older brothers. By age thirteen, Luisa, who never went to school to learn to read and write, was working as a tailor's apprentice, sewing buttons and stitching hems.

As Maria Putti and Roberta Ricca recount in their biography, *La signora dei Baci* (The Lady of the Kisses), Luisa met her first love at a Sunday afternoon concert in Perugia. The dark-eyed beauty noticed a clarinetist in a visiting band who had clearly noticed her. In 1898, Luisa married Annibale Spagnoli and, in the next seven years, gave birth to three sons and a daughter (who lived for only about a year).

In 1907, Luisa and Annibale invested their savings in La Perugina, a small store where an elderly *confettiere* taught Luisa the secrets of creating mouthwatering chocolate confections. As the business grew, Luisa and Annibale brought in partners, including Francesco Buitoni, head of a successful large pasta company. When the chocolate factory ran into difficulties, Francesco's son Giovanni (1891–1979) became more involved in day-to-day operations. The brash eighteen-year-old struck Luisa, fourteen years his senior, as a cocky upstart; he chafed at accepting a woman as his equal.

The outbreak of World War I conscripted Italy's able-bodied men—including Annibale and Giovanni—into service. Rather than shut down, Luisa, in an unheard-of move, hired local women to do the jobs of their husbands, fathers, and brothers. Because many had small children, she set up a "lactation room" for breast-feeding and a prototypical on-site day care center. With the war's end, Luisa resisted pressure to lay off her female employees. Instead, she expanded the business to offer jobs to both sexes and advocated greater rights for all workers.

When Giovanni Buitoni returned to Perugia in 1918, the tall, self-assured twenty-seven-year-old seemed far more mature—and such a *bell'uomo* that the female workers giggled and blushed when he walked by. Something changed between Luisa and him. According to her biographers, for the first time, Giovanni addressed her with the informal *"tu"* and, when they were alone, called her *"dolce Luisa"* (sweet Luisa).

On a trip to Paris to inspect a chocolate plant, Giovanni blurted out a heartfelt confession: he had loved Luisa, the only woman he ever wanted, for years but didn't dare say anything because she was married and had a family. His words melted her heart. Back in Perugia, the lovers kept their romance secret, but Luisa's passion exploded in a burst of creativity. Over the next few years, she introduced an array of new silky chocolate temptations—from pralines to caramels to coffee truffles.

After extensive experimentation, Luisa found a way to release the natural oil of hazelnuts into a creamy mix, which she smoothed around a whole nut, coated with chocolate, and wrapped in paper. The resulting candy—bigger than a typical *cioccolatino*—looked like a fist, curled as if to strike. But what to call it? Some suggested *cazzotto,* for "punch," but the word seemed too *brutta* (ugly) for something so *bella*.

According to family lore, Luisa and Giovanni, clandestine

lovers, sometimes hid amorous love notes inside the wrappers. When workers discovered the tender missives, everyone applauded them as a brilliant marketing touch, inspiring a more enticing name for the new candy. Il Bacio (the Kiss) debuted officially in 1922—a scrumptious treat with a sweet message tucked inside that gave new meaning to the request *"Un bacio, per favore!"* (A kiss, please!).

Despite the lovers' attempts to conceal their relationship, rumors inevitably spread—especially after Annibale and Luisa quietly separated in 1924. But the business grew into a bustling enterprise with hundreds of employees. Mussolini himself paid a visit. A photograph in the family album shows an exultant Il Duce giving the stiff-armed Fascist salute as Luisa and Giovanni stand nearby.

EVER ADVENTUROUS, Luisa became the fourth woman in Italy to obtain a driver's license. Her creative passion found a new outlet when she began breeding long-haired Angora rabbits at her country villa to use their silky hair as an inexpensive alternative to cashmere. Although she envisioned an entire industry built around angora clothing, Luisa didn't live to see its fulfillment. (Her descendants did, though, shepherding the Luisa Spagnoli brand into a thriving international franchise.)

At age fifty-eight, plagued by a chronic sore throat and cough, Luisa learned that she had advanced throat cancer. Despite surgery at a specialized clinic in Nice, her health deteriorated rapidly. Giovanni took Luisa to Paris for an experimental treatment, but she died there, with her lover at her side, on September 21, 1935.

In the final scene of a heart-strumming television movie of Luisa's life produced by Italy's RAI channel in 2016, the music from

the final act of Puccini's *La bohème* surges as Luisa and Giovanni share a last embrace. As I streamed the film alone in Rome, tears trickled down my cheeks.

Luisa's heirs oversaw the Perugina business until the 1980s, when they sold it to an Italian financier, who in turn sold it to the international conglomerate Nestlé in 1989. The family's passion for chocolate passed to Luisa's grandson Gianni and to the daughter he named for his *nonna*.

"My father refused to teach me his grandmother's recipes and insisted that I study music, which I did," the contemporary Luisa Spagnoli tells me. But her passion to make chocolate, as if embedded in her very soul, never wavered. Finally, when she put on the uniform and hat of a Perugina factory worker to demonstrate her resolve, her father relented.

"By that time I was married and pregnant. So there I was with my big belly in the kitchen. And my father was such a demanding teacher! Every *cioccolatino* had to be perfect, arranged in perfect rows. It took a long, long time before he finally tasted what I had made and said, 'These are good.'"

Her artisanal boutique, Spagnoli Confiserie du Chocolat, sells chocolates made entirely by hand, without any machinery. A mother of five, Luisa has turned down lucrative offers for expanding production and marketing her confections.

"I do not make chocolates for money," she says. "I make them because I must." She pauses as I linger over another bite of bliss and smiles. "You cannot sell passion, but you can taste it."

A PASSION FOR FOOD MERITS a precise word in Italian: *golosità* (from *gola*, for throat), which goes beyond appetite, craving, gluttony, or hunger. Friends proudly declare themselves *"golosi,"* often for a dish

made only in their hometowns, only with local ingredients, only with a recipe handed down from a great-grandmother to a grandmother to a mother.

Michelangelo was *goloso* for a favorite of the stonecutters of Carrara called *lardo,* the subcutaneous fat layer of a pig's abdomen—salted, aromatized, spiced, aged in marble for six to twelve months, and melted over hot bread. The composer Gioacchino Rossini, the sophisticated gourmand you will meet in chapter 11, inspired—and enthusiastically consumed—various recipes *alla Rossini,* such as cannelloni made with a rich mix of veal, butter, cream, béchamel, and Parmesan. "Appetite is to the stomach," he wrote, "what love is to the heart."

At Camponeschi, our favorite restaurant in Rome (so romantic that its blog is called *Love Affair*), friends linger over each item on the menu, reciting ingredients as tenderly as Don Giovanni reminiscing over the women he loved. Seasonal foods like white truffles are greeted like old friends. When the maître d' Costantino Rossi ignites a flaming brandied dessert at our table, the entire room erupts in applause.

When not preparing or consuming meals, Italians are talking about food—or so it often seems. In decades of eavesdropping, I've listened to Italians, who can taste the sun in Sicilian tomatoes and the wind in Ligurian olive oil, expound on what they are eating, are thinking about eating, have eaten, might eat, will eat, would rather eat, wish they had eaten, or eat only the way *mamma* makes it.

Why does food so enrapture Italians? Quite simply, because it matters—not just nutritionally but historically, culturally, and emotionally. In Italy, eating does more than sustain life: it embellishes daily existence.

Flavors cajole the taste buds. Textures caress the tongue. The soft center of a *pagnotta* (a round loaf of bread) feels like a puff of

cloud in your mouth. The sound of a Florentine *bistecca* sizzling on the grill tingles the ears. The plate itself poses like an edible still life. *"Anche l'occhio vuole la sua parte,"* Italians exclaim. The eye also wants its part, its share of delight.

The primal passions of eros and food, libido and appetite, intertwine like lovers, blurring the border between one carnal desire and another. As a cooking instructor once pointed out to our class, eating induces sensations similar to those of sex. Blood races through the veins. Cheeks turn rosy. A satisfying warmth lingers after we indulge. Not surprisingly, Italy gave rise to the Slow Food movement, which encourages the sensual savoring of authentic flavors.

To Italians who truly appreciate food, "a successful dish is a pleasure superior to erotic bliss," writes Elena Kostioukovitch in *Why Italians Love to Talk About Food,* "a sublime joy that . . . elevates existence to a height beyond which there is nothing more to be desired." No less than the bed, the Italian table serves as a stage for human drama. Here people connect, reveal themselves, share pleasure, satisfy curiosity, experiment, and indulge.

Eating itself can become a sensuous spectacle. The most erotic public act she ever witnessed, a friend recounts, was a Venetian man guzzling oysters, with darting tongue, noisy sucking sounds, and juice dripping from his lips. Casanova reportedly enjoyed licking the mollusks from a woman's breasts. For those who prefer a non-X-rated example, think of Disney's Lady and her Tramp, slurping their way to a first kiss from opposite ends of a strand of spaghetti.

ITALY'S CULINARY SEDUCTION STARTED millennia ago. In an empire that had conquered some thirty countries, exotic foods and cooks to prepare them made their way into Roman kitchens—artichokes from Africa, cherries from Asia, pistachios from Syria, dates from

Egypt. Nero and other patricians enjoyed flavored snow from nearby mountains—a precursor of gelato. Julius Caesar once attended a repast with the Vestal Virgins that included—just as appetizers—mussels, asparagus, oysters, ribs, shellfish, and songbirds.

In the first century AD, a *buongustaio* (gourmand) named Apicius spent a fortune on camel and flamingo tongues, swans, and parrots, washed down with wine scented with rose leaves. Once, he commissioned a ship and sailed to Libya to catch shrimp rumored to be more succulent than any in Rome. They weren't, he concluded after a sampling and headed home. When his extravagance drove him into bankruptcy, Apicius swallowed a lethal dose of poison rather than live without the dishes he craved.

After the empire's fall, hunger stalked the peninsula. Yet rather than extinguishing culinary passion, *la cucina povera* (the cooking of the poor) emerged. Coaxing intense flavors from ingredients scrounged from the earth, Italians made bread out of berries and seeds, brewed soup with roots and herbs, and flavored "fish" stew with rocks from the sea.

Renaissance chefs, like other artists, found inspiration in female beauty. The cooks of Duke Ercole d'Este of Mantua invented the golden eggy noodles called fettuccine as a tribute to his son's blond-tressed bride, the infamous Lucrezia Borgia. The navel of Venus inspired the cardinal of Bologna's cook to fashion tortellini, although local gossip claimed that the beguiling belly button actually belonged to an innkeeper's daughter.

YET NO DISH HAS SEDUCED more people around the world than pizza—and, in Italy, the only pizza worthy of the name comes from Naples. Originally, Neapolitan pizzas were white and topped with garlic, lard, and anchovies. In the 1600s, locals began grow-

ing *pomodori* ("golden apples," or tomatoes) from seeds imported from the New World. Hungry fishermen just back from the sea eagerly devoured flatbread topped with slices of tomato and garlic—the original *pizza marinara* (sailors' pizza).

Pizza quickly won over food lovers from all classes. The Bourbon king Ferdinand I, ruler of Naples in the nineteenth century, would dress in shabby clothes to sneak into a local pizzeria and indulge his passion. A later ruler, Ferdinand II, invited a *pizzaiolo* named Don Domenico Testa to come to his palace and bake pizzas for the ladies of the court. As a tribute he bequeathed to Testa the title Monsieur, usually reserved for the *chefs de cuisine* of royal households. *Monsu,* as the Neapolitans pronounced the honorific, became a nickname for the city's pizza bakers.

One *monsu* created a classic in 1889, on the occasion of King Umberto I and Queen Margherita's visit to the city. When the queen requested a pizza, Raffaele Esposito festooned his creation with green basil, white mozzarella, and red tomatoes, the official colors of Italy's new flag, to make the first *pizza Margherita*. A letter of recognition from the queen's "head of table services" still hangs in the Esposito shop, now the Pizzeria Brandi.

Neither the ingredients nor the recipe for *la vera pizza napolitana* (true Neapolitan pizza) have changed over the centuries. The dough must be made only from flour, yeast, salt, and water, kneaded by fists, allowed to rest, and then formed into balls that pizza makers may spin in the air or "slam" and stretch into a circle. The pizza can be cooked only in a stone-lined, wood-fired oven, heated to a temperature of at least 750 degrees Fahrenheit, with the ingredients melting together in two minutes or less. If done right, the finished product qualifies as a culinary work of art, with a golden center and slightly scorched edges

In 2017, UNESCO honored Naples's *pizzaiuolo* (art of pizza making) as part of the "intangible cultural heritage" of humanity,

not only for its taste and techniques, but also for the social interactions between pizza makers and their customers and the "character of the spectacular" it brings to life. The passion behind the pizza, according to the esteemed judges, merits as much appreciation as the "pie" itself.

WHILE LAUDING THEIR LOCAL SPECIALTIES, Italians urged me to go to Emilia-Romagna, Italy's well-fed "belly," to fully appreciate their country's passion for food. The region's savory reputation extends beyond the kitchen. Emperor Frederick II, the ruler of much of southern Italy and Sicily, engaged in his last desperate clash with papal forces there in 1250. Frederick died of dysentery after the battle. His soldiers retreated, but his legendary harem of three hundred exotic beauties, who had traveled with him, settled in the province. Ever since, the local women have been hailed as the most luscious in Italy—and its prostitutes as the most proficient and highly paid.

Bologna, the region's culinary queen, long ago gained fame as La Grassa (the Fat One) for its lavish abundance. In 1487, the town's ruler celebrated the birth of his son with a feast that included ostrich, meat pies, calves' heads, stewed capons, veal breasts, goat, sausages, pigeons, peacocks cooked and re-dressed in their feathers in the shape of a fan, trays of venison and stewed hares, roast suckling pigs, cheese, pastries, marzipan, and ice cream. A nineteenth-century commentator observed, "One eats more in Bologna in a year than in Venice in two, in Rome in three, in Turin in five, and in Genoa in twenty."

My husband and I arrive in Bologna tired and, appropriately, hungry. The Grand Hotel Majestic quickly takes the edge off our appetites with a tray of *salumi* (cold cuts) that includes half a dozen types of salami. Just as we prepare for a late dinner, our guide Mar-

cello Tori calls to remind us of an early morning departure for a *caseificio,* a cheese processing plant, in Parma.

"I don't see why we have to get up at dawn," I grumble to my husband. "Surely cheese can wait."

As I discover, it can't.

TO EARN OFFICIAL DESIGNATION as Parmigiano-Reggiano, a trademark that dates back to 1612 (although production began in medieval times), this cheese can be produced only in the provinces of Parma, Reggio Emilia, Modena, Bologna, and Mantua and only in a series of precise steps. Every evening, milk from free-range cows fed only on green fodder arrives from local dairy farms. Overnight, the cream rises to the top. In the morning, workers skim it off and add freshly delivered whole milk.

Donning white paper caps and robes, we enter a cavernous hall just as the mixture is being heated in bell-shaped copper cauldrons to a temperature of about 86 degrees Fahrenheit. The *casaro* (cheese maker) stirs in calf rennin and whey from the previous day to trigger fermentation. Within ten or fifteen minutes, the milk curdles.

At this point, the process of cheese making turns unexpectedly physical. The dreamy-eyed *casaro,* his ponytail tucked into a white cap, breaks down the curd with a handheld *spino,* a huge metal whisk with many blades. Then, stirring the mix with a long wooden paddle, he moves rhythmically from side to side, spinning concentric white circles into a dance of curds and whey, as if in tune with a melody only he can hear.

The *casaro* pauses every few minutes to plunge his ungloved hands into the cauldron to check if the curd has broken down into minuscule granules. His eyes drift into space, his attention focused on the sensations at his bare fingertips.

In the next step, the *casaro* turns up the heat to expel excess

water. As we walk in booty-clad feet over a floor wet and white with milk, we can see the cheese clumping together in the bottom of each cauldron. Two men, working in silent unison with large white cloths, heave giant balls weighing about 130 pounds each out of the vats and onto a pulley. The dripping sacks fly over our heads like Halloween ghosts to a long table where they are divided in two and pressed into wooden molds. After a brief rest, the cheese soaks in a solution of water and natural salt for about twenty days.

Climbing upstairs, we enter a gigantic storeroom called a *cattedrale* that can hold 50,000 to 100,000 wheels of cheese. In an incongruous modern touch, robots work continuously to turn the rounds on a regular schedule for periods of one to three years to produce cheese that may be *fresco* (fresh), *vecchio* (old), or *stravecchio* (extra old).

Imagining all this cheese piled into a massive hill, I think of Boccaccio, chronicler of delights, who created a gastronomic fantasy: *il paese di Bengodi* (the land of good and plenty). In this food paradise, he placed a "mountain made entirely of grated Parmesan, on whose slopes were people who spent their time making macaroni and ravioli, which they cooked in chicken broth and then cast to the four winds." A teacher once described the scene as one of the most sensuous in Italian literature. I didn't understand—until now.

"Do you know about *il paese di Bengodi*?" I ask the young woman who offers us samples of cheeses of various ages. (I prefer the one that's neither too old nor too young.)

"Of course," she says, spreading her arms wide. "It's here!"

SHE'S RIGHT. Emilia-Romagna seems a geographic cornucopia of flavors, a foodie heaven where an opulent breakfast buffet segues into a three-course lunch that serves as a prelude to a five-course dinner. In between meals, I find passion even *in mezzo ai prosciutti* (in the

midst of prosciutto hams) at Parma's Salumificio Santo Stefano, which produces some 110,000 prosciutti a year.

"My earliest memories are of playing and doing my homework under the prosciutti," says Stefano Tondelli, who, like his father and grandfather, has mastered centuries-old techniques for transforming a still-bloody pig thigh into the flavorful delicacy prized around the world. "This was the only school I wanted to attend. This was all I wanted to learn."

We follow Stefano through every step: pressing the pig thighs in what looks like a gargantuan *panini* maker; sealing them with a gooey mixture of fat, salt, pepper, and farina; storing them in cold rooms to draw out water from the meat; then waiting months— from a minimum of six to eighteen or longer—while the pig haunches hang from rafters in vast barns with shafts that open to catch the breezes wafting from the mountains in one direction and the sea in the other.

How do you know when a ham is "done"? I ask Stefano, who responds by tapping his nose. The art of prosciutto processing is indeed an ancient one: Even in today's tech-savvy world, it all comes down to a single sense. He shows me thin wooden skewers, inserted into each ham at four precise points. *Il profumo* (the scent) tells inspectors if a ham is up to the high standard required to earn the coveted insignia of a Parma "crown."

When I ask whether he has a passion for prosciutto, Stefano pauses. "This is what I am, what I do, my life. The people who work here are almost another family to me. We put a bit of ourselves into what we make, and when our prosciutto goes into the homes of other families, we become part of their lives. If this is what passion means, my answer is yes."

OF ALL THE FLAVORS Emilia-Romagna offers, one rises above the realm of sustenance to sublime: *aceto balsamico tradizionale* (traditional balsamic vinegar). I first tasted this flavoring when a friend from Modena arrived for dinner with a tiny bottle a quarter filled with a dark liquid. After cutting a chunk of Parmigiano-Reggiano for each of us, he tilted the bottle above my plate. I waited, and waited, and waited. Finally, a few dark pearls emerged, hung on the bottle's lip, and dripped ever so slowly onto the cheese.

"It's worth waiting for," he assured me. "It's been aging for sixty years." It was indeed worthy of anticipation. Rather than the acidic flavor I expected, the syrup tasted rich, smooth, velvety, soothing.

When we arrive at the Acetaia Villa San Donnino in Modena, I ask Davide Lonardi, a third-generation balsamic vinegar producer, why this elixir doesn't taste at all vinegary.

"There's no vinegar in it," he explains. "The only ingredient is *mosto* (must), or cooked grape juice." The misleading name dates back to the Middle Ages, when apothecaries sold *aceto* as a treatment for everything from sore throats to fussy stomachs. Some claimed the tincture could even raise the dead—or, at least, revive victims of the plague.

The process, which has changed little over the centuries, begins with skinning and pressing local grapes—white Trebbiano, red Lambrusco, or a mixture of both. Then the vinegar maker cooks the remaining must very slowly in a vat for twenty-four hours, never letting it boil. Unlike wine, which comes to its fullness in carefully regulated conditions, true *aceto balsamico* matures in lofts and attics that are cold in winter, hot in summer, and damp during rainy seasons.

In the attic of his converted farmhouse, Davide displays rows, called *batterie,* of five barrels, made of mulberry, cherry, or oak for different flavors, arranged from the largest at the top to the smallest at the bottom. The must mingles with a "mother," or starter, from a

previous season, in the biggest barrel. As liquid evaporates, Davide replenishes the level in the smallest barrel from the next-biggest one, repeating this process with every barrel—over and over again for a minimum of twelve years, although longer is better. A committee of experts, relying on their discerning palates in blind tastings, determine if the final product merits designation as an official *aceto balsamico tradizionale di Modena.*

The longest-aged bottles of this liquid gold cost more than rare cognacs. Yet the high price doesn't cover the labor and time the arduous process demands. "That's why passion is the most important ingredient," says Davide. "The last vacation I took was five days in 1995. I have to be here, in my attic with my barrels, working from the heart. This is what makes it different from commercial products that just add flavorings to vinegar."

At the end of our tour, we sample traditional balsamic vinegars of various ages, relishing the richness that time imparts. Then Davide pours a thick *aceto balsamico tradizionale,* twenty-five years old, over a scoop of vanilla gelato. With no idea what to expect, I take a tentative lick. The combination of dark and light, tart and sweet, tepid and cold explodes in my mouth, and I almost laugh in surprised delight.

Davide grins. "This is my passion—the emotion, the tradition coming together to give people a true flavor of Italy, something that can't be found anywhere else in the world."

IN BOLOGNA'S HISTORIC QUADRILATERO MARKET, I find the flavors of Italy displayed in all their taste-tempting glory. In a *salumeria,* an array of pork products—*bondiola, coppa piacentina, cotechino, culatello, lardo di gola,* pancetta, prosciutto, *salama da sugo, salame, speck, zampone di Modena*—dangle from the ceiling, crowd the shelves, and spill out of bins. A *formaggeria* offers cheese from

cows, goats, and sheep; hard and soft; piquant and mild—and one wrapped in cloth and stored for thirty days with living worms burrowed inside.

A pasta emporium sells *pasta secca* (dry pasta) in every shape imaginable: little ears, bells, seashells, flowers, leaves, cones, snails, triangles, spirals, corkscrews, tubes, coils, rods, ribbons, shoelaces, beads, rings, stars, thimbles, butterflies, and cocks' combs, along with the tartly named *lingue di suocera* (twisted mother-in-law tongues) and *strozzapreti* (priest stranglers, rich enough to sate gluttonous clerics before the expensive meat course). The prize jewel of Emilia-Romagna's *pasta fresca* (fresh pasta), *l'ombelico di Venere* (Venus's navel), reigns over mounds of jaunty cappelletti and ravioli.

Overwhelmed by the abundance of options, I ask the clerk which is best.

"You won't find it here, *signora*," she says with a shake of her head. "The best pasta is always made at home."

AND SO IN THE WELCOMING KITCHEN of Raffaella Tori, I learn to make *passatelli,* a classic of Emilia-Romagna's *cucina povera.* Frugal housewives, not letting a crumb go to waste, took stale bread, added eggs and a sprinkle of spices, and rolled the mixture into a dough.

Passatelli translates as "pass through," which is exactly what the pasta does as it goes in one side and comes out the other of a specialized handheld device called a *ferro* (iron) *per passatelli.* Like other once-humble dishes, the pencil-thick strings of *passatelli* have gained culinary stature over time and now appear on Easter and other important eating occasions.

Raffaella starts by combining bread crumbs, finely grated Parmesan, seasonings, and two eggs—maybe one more, if the pasta "wants" it.

"How will I know?"

"It will let you know."

I am not dealing with an inert substance, I realize, but an organic life-form, fully capable of communicating—if only I can interpret its wordless language.

"Look!" Raffaella instructs, and I see that the pasta is becoming firmer. I touch it gingerly, and it bounces back, like a thumbprint on flesh. She presses my palms down on the pasta. I must cook "with my hands," she instructs, to recognize how the dough should feel. But the rhythm of her caressing, pressing, rolling, massaging—how do I master this motion?

"Just start working the dough," she says. "Maybe you will discover something you do not know you knew."

Awkwardly at first, I push forward and back. Then I recall the cheese maker's sensual rhythm and start shifting my weight from foot to foot, moving my entire body. As the dough becomes increasingly pliant under my fingertips, I sense that I am putting something of myself—energy, attention, caring—into the mix as well.

When we add the *passatelli* to boiling broth—not water, Raffaella stresses—I take a wooden spoon and begin to stir. Raffaella slows my too-eager hand.

"Gently, slowly," she advises. "Pasta has a heart. You must be careful not to break it."

That evening as we sit down with Raffaella and her family to eat, drink, and share stories and laughter, we are consuming more than a meal. We eat food that tastes of the sun and the soil, steeped in tradition, flavored with emotion, prepared with patience, and served with love. We are also savoring, whether in a bite of chocolate or a plate of *passatelli,* a secret and subtle ingredient: *la passione italiana.*

GRAPES
OF PASSION

My husband and I own a vine in Umbria. Not a vineyard, but a single vine (row 11, number 18), in Vigna Lorenzo at Monte Vibiano Vecchio. Since centuries before the birth of Christ, grapes have grown in this field, on a hillside that catches every ray of light from dawn to dusk, sheltered from harsh winds, its soil rich and its air pure. As we perch on sun-warmed stones overlooking rows of vines in stately formation, Maria Camilla Fasola Bologna, whose family has lived in the hilltop *castello* for centuries, tells me its story.

More than two thousand years ago, a young widow named Vubia and her two sons cultivated grapes on this hill. In 218 BC, the fearsome Carthaginian general Hannibal crossed the Alps into Italy and pushed south, destroying everything in his path. Rome's legions marched north to confront the invaders, conscripting every

male who could fight along the way. Vubia's teenage sons were forced into service.

At Lake Trasimeno, less than twenty-five miles from Vubia's home, Hannibal's troops charged out of the fog in a surprise attack, pushing the Roman forces into the water. Within hours, thousands of men died—some drowning in their heavy armor, some wounded in hand-to-hand combat. The water of the lake turned red with their blood.

When she heard the terrible news, Vubia ran to her vineyard to pray to Bacchus, the god of wine, vines, and those who tend them.

"If you bring back my children," she pleaded, "I promise to give you the other precious thing that I have, which is the wine from these grapes. I will never sell it again. It will go only to your temple."

For long days and nights, Vubia prayed. Then, on the little road that survives to this day, she saw two figures. Even at a distance she recognized her sons—bloody, dirty, tired, hungry, but alive. She rushed to fold them in her arms.

Vubia kept her vow to Bacchus, built a protective wall with a gate around the vineyard, and consecrated its grapes to the god of wine.

TIME AND AGAIN Italy's turbulent history touched this sacred space. In the third century AD, the two Roman emperors born in Umbria— Gaius Vibius Trebonianus Gallus and his son—cultivated its vines and drank its wine. Through the centuries after the empire's fall, the vineyard survived despite violent clashes that pitted town against town and clan against clan.

In August 1393, local families gathered in the great hall to celebrate the wedding of a young noble named Ruggero and his bride Matilde. After a huge dinner and many toasts with the fine wine

from the hillside vineyard, the guests fell into a deep sleep. In darkest night, a band of mercenaries hired by a rival family attacked.

Amid the clang of swords and the screams of the wounded, Ruggero and Matilde ran to the vineyard. Safe inside its stone walls, they watched as the brigands set fire to the fortress on the hill above them. The stone structure survived—only to be sacked a few years later to rid the area of bandits preying on traders' caravans on the road below.

After Napoleon annexed Umbria to his Kingdom of Italy in the early 1800s, a family with the genial name of Sereni took up residence atop Monte Vibiano. Their *castello,* with terraced lawns, a garden maze, an amphitheater, and a 360-degree view, still towers over the pastoral countryside.

Although they didn't sell their wine commercially, the Sereni family occasionally entered an outstanding vintage in competition. In 1900, two brothers—Vincenzo and Antonio—brought bottles of Monte Vibiano's best wine to the Paris Exposition Universelle. The city buzzed with excitement over the Olympic Games it was hosting, the radiant Eiffel Tower, the moving pictures pioneered by the Lumière brothers—and a remarkable red wine from Umbria. When it won the gold prize among entries from many countries, everyone clamored to learn more about its origins.

Maria Camilla's great-granduncle Vincenzo, a lawyer, a scholar, and an enlightened farmer, recounted the story of the extraordinary grapes that grew in a walled vineyard, "protected like a treasure." Her father, Andrea, once told me of the day he watched as a wide-eyed boy when an American tank rolled up the hill at the end of the Second World War. The family celebrated the joyous liberation with a bottle of wine stashed in the cellar cantina.

In 2000, Andrea and Lorenzo, Maria Camilla's brother and chief executive of Monte Vibiano Vecchio, planted 4,625 new vines, mainly Merlot, in the ancient vineyard. In 2008, the family

launched a "green revolution" and created a carbon-neutral *azienda*, where they grow and process grapes solely with energy derived "from the sun, the purity of the air, and the smiles of our employees." Honoring Vubia's ancient vow, they chose not to sell the wines from Vigna Lorenzo with their other varietals, but to entrust the vineyard to investors like me and my husband.

"I call the owners our gladiators, because they protect our land and our vision," says Maria Camilla. "The mission we share is to keep a little part of the world, blessed by nature and the work of men, safe, with great respect for life—all life."

That evening, we taste the first vintage from the replanted Vigna Lorenzo. Others with trained palates might detect notes of fruits or spices. I taste something profound, deep, alluring. This is a wine to hold on your tongue and let slide into your heart.

"It's not only nature that nourishes grapes," says Maria Camilla. "With this wine, you know you are drinking a nectar, and inside that nectar is the work of all the people involved in making the wine. There is history. There is tradition. There is love for life, for this beautiful place, a love so deep that it becomes a passion."

WINE HAS PULSED LIKE LIFEBLOOD through Italy's long past, its history blending with that of the Mediterranean boot. Greek settlers brought vines to the colony they called Oenotria (land of wine) as early as the ninth century BC. A Sicilian legend claims that vineyards sprang up under the feet of the Greek god Dionysus (Bacchus's counterpart) as he danced along the foothills of Mount Etna.

The Romans named one of their most widely planted grapes Sangiovese, for "blood of Jove" (Jupiter), and exported wine throughout their empire. An archaeological excavation in Israel unearthed twelve Roman amphorae among the ruins of the royal

palace in Jerusalem. Each was marked "I am for Herod, King of Judea."

Young and strong, Roman wine was diluted, often in a three-to-one ratio of water to wine, and seasoned with spices, herbs, rose and lavender essences, and seeds like fennel and cumin. Travelers carried their preferred flavorings to add to the crude wines served in taverns along the way.

Devotees of Bacchus in ancient Rome formed a hedonistic cult that gathered to consume huge quantities of wine, dance by torchlight, and achieve "sexual immortality." When the Bacchanalia grew out of hand, Augustus clamped down on the secret society, but the enthusiasm for wine endured.

Even the humblest *contadini* toted flasks of home-brewed wines to quench their thirst as they worked in the fields. Princes of state and of the Church developed a more sophisticated palate. A twelfth-century bishop traveling to Rome sent a prelate ahead to taste the local wines and indicate the best ones.

Whenever this oenological scout found an impressive wine, he wrote *"Est"* (Latin for "it is") in chalk on the door. In Montefiascone, north of Rome, he found a wine so exceptional that he gave it the equivalent of three stars: *"Est! Est!! Est!!!"* The bishop agreed—and, some claim, settled in the region to imbibe its delicious wine for the rest of his days.

A passion for wine also inspired poets, philosophers, and composers. "We shall, then, sing in native songs," wrote Virgil, "our debt of praise to Bacchus." In a spirited ode called "Bacchus in Tuscany," Francesco Redi, a seventeenth-century enthusiast, exclaimed, "Wine, wine is your only drink!" Raising his glass for the rousing *brindisi* (toast) of Verdi's *La traviata,* Alfredo exhorts his fellow revelers, "Let's drink! Let's drink from the joyous chalices that beauty so truly enhances." *Buon vino fa buon sangue,* an Italian proverb declares. Good wine makes good blood.

-*%%-

IN THIS AGE OF ERUDITE viticulture, wine making in Italy remains as much an art as a science. The French speak of *terroir,* the climate, geology, and topography of a vineyard, to explain why wines taste the way they do. Italian winemakers talk of *ambiente*—a word that literally means "environment" but encompasses the feel of a place and the passion of the people who produce the wine. The best *ambiente* for drinking Italian wine, they insist, is where it's made.

I agree. Over the years, we've tasted Asti's Spumante, Montalcino's Brunello, Montepulciano's Nobile, San Gimignano's Vernaccia, Campania's Greco di Tufo, Sicily's Marsala, Sardinia's Vermentino, and many a family's *vin santo*—all on their home turf. But on this quest, I wanted more than a glass of the finished product, however exceptional. I was looking for a passion for wine so deep that it had shaped a region's history, defined its spirit, and produced vintages unlike those in any other place.

My Italian wine consultants—a mix of winemakers, amateur oenologists, and sommeliers—directed me to Piedmont, literally "the foot of the mountain," tucked into Italy's northwestern corner on the border of France and Switzerland. Its rolling hills and river valleys are the fiefdom of Barolo and Barbaresco, revered as "the king and queen of Italian wines," with a wine-growing tradition that dates back to the Etruscans in the fifth century BC.

My husband and I arrive in monochromatic midwinter, when the skies are milky and the fields pale. The typical fogs of fall and winter inspired the name of one of Piedmont's premier grapes, Nebbiolo, from *nebbia* (fog). Regardless of the season, driving through the hills of the Langhe grape-growing region is exhilarating—"like surfing on waves of vines," as one local puts it.

An ancient sea once covered this land, leaving layers of sand-

stone and fossilized crustaceans. Alpine winds chill the winter; a relentless sun scorches the summer. Unlike plump and prosperous Emilia-Romagna, Piedmont has long been a hardscrabble territory where farmers grew whatever they could coax from the flinty ground. Plowing fields by hand, they treated grapes like any other crop and sold them in bulk to large producers, with a barrel or two of plentiful Barbera kept to ferment in the cellar for the family.

The vines grown around the town of Barolo produced a distinctive sweet and sparkling wine, a favorite of Thomas Jefferson during his European sojourns. A passion shared by a Frenchwoman and her Italian husband transformed both this wine and the town for which it's named.

THE STORY OF GIULIA (originally Juliette) Colbert Falletti (ca. 1785–1864) begins in the bloodbath of the French Revolution, when the guillotine beheaded more than forty thousand citizens—Giulia's aristocratic grandparents among them. In 1792, young Giulia, dressed as a boy to escape notice, fled with her parents to Koblenz, the German city that sheltered many French nobles. Her mother died there; her father provided their three children with an outstanding classical education.

After Napoleon granted amnesty to most exiles in 1802, the Colberts returned to France and regained their title and property. In Paris, the emperor took notice of pert young Giulia and selected her as an alluring pawn for a politically strategic marriage. To cement France's ties to the Savoy dynasty, rulers of Piedmont since 1046, he arranged her wedding to Marchese Carlo Tancredi Falletti (1782–1838) of Barolo, the last descendant of the region's oldest and richest family.

The newlywed Marchesa Giulia charmed local intellectuals, writers, and statesmen at her salon in the family palazzo in Turin.

When she and her husband built a country estate among Barolo's vineyards, she had only one complaint: the local wine didn't compare with those she had drunk in France. Could this humble region ever produce a vintage as sophisticated as the wines of her homeland?

Calling upon esteemed vintners, the marchesa and her husband directed a drastic change in the cultivation of Barolo grapes, adopting the longer fermentation used in Burgundy to produce wine with a lower sugar content and a more refined dry taste. Within a few years, Barolo was reborn as a sophisticated and complex red wine, the toast of Piedmont's social and political elite.

"I've heard a lot about the wine you are producing on your estates," the Savoy king Carlo Alberto said when Marchesa Giulia appeared at court. "When will I have the pleasure of tasting it?"

"Soon," she replied. "Very soon."

A few days later Giulia dispatched a caravan of 325 ox-driven carts, each bearing a barrel of her estate's wine—one for each day of the year, excepting Lent. With this grand gesture, Barolo gained fame as "the king of wines and the wine of kings." Giulia was hailed as "the mother of modern Barolo."

With no children of their own, Giulia and her husband devoted themselves to good works, a passion underwritten by the profits of their wine business. Horrified by the conditions of women in the local jail, Giulia fought for prison reform. To break the cycle of "poverty and sin," she set up a day care center in their palazzo, where mothers could leave their children while they worked.

In 1838, Giulia's husband fell grievously ill after tending to the cholera patients they had taken into their home. Upon his death at age fifty-six, the marchese left his entire estate to his wife to carry on their charitable endeavors. Eventually, Giulia turned their palazzo into an orphanage for girls and established a school to teach sewing so local women could support themselves and their fami-

lies. Opera Pia Barolo, the foundation she created, continues this tradition, funded by Marchesi di Barolo wines.

EVEN WHEN THEIR WINES GRACED noble tables, Piedmont's farmers struggled against grinding poverty. Under the sharecropping system, landlords skimmed half of every harvest's yield. Torrential downpours and hailstorms regularly wiped out entire seasons of work. Running water and electricity didn't arrive in some villages until well into the twentieth century.

When the Fascist regime marched Piedmont's men off to fight in World War II, wives, grandparents, and children tended vines, harvested grapes, and hauled them to market. Italy's surrender to the Allies in 1943 brought a new nightmare: occupation by Nazi troops, who terrorized the locals and plundered their wine cellars.

"You can still see traces of bullets and bombs from the fighting between the Germans and local partisans," Paolo Ferrero, an endlessly informative guide steeped in his region's history, tells us. "When Fascism and the war finally ended, people were hungry, not only for food but for life." Wine embodied this spirit, and consumption soared. Gas stations sold wine by the liter in two basic varieties: red and white.

To increase their output, farmers began treating vines with the same fertilizers and pesticides they used for other crops to improve the harvest. "But great wines can be obtained only from quality grapes grown with great respect for the land," says Beppe Dosio, a Barolo producer in La Morra. As Piedmont's grapes lost their distinctive taste, both demand and prices plummeted. Pushed to the brink of starvation, many growers were forced to abandon their lands and move to Turin or Milan for jobs in the booming factories.

Then, in the 1970s, *la passione italiana* ignited once again, exploding with such force that it tore families apart.

A GROUP OF YOUNG REBELS who came to be known as the Barolo boys—although there was at least one girl among them—led the revolution. Driving to Burgundy, they worked in vineyards and cellars, asked questions, and learned techniques the French had perfected over centuries of making fine wine. Adapting them to Piedmont's distinct climate and soil, they infused something unique into their wines: *la passione italiana*.

One of the young rebels, Elio Altare, came from a family that had grown grapes, corn, nuts, and fruit in Piedmont's Langhe region for two hundred years. Heavy use of toxic chemicals had poisoned the soil and so sickened Elio that he was hospitalized for weeks. In 1983, despite Elio's protests, his father once again sprayed industrial pesticides on fruit trees adjacent to the family vineyards.

Like a man possessed, Elio bought a chain saw and chopped down the orchard. Then he marched into the wine cellar and butchered the *botti,* large Slavonian oak casks that had been accumulating mold for decades.

Elio's father never spoke to him again. Disinherited, he rented vineyards, adapted alternative ways of growing grapes, and eliminated all chemicals. To replace the old-style large casks, he aged his wine in smaller French oak *barriques* that mellowed the powerful grapes. Within a few years, Elio established himself as a living legend and his wines as some of the region's finest Barolos.

A few miles away, another revolutionary, twenty-one-year-old Angelo Gaja, took the reins of his family vineyards in 1961 and transformed production of Barolo's "sister" grape, the queenly Barbaresco. He shocked local vintners by "green pruning" (trimming vines during the growing season) to enhance the quality of the

remaining grapes, producing single-grape wines called *crus,* and introducing new varietals, such as Cabernet Sauvignon and Chardonnay, into the region. Gaja wines—now under the stewardship of Angelo and his adult children—have achieved such cachet that in some places even an empty bottle is prized as a status symbol.

"Why did we have to change?" asks another of the no-longer-young rebels, Augusto Olearo, whose stately Castello di Razzano overlooks a sea of undulating vineyards. "You could say it was passion. We—myself and many others—were feeling, probably more instinctively than rationally, that we were right."

ULTIMATELY THE REVOLUTION IN PIEDMONT'S wine industry ended in evolution. Many vintners switched to smaller oak *barriques;* others experimented with a combination of big and small, old and new, stainless steel and oak. Then a worldwide scandal threatened all the winemakers of Piedmont.

When the demand for high-alcohol, low-cost wines skyrocketed in the 1980s, some mass producers of Barbera, the region's inexpensive table grape, eager for quick profits, added methanol (highly toxic methyl alcohol) to their wines. More than twenty consumers died; at least ninety suffered blindness or other serious side effects. Wine distributors around the world canceled orders and pulled all Piedmont—sometimes all Italian—wines from their shelves.

The crisis propelled a drive for purer, cleaner, greener vineyards and scrupulously supervised production. The vintners who survived the shakedown renewed their commitment to producing wines of depth and character without chemicals.

"We can never forget that we are, first and foremost, farmers," says Giorgio Pelissero, a third-generation vintner in Teiso. "Ninety percent of wine is made in the vineyard, a gift from heaven, nature,

soil, and climate. If you ever stop making wine for passion and do it for profit, that is the moment to stop."

A new generation of winemakers has taken this lesson to heart. On a February day when the chill fog has burrowed into our bones, in his Azienda Agricola BUT in Costigliole d'Asti, Flavio Meistro invites us to share a Piedmont tradition: *bagna cauda,* a "hot bath" of a slowly simmered sauce of olive oil, garlic, and anchovies chopped to a fine paste, served with bread and an array of vegetables for dunking. For centuries, this dish warmed vineyard workers in the Langhe hills on wintry days.

"It reminds me of my grandparents," says Flavio, who pursued a passion for music before returning to their land. "They worked this soil for a lifetime and gave it a soul. I'm happy and proud to follow them as a bearded farmer with dirty hands."

His friend Enrico Orlando of Cà Richeta in Castiglione Tinella also sees himself as continuing a tradition—not just of making wines, but of preserving history. "When I drink one of my wines, it's like opening a photo album that brings back everything that happened that year: a wedding, a baby, a death. To me, a wine should always tell a story about the people and place it comes from."

AS WE SIPPED AND SUPPED our way through Piedmont, we came upon an especially sweet story of love among the vines. On a hilltop in Vergne, above the village of Barolo, Aldo and Milena Vaira have worked together at the G.D. Vajra winery since their wedding in 1984. He is buff, gregarious, direct; she has shimmering silver hair framing a smile that glows from within to light up her eyes.

"Milena is my passion," Aldo declares, "and I am hers." Their shared passion for wine has seen them through outstanding, good, bad, and excruciating years. In 1986, hail wiped out their entire harvest—at the exact time that the "methanol-gate" scandal evis-

cerated the market for Piedmont wines. How did they bounce back?

"Passion!" Milena exclaims. "The Italian words for life, *vita,* and vine, *vite,* are almost the same. When you have passion for both, you learn from every difficulty and keep moving forward." To them, wine represents far more than a commodity—a lesson they passed on to their son Giuseppe when he had to write a school essay about the social significance of his parents' work. At first, he couldn't think of any.

"I told him to look at the paintings on the wall, to listen to classical music, to read poetry or philosophy," says Aldo. "We make wine, not just to sell a product, but for the same reason artists and writers create their works: to make life more beautiful and more meaningful." (Giuseppe went on to study viticulture and now works with his parents in the family business.)

Before we leave the estate, we pause in a high-ceilinged hall with towering stainless steel fermentation tanks. Most such industrial spaces look chillingly sterile, but at G.D. Vajra, a twenty-six-foot-high stained glass window, created by an artist-priest who was a close friend of the couple, bathes the room with a luminous glow.

"Perhaps when people drink our wines," says Milena, "they taste a bit of this beauty as well."

A COMBINED PASSION FOR WINE and for art reaches a zenith several hundred miles from Piedmont in the heart of Chianti at the Castello di Ama. The castle of love, as I think of it, looks like a scene from an Italian fable, perched above a patchwork of vineyards, olive groves, and forests.

"Think of it as a love story," its website suggests, "a tale of the passion of sun for earth that reaches back through history." As soon as I read this description, I couldn't resist a visit.

Five centuries ago, Ama was a wine-making and farming hub overseen by prominent families in the region. The Grand Duke of Tuscany praised its setting as "the most beautiful in all of Chianti, superbly tended with fertile grain fields, olive groves, and magnificent vineyards." But by the second half of the twentieth century, Ama had tumbled into near ruin.

In the 1970s, four Roman families fell under its thrall and bought the property. "Its beauty seduced them, then they discovered the wine," says Marco Pallanti, the agronomist they sent to Bordeaux to study with some of the world's leading winemakers. He returned with a passion to do something no one had thought possible in a region known only for straw-wrapped flasks of cheap red wine: to make great Chianti vintages to rival those of France.

In those early years, Lorenza Sebasti, the teenage daughter of one of the investors, came for a weekend and realized at first infatuated glance that she had found "the place of my life." After completing a degree in business (at her father's insistence) in Rome, Lorenza moved to Ama in 1988, determined to learn everything she could about wine. She found a great teacher in Marco.

"We spent three years speaking and 'sniffing' each other before we started our story," he recalls, a smile softening classic Tuscan features that seem stolen from a Ghirlandaio fresco. Their passion for wine ignited a passion for each other. They married in 1996 and had three children. They also committed themselves to producing world-class wines, a massive undertaking that required replanting about fifty thousand vines, introducing new varietals such as Merlot and Chardonnay, and combining innovative techniques with time-proven traditions.

"To be good is not enough," says Marco, who describes himself as a "guardian" helping the grapes along so they can transform themselves into a great wine. "When you open a bottle of our wine,

I want you to enter a new world the same way you do when you listen to a symphony or read a book."

In the fiercely competitive arena of fine wines, Castello di Ama's vintages have excelled. Its San Lorenzo blend, a classic Chianti, has ranked near the top of *Wine Spectator*'s prestigious Best Wines of the World list. Its L'Apparita, rated among the best 100 percent Merlots, has become a cult classic. Season after season, Ama wines win stellar reviews from wine critics—and sell at often-astronomical prices.

LORENZA AND MARCO'S PASSION for wine begat another passion. Like noble landowners of the Renaissance, they began inviting renowned artists—one every year for more than fifteen years—to create original on-site works. The results are stunning.

In a restored medieval chapel, a huge rounded pyramid of Carrara marble hangs from the ceiling, while its twin rises from the floor, their pointed aluminum tips not quite touching. A pool of iridescent red light glows like a basin of sacrificial blood before the altar of another chapel on the estate. Along a terrace, a wall of mirrors reflects onlookers while cutout windows allow glimpses of the classic Chianti landscape in the distance.

Huge neon lights in a vast wine cellar spell out REVOLUTION in reversed letters, with L-O-V-E blazing brightly above barrels arranged like a revolutionary brigade. We peer through a grate into a dark chamber where a statue of a girl—poignantly small and solitary—morphs into a stalk. Eye-catching graffiti combining whimsical black sketches and witty captions scroll up, down, and across the white walls of several tasting rooms.

"The art changed everything for me," says Marco. "I feel a kind of competition with the artists. I try to make wine at an even

higher level so it will match the quality of their work. Together we are creating something that will carry forward only the best from the past into the centuries to come."

"How important is passion in what you do?" I ask the couple.

"One hundred percent," says Lorenza, a tiny woman who exudes energy from every pore. As the Castello itself becomes a work of art, passion unites vineyards, olive groves, art, architecture, history, nature, tradition—and wine.

"You don't just drink wine; you engage with it," Lorenza observes. "It's an encounter, just as happens with art. Great wine has the same complexity and capacity to touch the person who drinks it—and not only through the senses of taste and smell."

As we gather with other visitors before a massive fireplace on an autumn evening suddenly turned chill, I think of Vubia and her sons, Bacchus and his followers, centuries of *contadini* and winemakers tending vines, harvesting grapes, and blending wines. Amid medieval parapets and contemporary works of art, we raise our glasses and toast the passion that sustained them all.

11

DIVINE
VOICES

Most opera lovers never forget the first time a sound unlike any other bypassed their ears and shot straight to their hearts. Mine came at the New York City Opera in the 1970s, when Beverly Sills was ecstatically warbling her way through Donizetti's queens and Rossini's heroines. A graduate student at Columbia University, I would buy cheap tickets and inch into empty seats closer to the stage. From the very first performance, I was transfixed.

I couldn't explain why. Growing up in a Polish American family that played polkas rather than Puccini, I, like most of my generation, listened to Simon & Garfunkel, Joni Mitchell, and, of course, the Beatles. Yet not even bridges over troubled waters, Chelsea mornings, or gently weeping guitars captivated me as opera did.

Italian coined a word for such infatuation: *melomania,* an

"excessive love for music." Opera—a quintessentially Italian invention—incites the most extreme cases. Why? According to the music expert and author Fred Plotkin, a former performance manager at the New York Metropolitan Opera, it's "all about passion . . . about the rekindling of the soul, about having an open window into what makes us human."

He also identifies something else: the "essential secret that opera lovers know and those on the outside never suspect," an undercurrent of raw sexuality, presented in onstage dramas that often are "far more erotic than a cheap film, a pulpy novel, or the latest rock video." Lust, incest, rape, jealousy, betrayal, revenge—all strut and slink across the opera stage. Lovers furtively embrace. Spouses cheat. Courtesans lose their hearts. Serial seducers leave no petticoat unturned. Nobles and slaves, consumed by passion, lie, steal, bribe, kidnap, even kill.

These sweaty carnal impulses appear before us robed in sumptuous arias, poignant duets, and throbbing choruses. The plot twists may defy logic. The sets may be opulent or spare. The performers may be older, heftier, or shorter than the characters they play. None of these things matter. During one performance of Puccini's *Turandot,* the soprano in the role of the irresistible ice princess bore such a disconcerting resemblance to John Belushi that I simply closed my eyes and listened. Ultimately voices—deservedly described as divine—seduce us by creating sounds that express feelings words alone could never convey.

This splendid confection of music, drama, costumes, sets, special effects, and complete suspension of disbelief could not have emerged anywhere but in Italy. Maestro Mario Ruffini, a conductor and composer in Florence, describes opera (*la lirica,* in Italian) as "the ultimate expression of the collective Italian genius—the Italian sun captured in sound . . . the epitome of the Italian voice, the Italian soul, the Italian passion."

IN THE TWILIGHT of the Renaissance, a group of Florentine poets, philosophers, and professional musicians devoted themselves to recreating something that hadn't been heard since ancient Greece—a stage drama set to music. One evening in the late 1590s, they performed *Dafne,* the story of the innocent maiden turned into a laurel tree to escape Apollo's lustful pursuit, in the elegant Sala delle Muse (Hall of the Muses) in Florence's Palazzo Tornabuoni (where I've had the extraordinary thrill of presenting my books). The enthralled audience had no idea they were listening to the first *opera in musica* (work in music).

Opera emerged as a true art form with the 1607 premiere in Mantua of *Orfeo: Favola in musica* (*Orpheus: A Fable in Music*). Claudio Monteverdi included roles for a type of singer who no longer exists: a castrato, who underwent "castration for artistic purposes," as historians refer to it, to preserve a boy's high-pitched voice. Now viewed as bizarre and cruel, castration was once widespread—almost solely because of Italy's passion for music.

As composers added different voices to create harmony in religious works, choirmasters needed singers capable of carrying the higher notes. Women, the obvious candidates, were excluded. The apostle Paolo had explicitly directed that female worshippers "keep silence in church." In Rome and the Papal States, the Vatican extended this injunction to any public venue.

Young boys could sing like angels, but their musical careers typically ended when their voices broke. In the sixteenth century, a few Spaniards who had been accidentally castrated by injuries in childhood joined the Sistine Chapel choir, one of the jewels of the papacy. In 1599, besotted by their voices, the music-mad Pope Clement VIII approved the hiring of Italian castrati. In a country

with many children but limited opportunities, parents, often impoverished, opted for castration in the hope (not always realized) of ensuring their sons'—and their families'—financial security.

From the seventeenth through most of the nineteenth century, thousands of Italian boys underwent a surgical procedure, usually performed by "doctors" (many less than reputable), to remove the testicles or crush the spermatic cord. Never officially condoned, castration was explained as a necessary "treatment" after a fall or a bite by a goose or pig. Boys—some as young as seven and none older than twelve or thirteen—may not have grasped its lifelong consequences.

Without testes, a male's vocal cords and larynx remained small, but his lungs and rib cage continued to develop. Most castrati grew tall, with barrel chests, gangly limbs, beardless faces, and hairless bodies. The penis remained intact; sexual desire—if not performance—also seems to have endured. As he grew to adulthood, one young man poignantly described himself as "castrated in the genitals, not in the heart."

The *voce bianca* (white voice) of a castrato, fuller and richer than a boy's and extremely flexible, was often compared to a nightingale's. The most successful castrati pursued careers that straddled church music and popular opera, appearing both as handsome heroes and, gowned and wigged, as heroines. Astounded by their virtuosity, enraptured audiences would shout, *"Evviva il coltellino!"* (Long live the little knife!).

THE CASTRATI, WHO WERE BELIEVED to sublimate sexual passion into song, provoked endless curiosity and gossip. One ran off with an Irishwoman; their marriage ended in an annulment. Another fell in love with a widowed *contessa* in Bologna whose outraged brothers hired assassins to murder him. A singer in the Sistine choir

conducted an ongoing homosexual relationship, described as a "veritable passion," with a cardinal.

The best-known castrato, Carlo Broschi, known as Farinelli (1705–1782), showed early musical promise and underwent castration at twelve, after his father's death. Called Il Ragazzo (The Boy), he began touring Europe at fifteen, astounding crowds with his enormous range, supple voice, and vocal stamina. Farinelli and a trumpet player once engaged in a musical duel, with the singer matching and surpassing every flourish, "at last silenced only by the acclamations of the audience." Yet particularly in women's roles, Farinelli also elicited some barbs.

"What a pipe! What modulation! What ecstasy to the ear!" wrote a London critic. "But heavens! What clumsiness! What stupidity! What offense to the eye!"

In 1737, the queen of Spain entreated Farinelli to come to Madrid in the hope that music therapy might lift her husband's severe depression. Night after night he would sing the same melodies, a ritual he repeated until the monarch's death nine years later. Under the king's successor, Farinelli's role expanded to master of court entertainment. Retiring as a Spanish knight with a generous pension, he bought a villa near Bologna and entertained celebrity guests, including Mozart and Casanova, until his death at age seventy-seven.

Unlike Farinelli, many castrati had lonely personal lives and lackluster careers, limited to singing in church choirs. As attitudes changed over time, they were increasingly mocked and ostracized. After the French invasion of Italy in 1796, Napoleon banned the procedure—a step Italy itself finally took in 1870. The last castrato in the Sistine choir retired in 1913.

OPERA LOVERS' PASSION for heavenly voices gave rise to a new genre: bel canto, or beautiful singing, in which the meaning of

words mattered less than their impact on the ear—and the heart. Three Italian composers with names as lyrical as their music— Rossini, Bellini, and Donizetti—infused their compositions with a passionate effervescence that enchanted audiences.

Gioacchino Rossini (1792–1868), son of a trumpet player and a singer in Pesaro on Italy's Adriatic coast, seemed born with music in his blood. He sang as a child, started composing as a young teen, and soon mastered the violin, horn, and harpsichord. His lilting melodies, rhapsodies of joy with a thrilling buildup of orchestral sound over a lyric repeated again and again, won him the nickname Monsieur Crescendo.

"Give me the laundress's bill," he once said with typical geniality, "and I will even set that to music." In less than three weeks, Rossini created one of the most charming romantic operas: *Il barbiere di Siviglia* (*The Barber of Seville*). Beethoven predicted, rightly, that it would be "played as long as Italian opera exists." Even if you have never heard any of Rossini's forty full-length operas, you would recognize his stirring *William Tell Overture,* which provided the theme for the classic *Lone Ranger* television series as well as countless commercials.

Rossini's passions extended beyond music to food. After *Il barbiere*'s opening night, Rossini wrote to the soprano Isabella Colbran (whom he married in 1822) that "what interests me more than music is the discovery that I have made of a new salad, which I hasten to send to you."

A connoisseur of sophisticated pleasures, Rossini retired from opera composition in his late thirties. Separated from his volatile first wife, he lived with and eventually married Olympe Pélissier, an artist's model and vivacious socialite. The ebullient couple, the toast of Paris, reveled in the delights of the musical mecca of their day until Rossini's death at age seventy-six.

WHILE ROSSINI ENJOYED a long and pleasurable life, Vincenzo Bellini (1801–1835), as if sensing that his days would be tragically few, rushed to fill them. A child prodigy, the son and grandson of accomplished organists and music teachers in the Sicilian city of Catania, he could sing an aria at eighteen months, read music at two, and play the piano at three. He composed his first songs when he was six.

The handsome young artist, according to anecdotal accounts, wrote his first opera to win the approval of the parents of a girl he hoped to marry. Yet Bellini never wed. Instead, he became entangled with a series of married women—who, as he wrote to a friend, saved him "from a passion for an unmarried girl, which could land me with an eternal tie."

Surrendering wholly to his passion for music, Bellini swore, "I will stamp my name on this epoch." And so he did. Works such as *La sonnambula* (*The Sleepwalker*) and *I puritani* (*The Puritans*) won praise from Liszt, Chopin, and the hypercritical Wagner, who admired the Italian's "uncanny ability to match music with text and psychology." In a letter, Bellini reported, "My style is now heard in the most important theaters in the world . . . and with the greatest enthusiasm."

Bellini labored over each of his ten operas so intensely that he compared his efforts to "vomiting blood." He expected audiences to respond with equal emotion. "Opera must make people weep, feel horrified, die through singing," he insisted.

That's exactly how I feel when I listen to his Druid high priestess in *Norma,* considered the most difficult role in the soprano repertory. As if exposing every micrometer of her psyche, Norma's

voice rises and falls, softens and deepens, all the while floating hypnotically from the stage.

The pressures of living up to expectations—his own above all—undermined Bellini's health. At about age thirty, he developed a digestive disorder he described as "a tremendous inflammatory gastric bilious fear." In 1835, at thirty-three, he suffered an acute attack and died of dysentery in Paris. Music lovers lauded him as one of Italy's greatest composers but also mourned the loss of the works he didn't live long enough to write.

WITH ROSSINI'S RETIREMENT and Bellini's death, Gaetano Donizetti (1797–1848) stepped into the spotlight—an unlikely position for a poor boy from Bergamo whose father ran the municipal pawnshop. Yet at age nine, he won a scholarship to a local music school.

In his thunderbolt career, Donizetti would write 75 operas, 16 symphonies, 19 string quartets, 193 songs, 45 duets, 3 oratorios, 28 cantos, and several chamber pieces. The intense young artist fell in love with the daughter of a prominent Roman family when she was just thirteen; they wed several years later in 1828.

The first opera I saw in Italy—in Venice's jewel-box Teatro La Fenice (before it burned to the ground in 1996, to be rebuilt in 2003)—was Donizetti's frothy *L'elisir d'amore* (*The Elixir of Love*). New to Italian, I couldn't understand the lyrics, but the score bubbled like musical champagne. Donizetti gained even greater popularity with operas such as *Anna Bolena* and *Roberto Devereux* that brought British history to dramatic musical life.

Yet Donizetti, with his light, bright touch, gained his greatest acclaim for setting madness to melody. The heroine of his best-known opera, *Lucia di Lammermoor,* pulls us with her as she loses her grip on reality in a coloratura tour de force. When I saw Bev-

erly Sills perform the role, I immediately understood why she was acclaimed as "the fastest voice alive."

Ironically, Donizetti himself would descend into madness. Biographers believe that he contracted syphilis in his youth. Undetected, it may have led to the death in infancy of his three children and possibly contributed to his wife's demise as well. In 1845, at age forty-eight, the composer was diagnosed with advanced syphilis and severe mental illness.

The following year, he was confined in an establishment "devoted to cerebral and intellectual maladies." He wrote desperate letters seeking freedom; no one ever mailed them. His brother and nephew finally managed to bring Donizetti home to Bergamo, where he died in 1848.

DONIZETTI SOMETIMES WROTE OPERAS for specific sopranos, including the diva who would gain fame for her voice and infamy for her relationship with Giuseppe Verdi. Giuseppina Strepponi (1815–1897) appeared the perfect bel canto heroine: slim and pretty, with an oval face, a prodigious memory, superb training, and well-honed acting skills. By age twenty, she toured constantly through Europe, her life a whirl of triumphs, applause, and adoring crowds.

"No woman but me is so desired by the public," she wrote to her manager, who called her La Generalina for her steely determination. But, as often happened with female singers, romantic passion—and its consequences—soon jeopardized her professional career. At age twenty-two, Giuseppina discovered she was pregnant (probably by one of her managers), practically an occupational hazard for sopranos at the time. ("For a woman to keep her virtue in a stage career," an eighteenth-century pope observed, "is like making her jump into the Tiber expecting her not to get wet.")

Giuseppina arranged for a family in Florence to care for her son and quickly returned to the stage. Within two years, she placed another newborn, father unknown, on the foundlings' turnstile at Florence's orphanage, with half a coin attached to her hand with a ribbon. She gave the other half to a couple who, for a guarantee of steady payments, claimed the girl as their own.

A mesmerizing performer, Giuseppina achieved the level of *primadonna assoluta* (leading soprano of the highest rank) and realized her dream of singing to rapturous acclaim at Milan's La Scala, the premier opera house in Italy. While there, she encouraged the theater manager to produce a new opera by young Giuseppe Verdi, with her in the female lead.

During rehearsals, the celebrated soprano met the ruggedly handsome composer. They shared several passions—for music, of course, but also for English literature, especially Shakespeare. However, life soon swept them in different directions.

Verdi (1813–1901), born into a poor rural family, learned music from the local priest before studying in the country town of Busseto. Married with two small children, he struggled for recognition as a composer. Then tragedy struck—again and again and again. His daughter, not yet a year old, died in 1838. The following year, his infant son developed pneumonia and passed away in the arms of his anguished mother. Then encephalitis killed Verdi's young wife. For the third time in as many years, he wrote to a friend, "A coffin leaves my house! I am alone! Alone!" He swore never to compose again.

Then a libretto, shoved into Verdi's coat pocket by a Milan impresario, revived his passion for opera—and life. *Nabucco,* the story of Hebrew slaves yearning for freedom in Babylon, would tap into the nationalism pulsing through the Italian peninsula. Verdi wrote the female lead for Giuseppina as he recalled her glorious prime. But her overworked voice had begun to falter.

As a single mother providing for her illegitimate children and her aging mother, Giuseppina had performed nonstop for years, sometimes five or more times a week. She struggled valiantly through the first performances of *Nabucco* at La Scala in 1842 but soon reached the limits of endurance.

As her career waned, Verdi's star rose, and he turned to Giuseppina to navigate the behind-the-scenes labyrinth of contracts and negotiations. By 1843, newspaper gossips hinted of a romance between the maestro of the moment and the fading prima donna.

IN 1846, AFTER RETIRING at age thirty, Giuseppina moved to Paris, where she taught singing and performed for private audiences. When Verdi joined her, Giuseppina took on new offstage roles—as his companion, lover, secretary, adviser, hostess, and muse. She adored loving and being loved by the man she called her "magician," who gave her back the respectability she feared she had lost forever.

In 1848, as political upheavals rocked Europe, the lovers returned to Italy to settle in Busseto. The townspeople were outraged to discover that the maestro had dared to bring an unmarried woman of the theater into their midst. Giuseppina soon became, as the biographer William Berger put it, "the Yoko Ono of Busseto." When newspapers ran stories of her past lovers and abandoned children, locals threw stones at Verdi's windows.

Desperate for tranquillity, the couple moved to rural Sant'Agata—an oasis for Verdi, but a solitary "valley of tears and yawns" for Giuseppina. As Verdi took on commissions from Europe's leading opera houses, the pair traveled, often returning to Paris for prolonged periods.

After seeing Alexandre Dumas's *Lady of the Camellias* in a Paris theater, they conceived of an opera based on a consumptive

courtesan who falls in love with a young aristocrat but sacrifices her happiness for his family's honor. For Giuseppina, the story paralleled her own life as a *traviata* (a woman who had strayed and lost her way). For Verdi, it exposed the moralistic self-righteousness they had encountered in Busseto.

Having shared the *croce e delizia* (torment and delight) of forbidden love that Verdi would immortalize, the couple worked together closely, with Giuseppina singing the mellifluous arias of the heroine Violetta as they flowed from the composer's piano. According to musicologists, *La traviata,* the opera born of their shared passion (and my favorite of Verdi's works), has been performed somewhere in the world every single night for the last hundred years.

In 1859, the composer and his first lady formalized their union. The groom, forty-six, and the bride, forty-four, traveled to a small village near Geneva, where an abbot pronounced them man and wife, with the coachman and bell ringer as the only witnesses. Verdi never issued any public announcement of the marriage.

AFTER ITALY BECAME an independent nation in 1861, the composer's genius and acclaim blazed brighter than ever. But, as Gaia Servadio reports in *The Real Traviata,* Giuseppina fell into a deep depression, complained of constant pain, and put on so much weight that a journalist described her ample chin as "lying restfully on her breast." The couple quarreled in high-decibel screaming matches, and Verdi began spending more time away.

In his midfifties, as if entering a passionate second spring, Verdi became infatuated with a much younger, zaftig Czech soprano named Teresa Stolz (1834–1902), the mistress of a frequent conductor of his works. Verdi wooed her by writing a great opera about a noble slave in ancient Egypt. Teresa, with formidable features and regal bearing, seemed born to play his Aida. The premiere in 1871

catapulted her to stardom. Touring in the role, sometimes with Verdi conducting, Teresa began signing her name "Aida."

In an odd romantic triangle, Verdi, his wife, and his presumed mistress lived at Sant'Agata and often traveled together, spurring talk throughout the opera world. Gossips whispered of a showdown, with Giuseppina threatening to leave if Teresa didn't and Verdi declaring that "she stays, or I blow my brains out." Both women remained in his life.

In her later years, Giuseppina, racked with physical and psychological maladies, wandered through the mists of Sant'Agata, cocooned in sorrow. In November 1897, after more than half a century with Verdi, Giuseppina came down with pneumonia. Her "magician" brought the last violets of the season to the woman who had inspired his Violetta. She was buried with the small bouquet in her hand.

Teresa remained the maestro's faithful consort but never became his lawful wife. At age eighty-seven, he wrote to her, "Believe in my love—great, very very great, and very true." The following year, Verdi, whose music seemed as vital as air to his countrymen, died.

A NEW GENERATION OF COMPOSERS forged a fresh approach they called *verismo,* which translates as both "truth" and "realism." Rather than creating grand epics, they strove to express the passions of real people, "great sorrows in little souls," as Giacomo Puccini (1858–1924), the last of Italy's operatic princes, put it.

While I was fascinated to find Puccini's notes, letters, libretti—and hat collection—on display at his unpretentious home at Torre del Lago in northern Tuscany, I was even more intrigued by his operatic love life. With equal passion, the composer pursued lovely ladies, fast cars, and wild geese.

After a scandalous affair, Puccini ran off with his pregnant

piano student Elvira, wife of a friend and mother of two young children. By the time her husband died, making it possible for them to marry, Puccini was involved with another woman, who fully expected to become his wife. Pressured on all sides, he eventually married Elvira—late in the evening in a local church, with only a few witnesses and cloths thrown over the windows.

Unlike this least romantic of weddings, Puccini's operas were saturated with passion. In *La bohème,* he translates what he called "tenderness mixed with pain" into music I think of as the sound of love's lightning bolt setting two hearts afire. In *Tosca,* passion compels his diva-heroine to do the unthinkable and murder the man threatening to kill her lover. In *Madama Butterfly,* our hearts break as the sweetest of Japanese brides sacrifices herself for her son and his American father. Only in *Turandot,* the grand spectacle Puccini didn't live to complete, does love prevail in triumphant majesty.

Puccini himself often chose the voices for his operas. During auditions for *La bohème* in Livorno in 1897, a rough-featured Neapolitan tried out for the romantic lead. As he sang Rodolfo's *"Che gelida manina!"* (What a cold little hand!), Puccini interrupted to ask two questions:

"Who sent you? Was it God himself?"

THE ASPIRING TENOR was Enrico Caruso (1873–1921), the third of seven children of a hard-drinking car mechanic in Naples, who left school at age ten to earn money for his family. Determined to pursue his passion for singing, Caruso paid for professional training by hiring out his voice to serenade the sweethearts of besotted suitors. At eighteen, he used some of these earnings to buy his first pair of new shoes.

Debuting in *La bohème,* Caruso electrified the audience with the full powers of his outsize lungs and vocal cords. His costar,

the soprano Ada Giachetti, was equally impressed. Their onstage passion sparked an offstage romance, but the situation was complicated. Ada was married with a young son. Caruso was renting a room at Ada's mother's home. Her seventeen-year-old sister Rina had become so infatuated with the tenor that she washed his clothes and ironed his shirts.

Ada soon became pregnant. With a substantial payment from Caruso, her husband slipped out of their lives. After she and Caruso had a second son, Ada withdrew from the stage and settled into the luxurious home the tenor bought in London.

The "voice of the century" would make its way into the homes of millions of fans who never entered an opera house—thanks to the newly invented gramophone, which revolutionized the way people listened to music. From 1904 to 1920, Caruso made more than 260 recordings, which sold so many copies that the poor boy from Naples became a millionaire and an international celebrity. As the first modern operatic superstar, Caruso found himself besieged by reporters, photographers, fans, sycophants—and groupies.

Neither tall nor handsome, the charming tenor nonetheless acquired lovers in every city he visited. Some of his liaisons lasted so long that the father of one "fiancée" sued him for breach of promise. Ada's younger sister Rina, who had blossomed into an international prima donna, began singing with Caruso in the same passionate duets as her sibling—with the same offstage romantic consequences.

In 1908, Caruso returned from a triumphant tour to an empty house. Ada had run off with the chauffeur. His son later described the tenor as "a man nearly gone out of his mind." Shattered by Ada's betrayal, he seethed at the humiliation of the mother of his children leaving the world's greatest singer for a driver.

Shortly afterward, Caruso, overcome with passion, sang the fervent lament of the jilted lover Canio in *Pagliacci* with real tears

running down his cheeks. The audience wept too—as they would whenever he performed what became his hallmark role.

"That night my voice changed forever," Caruso said. "I was living the great pain that you need to make great music." Critics applauded the transformation. Over time, Caruso's richly textured voice deepened into an instrument, in one's words, "of incomparable beauty, dazzling, inebriant, celestially harmonious, and sinfully carnal—one of the most seductive ever bestowed on man."

"THE SINGING MACHINE" EARNED this reputation with nonstop appearances. As the leading tenor for eighteen seasons at the Metropolitan Opera, Caruso sang in 863 performances as well as the earliest *Live from the Met* radio broadcasts. But fame brought Caruso fortune, not happiness.

When he was unknown, Caruso recalled singing "like a bird, careless, without thought of nerves." Later, he felt valued "only because of my throat, which I have sold to managers as Faust sold his soul to Mephistopheles."

Scores of women sauntered through Caruso's bedroom—or he through theirs—but he swore he'd never marry. Then at a christening party in Connecticut, Caruso met Dorothy Park Benjamin (1893–1955), the socialite daughter of a wealthy patent attorney. She was twenty-five, about two decades younger than the tenor. Passion once again prevailed.

In August 1918, Dorothy became Caruso's wife. Her disapproving father and invalid mother weren't invited to the wedding. Caruso's children, living with their aunt Rina (whom Caruso had promised to marry), read about the nuptials in a banner headline in the Livorno newspaper: CARUSO SPOSA AMERICANA (Caruso marries American woman). He never offered a word of explanation.

As ardent as any lover he played onstage, Caruso showered his young bride with jewels, evening gowns (she never wore the same one twice), and furs. Dorothy reciprocated with unmitigated adoration. A year after their marriage, she gave birth to a daughter whom Caruso named Gloria "because she will be my greatest glory." But his grueling performance schedule—and his two-pack-a-day smoking habit—had undermined his health.

Chronic headaches and a cough worsened. In 1920, during a performance of *Samson and Delilah* at the Met, Caruso knocked down two "pillars" woven of straw. One fell from a height of three stories, slamming into his back and causing excruciating pain. In another opera, he began hemorrhaging so severely from his throat that he kept wiping blood from his mouth with handkerchief after handkerchief passed to him by the chorus. Acute pleurisy, doctors determined, had fulminated into bronchial pneumonia.

Over the next few months, Caruso suffered through a series of misdiagnoses and questionable treatments still debated in the medical literature. After several operations, Caruso sailed to Italy in the summer of 1921 with his wife and baby daughter to recuperate. For a few idyllic weeks in Sorrento, he seemed to be improving. Then his condition worsened, and he died in Naples en route to Rome for emergency surgery. The cause of death was peritonitis (infection of the peritoneal sac) caused by a burst abscess below his kidney.

In 1986, the songwriter Lucio Dalla, inspired by a stay in Caruso's hotel suite in Sorrento, wrote a tribute to the tenor. The verses poetically describe his love as so passionate that it melted the blood in his veins. The haunting chorus in Neapolitan—*"Te voglio bene assaje / ma tanto tanto bene sai"* (I love you, you know / so much, so much, you know)—embedded itself in the hearts of listeners around the world.

OF ALL THE SINGERS who have belted out this soulful tune, none com-
pared with Luciano Pavarotti (1935–2007), another barrel-chested
tenor whose voice, like Caruso's, seduced audiences far beyond
opera stages. Born in Modena, the son of a baker who sang in the
local choir, Pavarotti studied to become a teacher (at his mother's
urging) but couldn't resist his passion for opera.

At nineteen, he began intensive musical training. Six years later
he debuted as Rodolfo in *La bohème* in Reggio Emilia. Not long
afterward, he substituted in the same role at London's Covent Gar-
den, personally selected by an acclaimed Mimì, the soprano Joan
Sutherland.

With a sonic marvel of a voice, Pavarotti quickly established
himself as the "King of the High Cs," performing on opera stages
around the world. Critics praised his clarity of diction, stage pres-
ence, and effortless high notes as well as his remarkable ability "to
attract people, perhaps seduce them, to his art"—with both a voice
of unmatched beauty and a warm, engaging personality that spar-
kled in his many media appearances.

Embraced by America, Pavarotti sang 379 performances at the
Met and sold more than one hundred million records. In his paral-
lel "poperatic" career, he paired with Elton John and Sting, spon-
sored a summer music festival, and played a sex symbol in a movie
called *Yes, Giorgio.* In 1990, the Three Tenors—Pavarotti, Plácido
Domingo, and José Carreras—established a new form of opera:
the stadium concert. Beginning in the Baths of Caracalla in Rome,
they performed more than thirty times around the world, selling
millions of recordings and videos.

Eventually Pavarotti's passions—for food, women (as gargan-

tuan as his love of food), and life itself—overshadowed his voice. After a string of no-shows, frustrated theater managers denounced him as the "King of Cancellations." He was booed off the stage at La Scala and caught lip-synching at a concert in Modena.

Living like a sultan amid a harem of doting beauties, Pavarotti remained married to his hometown bride, mother of their three daughters, for thirty-four years. At fifty-eight, balding and hugely overweight, he began bantering with a slim twenty-three-year-old graduate student at a horse show he sponsored in Modena. After several weeks of flirtation, Pavarotti asked Nicoletta Mantovani to come with him on a world tour. She refused.

Would she at least come to the airport to wave him off? Nicoletta agreed, then couldn't resist leaving with him—but only for a week, she insisted. She never returned to her studies. Instead, she became Pavarotti's assistant, lover, mother of his twins (a boy who died at birth of complications of prematurity and a girl), and, in 2003, his second wife.

In 2004, at age sixty-four, Pavarotti began a global farewell tour. Within two years, he was diagnosed with pancreatic cancer. In his truly operatic final months, Pavarotti reconciled with his estranged daughters from his first marriage and bade farewell to their mother. He was buried with solemn ceremony in Modena's cathedral in September 2007. Larger-than-life Luciano left behind an estate worth an estimated $465 million and a legacy that lives on in the passion he inspired in scores of young singers, who—despite formidable odds—hope to attain some small measure of his success.

WHEN PAVAROTTI LAUNCHED his career in the 1960s, advisers urged him to rise as far as he could as fast as he could because opera

"would be dead in ten years." Instead, he ushered in one of its golden ages.

In 1990, a young boy named Vittorio Grigolo sang the offstage folk song that begins the third act of *Tosca*. "Someday," Pavarotti, playing the idealistic painter Cavaradossi, predicted, "you will be singing my role."

The boy dubbed "Il Pavarottino" (Little Pavarotti) became a soloist in the Sistine Chapel choir before launching a career in opera. In 2018, Grigolo, praised as "the most galvanically convincing singer in the world today," debuted as Cavaradossi at the Metropolitan Opera. "All my life I've been preparing for this role, this moment," he said on opening night.

I watched Grigolo's incandescent performance, not at New York City's Lincoln Center, but three thousand miles away on a high-definition screen in a quaint theater in the little town of Larkspur, California, one of hundreds around the country that presents live operas from the Met.

Simulcasts are only one of the reasons the doomsayers predicting opera's imminent demise have been proven wrong—again. Despite decades of dire forecasts, the most passionate of performing arts endures. If opera were mortal, its devotees contend, it would be dead by now. Instead, like one of its mythic heroes, opera refuses to die.

Italian works remain the people's favorites, but the opera stage has evolved into a global village populated with performers of every nation, race, and hue. Recent seasons at the San Francisco Opera, my home company, have featured a Mexican Rodolfo in *La bohème*, a Romanian Violetta in *La traviata*, an American Radames in *Aida*, and a Swedish empress in *Turandot*—all giving masterful and moving performances.

Voices like theirs keep opera lovers like myself coming back season after season. The lyrics and notes may be the same, but every

singer brings a unique passion to the stage, a passion given eternal life by the music that Italian masters crafted centuries ago.

For as long as humans yearn to hear what words alone cannot express, we will return, time and again, to listen with our hearts as well as our ears. And the divinely gifted singers of opera will continue—as the Italian poet Gabriele D'Annunzio wrote of Verdi—to give voice to our hopes and to weep and love for us all.

12

CINEMA IN
THEIR BLOOD

"If you could live anywhere," the reporter asked, "which city would you choose?"

Federico Fellini, renowned director and cosmopolitan man of the world, didn't hesitate before answering: "Cinecittà."

Rome's "Cinema City" once rivaled Hollywood as an international hub of filmmaking, churning out some four thousand epics, thrillers, romances, and comedies over its first seventy years. Ben Hur raced his chariot on its back lot as thousands of extras cheered. Fellini re-created the via Veneto's cafés and cobblestones in *La dolce vita*. For directors, producers, and actors, La Fabbrica dei Sogni (the Factory of Dreams), as it was called, served as a creative home that remains a touchstone for all who, in its founder's words, "have cinema in their blood."

On the day I visit, Cinecittà feels like a ghost town. My footsteps echo through empty soundstages, used mainly for reality

shows like *Il grande fratello* (*Big Brother*) and corporate events. Students on a field trip wander among glass-cased displays of movie memorabilia. Tourists snap selfies in front of faux Roman temples that served as the backdrop for scores of movies.

Yet Cinecittà's legacy survives far beyond its fading sets. The cradle of Italian moviemaking gave birth to more than entertainment. A passion for this "seventh art," as Futurists termed it, with its lifelike immediacy and visceral impact, inspired new ways of portraying both reality and fantasy.

"If Dante were alive today, he would be writing movie scripts," says Gianfranco Angelucci, a cinema scholar and screenwriter who collaborated with Fellini on several films. "In effect the *Divine Comedy* was a movie people played in their minds centuries before film was invented."

From the shady terrace of Cinecittà's café, I imagine Leonardo as a cinematographer experimenting with light and camera angles. Michelangelo designing scenery. Verdi and Puccini composing scores. Artisans engineering spectacular special effects. They all would have felt right at home.

A MANIA FOR MOVIES SWEPT over Italy from the earliest days of silent films. Benito Mussolini (1883–1945), the swaggering strongman who came to power in 1922 as the head of the Fascists, watched a movie almost every night, including American Westerns and Laurel and Hardy comedies. Recognizing film's potential for political propaganda, Mussolini charged Luigi Freddi, his minister for cinema, with making Italy a world leader.

In 1935, under circumstances deemed "suspicious," the largest private film studio in Italy burned to the ground, and the Fascist government moved quickly to replace it. Freddi, who had spent

time in Hollywood learning the movie business, promised a state-of-the-art facility that would be "newer, better, bigger." On April 21, 1937, Mussolini presided over the opening ceremony of Cinecittà. Workmen raised their shovels and cheered. A large billboard proclaimed cinema L'ARMA PIÙ FORTE (the most powerful weapon).

Built on 145 acres, with seventy-three buildings, including fourteen soundstages, Cinecittà boasted its own medical and postal services, fire station, restaurants, sports facilities, greenhouses, and library. A "tram of the stars" linked Rome's central train station to the studio. The most modern and well-equipped facility in Europe produced movies as technologically advanced as Hollywood's.

What made Cinecittà unique was its workshop model, adapted from the Renaissance *bottega,* the ideal environment for Italian creativity and artisanal know-how. In this self-sufficient universe, an army of blacksmiths, carpenters, masons, draftsmen, tailors, painters, makeup artists, hairstylists, and costume designers worked together to bring dreams to cinematic life.

Grand-scale sword-and-sandal epics reenacted the glorious conquests of ancient legions. Audiences delighted in bubbly comedies known as *telefoni bianchi* (because telephones in these glamorous fantasies were gleaming white rather than quotidian black). Although the Fascist era produced no masterpieces, Cinecittà provided a unique training ground for young film enthusiasts.

In 1944, Allied bombings destroyed three soundstages, and the Nazis commandeered Cinecittà as a headquarters. When they retreated, they flung open the doors for the people to grab anything they could carry, right down to the bathroom fixtures. For years, families dispossessed by the war camped on the back lots, burned wood from the prop rooms and soundstages for heat, and sold scraps of metal to buy food.

EMERGING FROM THE DEVASTATION of Fascism and war, a generation of moviemakers created what Peter Bondanella, author of *Italian Cinema from Neorealism to the Present,* described as "the greatest art form of twentieth-century Italy": a revolutionary new genre of moviemaking called *neorealismo* that would influence filmmakers around the world.

A few years ago, at the Casa del Cinema in Rome's Borghese Gardens, I binge-watched several neorealistic classics. Despite the less-than-ideal setting (a cubicle with a hard chair, a desktop screen, and bulky headphones), I quickly understood why many consider these the most passionate movies ever made.

Rather than professional actors, ordinary Italians—literally plucked from the streets—revealed with unflinching honesty the wretched poverty, despair, and helplessness they and their countrymen had endured. Their emotions were so raw, their expressions so unguarded that they pulled me inside their very souls as they struggled to survive with some shred of hope and dignity intact. I wasn't watching their stories; I was living them.

Generations of filmmakers have had a similar response. "If you have any doubt about the power of movies to interact with life and restore the soul, study neorealistic films," Martin Scorsese urges in *My Voyage to Italy,* his video homage to Italian cinema. "They forced the rest of the world to look at Italians and see their humanity. To me, this was the most precious moment in movie history."

Roberto Rossellini (1906–1977)—"the great father, like Adam," as Fellini described this cinematic pioneer—grew up watching films almost daily in his father's movie theater in Rome. As debonair as a matinee idol, he acquired new passions as he grew

up, including women, airplanes, and fast cars, yet he never lost his desire for a career in film. At Cinecittà, he started as a gofer and progressed to sound technician, film editor, scriptwriter, and finally director of state-sponsored films.

After losing his studio and salary, Rossellini found his own voice. Burning with a passion to show life in Rome in the last months of the war, he scraped together the equivalent of $20,000, in part by convincing both his wife and his mistress to pawn their jewels. With no soundstage, no sets or props, not even a completed script, he shot *Roma, città aperta* (*Rome, Open City*) on the actual streets where the events had taken place, using leftover bits of unexposed film he found at Cinecittà and mooching electricity from American facilities.

Rossellini and his scriptwriters (including the young Fellini) drew on the chilling experiences of ordinary people caught in a wartime hell. Don Pietro, a partisan priest, joins with a partisan leader named Manfredi to fight the Nazis. Manfredi's former mistress Marina eventually betrays him to an evil Gestapo officer. Francesco, a friend of Manfredi's, is engaged to a working-class woman named Pina, who is shot when she runs after the Nazis taking him away. In the final scene, a firing squad executes the partisan priest as street urchins watch from behind a wire fence.

Roma, città aperta broke down the distinctions between life and art, feature film and documentary, to transport viewers into the realm of visual poetry. The film also unleashed the volcanic talent of Anna Magnani (1908–1973), who played Pina with a passion that burned up the screen. Raised in the city slums, Magnani received a spotty education, including some musical and theatrical training, and supported herself by singing in nightclubs and touring with small repertory companies.

In *Roma, città aperta*, Magnani, full-figured, with shaggy hair and a sharply sculpted face, acted as naturally as she breathed,

without vanity or pretense. Emotions—fear, anger, grief, despair—cascaded through her eyes and lips into every gesture. She became a living symbol of Rome, its she-wolf mother, the face and voice of its streets and people, the emblem of their moral and ethical strength—and Rossellini's latest mistress.

In 1946, the director followed up with another war story, *Paisà,* composed of six often-wrenching vignettes that followed American GIs up the Italian peninsula from Sicily. His groundbreaking films brought Rossellini critical acclaim—and a fan letter from Ingrid Bergman (1915–1982), who had catapulted to stardom in movies such as *Casablanca, Notorious,* and *The Bells of St. Mary's.*

"IF YOU NEED a Swedish actress who speaks English very well, who has not forgotten her German, who is not very understandable in French, and who in Italian knows only *'ti amo,'* I am ready to come and make a film with you," she wrote.

Rossellini was ready too. He cast Bergman as a Scandinavian refugee who marries a Sicilian fisherman and moves to a desolate island. In *Stromboli, terra di Dio* (*Stromboli, Land of God*), released in 1950, Bergman's character discovers a totally alien culture while the Swedish beauty and the Italian director discovered an all-consuming passion for each other.

One day Rossellini, still living with Magnani in a hotel in Rome, told her he was going out to walk the dog. Instead, he left the pet with a porter and flew to Bergman's side. (For years afterward, he lived in terror of Magnani's public eruptions when their paths crossed in Rome.) The romance between the suave director and the idolized Swedish actress made international headlines, produced three children, and drew the ire of the Catholic Church and the Italian and American governments.

Bergman, who had left her husband and daughter, was black-

balled by Hollywood. Although she and Rossellini divorced their spouses and were married by proxy in Mexico—a once-common ploy to get around the legal bans on divorce in Catholic countries—neither Italy nor the Church recognized their union.

Inspired by Bergman's talent, Rossellini directed the star in complex movies that expanded neorealism into psychological territory—but flopped at the box office. I can understand why: like a therapist observing his patients, Rossellini distanced himself from his characters. Even an actor as transparently radiant as Bergman never quite connected with viewers. Rossellini was accused of ruining her career as well as her reputation.

In 1956, after years of ostracism, Bergman accepted the starring role in Paramount's *Anastasia,* which was filmed in Europe and won her a second Academy Award for Best Actress. Rossellini, who had wanted Bergman to star only in his films, debarked for India to direct a movie and acquire a new mistress, the wife of one of his producers. Bergman returned to Hollywood.

Rossellini's passion for cutting-edge films outlived his adventures as a lothario. The visionary director continued to experiment with unconventional subjects and innovative techniques for both big and small screens, with a lasting impact on world cinema.

"When I came in touch with Rossellini," Fellini observed, "I saw at first a completely new world, the loving eyes through which Rossellini observed everything to make things come alive . . . without deceit, without presumptions, without thinking of sending around quite definite messages."

IN THE 1950S, Italy, still rebounding from World War II, faced a new invasion—of American filmmakers who transformed Rome into "Hollywood on the Tiber." Rather than the ravaged war zone of the neorealists, the Eternal City sparkled as the enchanting

playground for Audrey Hepburn and Gregory Peck in *Roman Holiday* and a trio of high-spirited American women in *Three Coins in the Fountain*.

Infused with American profits (which the law required foreigners to invest in Italian movie production), Cinecittà sprang back to life. Often several films, sometimes with overlapping casts, were shooting at the same time. Thousands lined up for day jobs as extras. Among the eager wannabes were two scrawny kids from hardscrabble backgrounds who would someday seduce audiences around the world: Sofia Scicolone, born in 1934 and taunted as "Sofia Stuzzicadenti" (Sofie Toothpick) as a girl, and Marcello Mastroianni (1924–1996), nicknamed "Skinny Paws" as a boy for wearing hand-me-downs with too-short sleeves.

Sofia grew up near Naples amid horrific Allied bombings that left a piece of shrapnel embedded in her chin. When the local theater reopened after the war, the twig-thin girl entered what she calls its "hallowed darkness" and discovered what seemed a preposterous passion: "I was suffused with the feeling that I was put on earth to act, to express myself, to let out whatever feelings I had inside. . . . I was not interested in what I could bring to myself by being an actress, but in what I could bring *out* of myself."

By fifteen, the scraggly duckling had blossomed into a tall, full-figured knockout. At her mother's urging, Sofia began entering beauty pageants—in an evening gown sewn from the pink living room drapes. Although she never won the top prize, directors noticed the brown-eyed *maggiorata* (as curvaceous Italian starlets were called) and began casting her in minor roles.

Cameramen complained that Sofia was impossible to photograph—nose too big, gap between front teeth, odd angles on her face. A short, bald man twenty-two years older saw something more in the sixteen-year-old: not a mere actress but "an artist, like a singer who either has a God-given voice or hasn't."

His name was Carlo Ponti; he changed hers to Sophia Loren. With his smarts and her beauty and talent, the Neapolitan waif would become the biggest star Italy ever produced and the first Italian to earn $1 million for a movie.

Winning a five-film contract, Sophia costarred with Hollywood's leading men. *Newsweek* hailed her as "a Mount Vesuvius." Cary Grant was so smitten during the filming of *The Pride and the Passion* that he swore to leave his wife to marry her. As Sophia later admitted, she was tempted, but decided to honor her commitment, personal as well as professional, to Carlo Ponti.

"I AM NOT A SEXY POT," Sophia once told reporters. She proved it with a performance of seething passion in *La ciociara* (with the English title of *Two Women*), a brutal tale of a mother who flees war-torn Rome with her twelve-year-old daughter. After the Allies advance, a gang of Moroccan soldiers rape both women.

Sophia, a twenty-six-year-old playing a mother ten years older, strips away any vestige of vanity to portray animallike terror and fury. The spitfire we see at the movie's beginning disintegrates into a broken woman comforting her traumatized child, cooing to her "little girl" as they sit alone in a desolate world. Revealing her full potential as a true cinematic "artist," Sophia won an honor no Italian had ever achieved: the Oscar for Best Actress.

Sophia's offscreen love story dragged on for decades. After officially separating from his wife, Ponti obtained a Mexican divorce and married Sophia by proxy (two male attorneys stood in for the couple). The Church and Italy's government considered him a bigamist. The couple moved to France and eventually acquired French citizenship, which allowed them to wed.

"I'd become an Eskimo to stay married to Sophia," Ponti declared.

"I'll become an Eskimo, too," echoed Sophia, "but I'll still feel like a Neapolitan."

After a string of miscarriages, Sophia took on what she viewed as her greatest role, as mother to two sons, although she continued to appear in occasional films for both the large and small screen.

When asked, at age seventy, what she liked most about acting, she replied, "I'm an actress. It's my passion. I've always lived for acting. . . . Every picture I do, I feel it is my first picture in my career. I love it so much. Really so much. So much." Aging gracefully and glamorously, Sophia reached the status of an international icon, recipient of innumerable honors, including designation as "one of world cinema's treasures."

MARCELLO MASTROIANNI INSISTED that he had always hated his looks. Idolizing American actors like Gary Cooper and Clark Gable, the star-struck teen earned 10 lire a day as an extra at Cinecittà—a fortune to him at the time. "Everything seemed magical, like an adult's game—a complicated and mischievous game that takes hold and doesn't let go." Once seized by the passion to perform, he had no other choice. As Marcello told journalists, "I act because I couldn't exist otherwise."

While nature had endowed the fledgling actor with the bedroom eyes, sensuous lips, dimpled chin, and rueful smile that came to be known as "the Mastroianni look," his stage experience in a theatrical company after the war refined his nasal voice and added a compelling presence. Bit part by bit part, B movie by B movie, Marcello earned his acting stripes.

His breakthrough role came in a Fellini film with the working title of *Although Life Is Brutal and Terrible, You Can Always Find a Few Wonderful Moments of Sensuality and Sweetness*—retitled and released as *La dolce vita*. As a jaded, perpetually horny gos-

sip reporter chasing scoops—and skirts—on the sultry via Veneto, Marcello became an international symbol of Italian sexiness, the ultimate "Latin Lover." He spent the rest of his career defying this characterization on-screen while living up to it offscreen.

Married for more than four decades to the mother of his Italian daughter (as he put it), he lived for years with Catherine Deneuve, the mother of his French daughter, and carried on often-tempestuous affairs with Faye Dunaway, Jeanne Moreau, Brigitte Bardot, and other leading ladies.

On-screen, Mastroianni played against type—as an impotent Sicilian cuckold, con man, drunk, lawyer, patriarch, assassin, homosexual, rapist, magician, novelist, police commissioner, director, beekeeper, priest, union organizer, dancer, professor, Russian aristocrat, General Custer (in a French movie called *Don't Touch the White Woman*), Henry IV, and film's first pregnant man. In all, he appeared in a staggering 140 motion pictures.

"No other actor in Europe or in the United States has worked and talked about his work as much as Marcello Mastroianni," observes his biographer Donald Dewey. "[He] has raged as much as murmured, sung and danced as deftly as he crooned sweet nothings, carried off acting awards and won three best actor Oscar nominations."

Marcello described taking on a new character as "almost like falling in love." Perhaps that's why I—and millions of fans—found him so lovable. Whether he was playing hero or rogue, killer or cleric, somehow Marcello won us over with his sheer delight in the game, which reached its infectious height when he costarred with Sophia, his perfect foil, in movies like *Marriage Italian Style* and *Yesterday, Today and Tomorrow*. (After twenty years of working together, she called him "my movie husband.")

Marcello and Sophia—never lovers, ever friends—paired up for the last time at the 1993 Academy Awards ceremony, where

they presented an honorary Oscar for his life's work to Federico Fellini.

IN A BUSINESS BUILT ON DREAMS, Fellini (1920–1993) may have been the biggest dreamer of them all. As a boy in Rimini, he kept a sketch pad and colored pencils by his bed so he could record his vivid fantasies when he woke. His lifelong passion was transforming these nocturnal visions into stories to share with the world—in sketches, comic books, and, by natural extension, films.

Cinecittà had been open only two years when Fellini arrived in Rome in 1939. Almost without anyone noticing, he slipped inside and began punching up scripts for movies. In 1942, he met a big-eyed gamine named Giulietta Masina (1921–1994), who had already established herself as a fine stage actor. They married in October 1943, on the eve of the Nazi occupation of Rome.

After the war, Fellini sketched caricatures for American GIs, penned gags for comedians, drafted radio plays, and contributed to the scripts for *Roma, città aperta* and *Paisà*. This experience, Fellini said, taught him that making movies was "the medium of expression most congenial . . . to my laziness, my ignorance, my curiosity about life, my inquisitiveness, my desire to see everything and to be independent, my lack of discipline, and my capacity for real sacrifice."

Fellini's first major international hit, *La strada* (*The Road*), spotlighted three circus performers: a brutish strongman (Anthony Quinn), a whimsical acrobat (Richard Basehart), and a simple good-hearted girl, played by his wife, Giulietta, in a performance that Fellini crafted especially for her, part Charlie Chaplin and part Shirley Temple. *La strada* won the first-ever competitive Oscar for Foreign Language Film.

In *La dolce vita*, Fellini reproduced via Veneto on Cinecittà's

largest soundstage. But the movie's signature scene, one of the most seductive in cinema, was filmed on location at night at the Trevi Fountain. The water cascades, the statuary gleams, a dripping-wet Anita Ekberg glistens like a tantalizing goddess fallen to earth. You feel the mist, smell the damp, tingle with the erotic energy.

Some critics compared this 165-minute movie to Dante's *Inferno*. Like the fourteenth-century pilgrim, the errant journalist Marcello wanders through a corrupt world teeming with memorable characters—120 named in the script—to emerge into the light of day. But Fellini's voyager, unlike Dante's, finds neither radiant stars nor any hope of salvation.

Despite critical acclaim, many Italians responded with outrage to Fellini's torrid depiction of Roman decadence. Audiences shouted *"Vergogna!"* (Shame!). A woman spat on Fellini in a piazza in Milan. Right-wing politicians denounced him. The Vatican declared the film an invitation to evil.

"These polemics fill me with sorrow," said Fellini. "I'm a storyteller. I've told a fable, a fable of our times. . . . I intended for it to be a document, not a documentary." Despite—or perhaps because of—the controversy, the film set box-office records. Six decades later *La dolce vita* remains a marvel of images, sounds, motion, light—hailed as one of the greatest masterpieces cinema has ever seen.

DEVASTATED BY THE FIRESTORM over *La dolce vita*, Fellini entered Jungian analysis and began sketching his dreams for his therapist, as he once did as a child. These fantastical images—a sad clown playing a trumpet, a dancing woman with a cat on her head, a kaleidoscope of strange and haunting faces—became the basis for the movie he called *Otto e mezzo* (*Eight and a Half*), since it came after seven full-length features and two short ones. Many viewers, myself included, were hopelessly confused, but this didn't faze Fellini.

"Either a film has something to say to you or it hasn't," Fellini remarked. "If you're moved by it, you don't need it explained to you. If not, no explanation can make you moved by it." Critics hailed *Otto e mezzo* as extraordinary filmmaking, a demonstration of postwar Italian film craft at its zenith that won the Academy Award for Best Foreign Language Film, the third for Fellini.

Otto e mezzo resuscitated Fellini's passion. "This picture has set me free," he said. "From now I'll be able to make a dozen different kinds of pictures." And so he did, among them: *Juliet of the Spirits,* a tender cinematic valentine to his wife; *Amarcord,* a tribute to his hometown of Rimini that won his fourth Best Foreign Language Film Oscar; *Ginger and Fred,* with his wife and Marcello as aging ballroom hoofers; and *Intervista* (*Interview*), a love letter to Cinecittà, in which the studio, not Marcello as the comic book hero Mandrake, emerges as the real star.

My favorite, *E la nave va* (*And the Ship Sails On*), combines two of my passions—opera and film—plus a fanciful cameo by a rhinoceros. At its end, as the ship sinks with the singers never missing a note, Fellini pulls back to show the magic makers—camera operators, sound engineers, stage technicians, the director himself—as if letting the audience in on the tricks he's been playing to seduce us.

"Wasn't that a great game?" he seems to be saying. "Did you have fun too?"

In their home on via Margutta, Fellini and his wife stored their many awards in a room they called the "Sanctuary of Divine Love"—but never entered. For them, the sheer joy of bringing fantasies and characters to life mattered more. Within months of receiving his honorary Oscar in 1993, both Federico and Giulietta were hospitalized with serious illnesses. In early October, he suffered a stroke, fell into a coma, and died.

Italians grieved for Fellini as they never had for a politician, an

athlete, or an artist. Some seventy thousand mourners filed past his casket in his beloved Cinecittà to pay their respects. Weakened by cancer treatments, Giulietta lived until the following spring, when she told a friend, "I am going to spend Easter with Federico." They were her last words.

In 1995, Marcello returned to the stage in Furio Bordon's *Le ultime lune* (*The Last Moons*), a play about a widowed poet whose family wants to put him in an old folks' home. He toured Italy with the role through 1996, even while undergoing debilitating chemotherapy for pancreatic cancer. In his final appearances, he had to perform sitting down. A consummate actor to the very end, Marcello died at age seventy-two.

In a solemn memorial ceremony at Rome's Trevi Fountain, massive black drapes were lowered slowly as a melody from the score of *Otto e mezzo* played on loudspeakers. When the curtains were fully unfurled, the flow of the fountains stopped. Two spotlights glowed on the shimmering water—a final tribute to Marcello, his passion for movies and life, and everyone who ever dreamed of romance in the Eternal City.

THE ITALIAN DIRECTOR BEST KNOWN outside Italy today, Roberto Benigni, once called my *telefonino* as I was walking in the Borghese Gardens. Expecting a call from a Roman friend with the same first name, I answered with a cheery, *"Ciao, Roberto!"*

"Diana, sei proprio brava! Come sai il mio nome?" (Dianne, you are really clever. How do you know my name?), an oddly familiar voice exclaimed.

As I struggled to keep up with the rapid-fire Italian, I realized that Benigni, a friend of a friend of a friend, was calling to talk about *La Bella Lingua*.

"If you love my language," he declared, "I love you."

How could I not love him in return?

Benigni grew up poor, the son of a farmworker near Arezzo. With no toys or books, the odd-looking boy created a world of make-believe, brimming with unusual characters and fantastic adventures. As a teenager, he memorized classic poems and excelled at an old Tuscan tradition of improvising raunchy eight-line rhyming verses.

Moving to Rome, Benigni perfected what a critic called "the erotic art of humor" and won recognition and a growing audience in live performances and on television. In 1980, he met Nicoletta Braschi, who became his muse, wife, partner, and costar. A string of frothy films that he both directed and starred in, including *Johnny Stecchino* (*Johnny Toothpick*) and *Il mostro* (*The Monster*), made him Italy's most popular comic and top movie moneymaker.

The hyperkinetic actor established an international reputation with *La vita è bella* (*Life Is Beautiful*), released in 1997. The film reflected his father's two years in a German POW camp, where he was nearly worked and starved to death, and the poignant stories—funny as well as sad—that he told his children about his wartime experiences. Deftly blending comedy and tragedy, Benigni achieved what he told me Italy's artists have always strived to do: transform all aspects of life, however ugly, into transcendent experiences. The film garnered awards around the globe, including Oscars for Best Actor, Best Foreign Language Film, and Best Original Score.

For several years, Benigni toured in a one-man show, *Tutto Dante,* a topical stand-up routine followed by an impassioned reading from Dante's *Inferno.* In the performance I saw in Rome, Benigni, standing at a podium on a starkly lit stage, held a stadium-size audience in rapt wonder, as if we were indeed watching a film.

In 2017, in his acceptance speech for a David di Donatello,

Italy's equivalent of an Oscar, for lifetime achievement in film, Benigni spoke eloquently about an art form that can inspire, elevate, educate, illuminate, and restore the soul. A loss of interest in film, he warned, could lead to many dangers, including *"perdita di felicità"* (loss of happiness). Imagine, he joked: we would have to go to the pharmacy for five milligrams of *Otto e mezzo*, two capsules of *La dolce vita*, and fifteen drops of *Il gattopardo* (*The Leopard*).

Given its precarious health, Italian cinema may need a prescription of its own. Yet, despite fears for its future, its heart continues to beat—and contemporary filmmakers continue to draw on the rich legacy of Rome's Factory of Dreams. In 2013, Paolo Sorrentino's Oscar-winning *La grande bellezza* (*The Great Beauty*), a sweeping epic, paid visual and thematic homage to Fellini's *La dolce vita* as it captured the excesses of the Berlusconi era.

SINCE FEW ITALIAN MOVIES make it onto American screens, I rarely get a chance to see smaller or independent films. But, thanks to the New Italian Cinema Festival in San Francisco, sponsored by the Italian Cultural Institute, I've sampled more than a dozen recent releases, ranging from edgy documentaries to droll comedies to a radiant reimagining of Shakespeare's *The Tempest*.

The films, made by both veteran directors and newcomers, introduced a cavalcade of thoroughly Italian characters: A troupe of actors and escaped criminals shipwrecked on an island off Sardinia. A sommelier who loses his "nose." Beautiful conjoined twins with exquisite voices yearning to pursue different dreams. A father and son hunting for a dangerous bear known as *il diavolo* (the devil).

As diverse as they were, each struck me as wholly, incontrovertibly Italian. When I ask what instills this unique style, Marco Spagnoli, the award-winning director of documentaries on cinema, offers an explanation: "American movies show us what we would

like to be, while Italian movies show what we are. For Italians, watching an Italian movie is like watching a story of your family. It's like some sort of mirror."

Yet, as with its other arts, Italy's cinema also reflects the humanity we all share—as I discovered in Luca Guadagnino's *Call Me by Your Name*. This lushly photographed film about an adolescent boy's summer romance with an older male graduate student—a subject that once seemed too daring ever to find commercial support—emerged as a "sleeper" international hit, nominated in 2018 for the Academy Award for Best Picture.

You don't have to be young, male, or gay to identify with its characters. In the final scene, the camera closes in on the broken-hearted teen as a spectrum of unspoken emotions washes over his face. Bittersweet lyrics by the American singer-songwriter Sufjan Stevens play in the background. The refrain asks again and again: "Is it a video? Is it a video?"

The movie itself feels like something much more, an experience that could have been created only by those with a passion for cinema in their blood.

13

PASSION
ON WHEELS

nside a blood-red Ferrari, the rumble of the engine crescendoes into a surround-sound roar. As the driver presses the gas pedal, the acceleration thrusts me back into the leather seat. The car, all sinuous curves and aeronautic vents, seems both to hug the ground and hover above it. As we approach a sharp curve, I brace myself. For a forget-to-breathe instant, I am sure that we are flying into the air. In that moment—both terrifying and absolutely glorious—I understand why an Italian race car driver is called a *pilota*.

Enzo Ferrari (1898–1988) wanted to be one from the day the eleven-year-old ran two miles across fields and railroad tracks to watch newfangled "horseless carriages" careen by at a then-astounding eighty-seven miles per hour. In a career that spanned decades of social and political upheaval, Ferrari transformed his boyhood passion into an international phenomenon.

His road rockets conquered the great racetracks of Europe,

entranced the rich and royal, and elevated the Ferrari brand to iconic status. The Ferrari *scuderia,* his racing team, boasts the most successful record in history, with the greatest number of championships and of winning drivers. Ferrari theme parks and boutiques around the globe draw millions. Each year, some 350,000 pilgrims visit the Ferrari Museums in Modena and nearby Maranello, where billboards urge: FAI BATTERE IL CUORE! (Make your heart beat!). Mine certainly did—faster than ever.

"Why do so many people, from all countries, of all ages, come here, to the middle of nowhere?" asks Michele Pignatti Morano di Custoza, the dashing head of the Ferrari Museums, as we chat during my visit. "Ferrari has never been just about cars. It's about dreams. It's about passion—not just for driving, but for daring to do the impossible."

ITALY'S GREED FOR SPEED dates back to chariot racing, the most popular spectator sport in ancient Rome. Then as now, drivers became death-defying sex symbols. Young charioteers, many of them slaves striving to earn their freedom, wrapped the reins around their waists to control the galloping horses—at the harrowing risk of being pulled under their hooves.

Just as they do today, fans rabidly rooted for their favorites. A two-thousand-year-old tablet records a curse against a rival team of charioteers: "Torment their minds, their intelligence, and their senses so that they may not know what they are doing, and knock out their eyes so that they may not see where they are going."

In time, chariots gave way to horse races, often run—like Siena's blistering Palio—bareback at breakneck speeds around a city's center. Almost as soon as bicycles rolled into Italy, cyclists vied to pedal harder, longer, faster in endurance races that captured the nation's imagination. As bikes muscled up, motorcyclists

revved their engines and roared over tracks and terrain. In the twentieth century, the car (from the Latin *carrus,* one of the oldest words for chariot) propelled racing to a different plane. The drivers, young and reckless, liked to live at full throttle. It didn't take long for them to test if they could drive just as fast.

WHEN ENZO FERRARI'S FATHER, owner of a metal shop in Modena, acquired one of only twenty-seven automobiles in the town, his younger son didn't dream merely of taking the wheel. He wanted to race the wind in a car that could fly without leaving the ground.

The Great War dashed the youngster's big dreams. Pneumonia killed his father in 1916, and the family business collapsed. While serving in the military, his older brother died of an infectious disease. Ferrari, assigned to a mountain artillery unit, also fell ill and spent months in a crude hospice for the incurably sick. Slowly he recovered and returned to a world forever changed.

"I was back where I had started," he wrote in his memoirs, poignantly titled *Le mie gioie terribili* (*My Terrible Joys*). "No money, no experience, limited education. All I had was a passion to get somewhere." He applied for a job as a mechanic at Fiat's bustling factory in Turin.

"Sorry, kid," he was told. There were too many veterans applying for too few jobs. Ferrari slumped onto a park bench. "I was alone. My father and my brother were no more. Overcome by loneliness and despair, I wept."

But Ferrari didn't give up his passion. He eventually started working for Alfa Romeo, first as a mechanic, then a test driver, then a junior member of a team made up of some of Italy's finest racers, engineers, and technicians. At one competition, Ferrari met the parents of a World War I ace who had downed thirty-four enemy planes before being killed in action. His mother suggested

that the young racer decorate his car with the Cavallino Rampante (Prancing Horse), the symbol of her son's squad, to bring him luck. Eventually the spirited stallion would become the logo for the Ferrari brand.

In 1923, Ferrari won his first race—and the hand in marriage of, as he described her, a "pretty, blonde, graceful, *simpatica*" young woman named Laura. The newlyweds moved to Ferrari's hometown of Modena. There Laura and his mother clashed constantly as they competed for the attention of a man who was always rushing out of the house—often heading for the local bars where he tirelessly pursued new conquests.

Whatever they knew about his after-hours diversions, Ferrari's wife and mother agreed on one thing: they hated his risking his life in races. "If you have a boy," he told Laura when she became pregnant, "I'll never race again." When their son Alfredo, nicknamed Dino, was born in 1932, he kept his word.

IF HE COULDN'T DRIVE, Ferrari wanted the most daring, competitive, fearless *piloti* representing him on the racing team he assembled at Alfa Romeo. Journalists called them *garibaldini,* after the brave and reckless young men who had fought under Garibaldi for a unified Italy. Ferrari, describing himself as "an agitator of men," managed his drivers as if they were gladiators, pitting them against one another to be the fastest—regardless of the risks. A driver willing to die at the wheel, he believed, would always beat a man in a faster car who valued his life.

Long before the era when jet pilots and astronauts exuded "the right stuff," Ferrari's "gentlemen drivers" set the standard for cool. Dressed in light street clothes in open cars, they eschewed seat belts and helmets as "unmanly." Rather than competing on fenced-in tracks, racers gunned their engines on the same streets that bi-

cycles and donkey carts traveled—steep, pocked, narrow, winding, slick in rain, glassy in ice. Italians crowded the sidelines to catch a glimpse of the daring young men in their racing machines.

Tazio Nuvolari (1892–1953), the Flying Mantuan, with a comic book hero's jutting jaw, became the most beloved sports figure in Italy. A puny child from a wealthy family, he always had a passion for going fast—very, very fast. As a boy, he galloped on his prized black horse without saddle or bridle. Then he mounted a bicycle and pedaled his way to three national championships. Nuvolari was competing on Bugatti motorcycles in 1920 when Ferrari recruited him to try four-wheeled racing. He ended up winning 150 competitions, including the most difficult and dangerous in the world.

"Nuvolari was not simply a racing driver," the British automotive historian Cyril Posthumus wrote. "To Italy he became an idol, a demi-god, a legend, epitomizing all that young Italy aspired to be, the man who did the impossible not once but habitually, the David who slew the Goliath in the great sport of motor racing."

Nuvolari once threw himself out of a burning car going ninety-nine miles per hour. In a distance race, he stalked the leader through the predawn hours with his headlights off to lull his rival into slowing the pace. At the last moment, he flashed on his lights and pounced to victory.

"The passion of his, that indomitable pride, was perceived by the fans and made him their hero," Ferrari wrote. Women adored him. At one finish line, he embraced the beauty who had been crowned "race queen" and scurried off with her—not to be seen until the awards banquet that night.

The daredevil driver's greatest triumph came in 1935 at the German Grand Prix, a race dominated by the seemingly invincible Mercedes team in "silver arrows" painted with swastikas. Nuvolari drove like a "berserk hare," as a reporter put it, hardly braking for

corners, charging flat out into bends, wrenching his entire body to maintain control. In the final stretch, a tire burst on the German lead car. Nuvolari zoomed from behind to clench what headlines proclaimed an "impossible victory," one of the greatest wins in motor racing history.

The shocked Germans had neither an Italian anthem nor a flag for the awards ceremony. Nuvolari, who had brought his own recording, pointed to a frayed Italian flag in the stands. On that proud day, the Prancing Horse came to represent not just a man or a company but a nation.

Nuvolari expected to die doing what he loved: driving like hell. Instead, with lungs ravaged by exhaust fumes, he found himself gasping for breath, finishing his last races with a bloodied handkerchief covering his mouth. "I, who could dominate any car, am incapable of controlling my own body," he said in his last debilitated year. Nuvolari's final request was to be buried in his racing uniform.

IN THE MACHO WORLD of car racing, a daring young woman snagged everyone's attention—including Enzo Ferrari's. At thirteen, Maria Antonietta Avanzo (1889–1977), the granddaughter of one of Napoleon's generals who had settled in the Veneto, stole her father's motorized tricycle for a joy ride, careened through the village streets, and ran into a pedestrian. At nineteen, she married a baron. At twenty, compelled by a passion to go as fast as possible, she entered her first car race—and won her class, despite having to stop to replace a tire.

Italy's first female racer lived up to the title of a biography of her extraordinary life by Luca Malin: *Indomita* (Indomitable). The mother of two wore her hair in a boyish Parisian bob, favored "short" skirts that skimmed her ankles, and left her husband after

a private investigator confirmed that he was cheating on her. She hunted tigers in India, bought a five-hundred-acre sheep farm in Australia, and developed friendships with Gabriele D'Annunzio, Amedeo Modigliani, and Ernest Hemingway.

But her greatest passion remained *la velocità:* speed. The Flying Baroness became the first woman to compete in some of Europe's most daunting races, to try out for the Indianapolis 500, and to join the most exclusive of racing teams, the Scuderia Ferrari. She first attracted Enzo Ferrari's attention—and respect—in a speed trial on a beach in Denmark, where her car, an enormous, torpedo-shaped, twelve-cylinder Packard, caught fire at full speed. Thinking fast, she drove the flaming auto into the sea and walked blithely through the waves to shore.

The "baroness of the roaring road" told an American reporter that, after being "crossed by love," she took up racing as "a safer alternative to drugs or drink." As she explained, "An automobile motor is more reliable than a man." Lauded in Italy for her *elegantissimo* style, she said she feared breaking her nose more than losing her life. Asked how she calmed her nerves before a big race, she replied, "I take a swallow of cognac and tell myself to be brave."

The baroness never lost her zest for adventure. At fifty, she placed sixth in the grueling Tobruk-to-Tripoli distance race. During World War II, she drove trucks for the Red Cross and helped trundle Jews out of Italy. After the war, the mother of Renzo Avanzo, an actor, writer, and film director, and aunt of Roberto Rossellini (whom she taught to drive) founded a movie production house specializing in documentaries. At age sixty-seven, she transported refugees during the Budapest revolt. Pulled over for speeding in a quiet Rome neighborhood in her seventies, she protested, "If my car travels at 180 (kilometers per hour), I go at 180!"

Looking back on decades of full-throttle living, the baroness reflected, "I have had everything from life: beauty, money, loves,

and two magnificent children—and I have always done what I wanted to do." She died of cancer at age eighty-seven.

ENZO FERRARI ALSO DID what he wanted—in his personal as well as professional life. A tall man with an aquiline nose, leathered skin, and metal-gray hair swept straight back like a don's, he dressed in a white shirt, suspenders, and drab business suits, with a Prancing Horse pin in the lapel. Working seven days a week, he rarely left the region where he had grown up.

Although he looked nothing like his sexy-as-all-get-out drivers, Ferrari's off-hours behavior was equally flamboyant. In 1929, he began a parallel family life with a tall, serene, striking young woman named Lina Lardi, who had come from a rural village to work at his factory. He settled her into a redbrick farmhouse conveniently located on his way home from work. He often ate two dinners—one with his mistress and one with his wife.

Despite his unconventional lifestyle, Ferrari felt that he "was acting with some sort of an honor," writes his biographer Richard Williams. After all, "he had walked out on no one, and he had built a business that provided for them all."

In 1945, Lina gave birth to a boy, Piero, registered as illegitimate. Only after his wife's death decades later did Ferrari legally adopt Piero and give him his name. Although they eventually lived under the same roof, he never married Lina.

"A man should always have two wives," Ferrari told his personal secretary. Yet even two women weren't enough for a man who never left the fast lane. Obsessed with winning on and off the track, Ferrari, as a longtime coworker observed, viewed women as objects "to be carted off to bed—notches in his belt, that's all."

In Ferrari's view, men forever remained "creatures of their passions, and this makes them victims of women." Even in his eight-

ies, he described himself as "a slave of desire." At a birthday lunch for a veteran racer with a reputation as a Casanova, Ferrari asked, "How many women have you had in your lifetime?"

"At least three thousand," said the debonair driver.

Ferrari pulled back in mock amazement and exclaimed: "Only three thousand?"

FERRARI SPLIT FROM ALFA ROMEO to establish his own business in 1939, then the Fascist government commandeered his plant to manufacture machine parts during World War II. Although he moved the facility from Modena to a seemingly safer site in nearby Maranello, Allied bombers leveled the factory.

With the war's end, Ferrari was ready to rebuild—and so was Italy. Seizing the opportunity to help Italy believe in itself again, he announced the debut of new race cars—even though metal was scarce, electricity a luxury, and fuel in short supply. The first automobiles to carry the Ferrari name blew past the competition to top places in both speed and marathon races.

The "magician of Maranello" transformed the once-sleepy region. Ferraris, Maseratis, and Lamborghinis, all produced locally, shrieked along the country roads. Church bells rang with every Ferrari victory. A parish priest raced for Ferrari with a rosary clutched in his teeth.

To finance his passion for racing, Ferrari began selling a limited number of handcrafted road cars, as bespoke as royal carriages, with no two exactly alike. Ferrari himself approved every buyer. Among the first proud owners were the shah of Persia, the crown prince of Saudi Arabia, the Argentine dictator Juan Perón, and the stars of Italy's booming "Hollywood on the Tiber." Roberto Rossellini bought a Ferrari for himself, another for his girlfriend Anna Magnani (who confessed that the vibration of a Ferrari engine at

full speed did "something curious" to her insides), and a third for Ingrid Bergman.

What made Ferraris so seductive? "The marvelous, screeching, thoroughbred bitchiness of the machines themselves," writes Brock Yates in his biography of Enzo Ferrari, "an electrifying quality that made even rival Jaguars, Alfa Romeos, and Maseratis seem almost crude by comparison." Not just another sports car, each model encapsulated Ferrari's ideal of a fire-breathing, rip-roaring, road-eating work of art.

BY THE MID-1950S, the Prancing Horse was dashing to victory after victory. But for Enzo Ferrari, the darkest season was beginning. Once consumed with every car and race, Ferrari withdrew completely in the spring of 1956. His firstborn son, Dino, was dying.

From an early age, the adoring boy had followed his father to garages, local test tracks, and the Ferrari factory. Groomed to inherit the family business, he studied engineering and learned English from a tutor (who had an affair with one of the Ferrari drivers). But beginning in his teens, Dino developed mysterious symptoms that progressively worsened.

The eventual diagnosis was Duchenne muscular dystrophy, a wasting disease that eats away at the skeletal muscles, passed by a mother's X chromosome to a son (a girl's two Xs usually protect her). Ferrari's distraught wife Laura blamed herself; he may have done the same.

"I had deluded myself—a father always deludes himself—that we should be able to restore Dino to health," Ferrari wrote in his autobiography. "I was convinced that he was like one of my cars, one of my motors." Despite every effort, Dino's health deteriorated. On June 30, Ferrari made a final note in a chart graphing his son's vital signs: "The match is lost."

Dino died at age twenty-four. For the rest of his life, Ferrari shrouded his eyes in dark glasses, as if to hide the pain of losing what he called "the only real love possible in the world, that of a father for his son." Increasingly reclusive, he visited Dino's grave every day. A large photograph of his young son still hangs in his blue-walled office, now part of the Ferrari museums.

Although Ferrari declared that his passion for racing died with Dino, the following year energized him with new hope. Seven drivers in *la squadra primavera* (the spring team)—young, aggressive, and impossibly good-looking—charmed the public and the press. Although no one could have guessed it in those days of hope and promise, all would die within the next two years.

The racers knew the odds: one in four Grand Prix drivers who started a season did not live to its end. Ferrari fanned his racers' bravura, taunting them to earn the coveted place behind the wheel of his fastest car. An effort of a mere 100 percent never sufficed; he demanded more.

BY THE 1950S, most European nations had banned open-road races that imperiled spectators as well as drivers. But Italy's Mille Miglia (Thousand Miles)—"the race of the people," as Ferrari described it—remained a national institution. Each year, dozens of drivers pitted themselves against a grueling figure-eight course from Brescia in the north to Rome and back again. Millions of onlookers lined the route to watch and wave.

Five Ferraris entered the Mille Miglia on May 12, 1957. Behind the wheel of the fastest model was Ferrari's favorite, the daredevil Marquis de Portago of Spain, an international celebrity, an Olympic bobsledder, and a playboy romancer of actresses and models.

"I like the feeling of fear," he told an interviewer. "After a while you become an addict and have to have it." But the Mille Miglia

scared him in a different way. "I did not want to go," he wrote just before the race. "Then Ferrari told me I must do it. . . . That means my early death may well come next Sunday."

After Portago ran into snow in the mountains and drizzle in the lowlands, a mechanic noticed that a wheel had rubbed against the chassis. He rolled out a fresh set of tires, but Portago waved him away, determined to overtake the cars ahead of him. Unleashing the full power of his mighty engine, Portago bulleted ahead—straight toward a knot of onlookers who had edged onto the roadway.

Swerving to avoid them, Portago spun out of control into a pinwheel of destruction. The car gyrated over the first row of onlookers to smash into a pole. Metal shards bombarded the crowd. Portago flew through the air, his body sawed in two by the Ferrari's spiraling hood. Nine spectators, including five children, and Portago's navigator died. Twenty more bystanders were seriously injured.

The entire nation erupted in anguish and outrage. A headline blared: MILLE MIGLIA, CIMITERO DI BIMBI E DI UOMINI, BASTA! (Mille Miglia, cemetery of children and men, ENOUGH!). The "magician of Maranello," denounced as its "monster," was personally charged with manslaughter.

After claiming a total of fifty-six lives in its history, the Mille Miglia was banned. Court proceedings dragged on for four years before Ferrari was exonerated. Feeling betrayed by those who branded him a murderer, the automaker focused on a new race car, the Dino Formula One, an automotive resurrection of the soul of the son he had lost. Then a driver of a Dino was killed in the French Grand Prix. At the German Grand Prix, a racer crashed his Dino and died of a massive head injury. The Vatican press attacked Ferrari as an "industrial Saturn who continues to devour his own sons."

The last survivor of the spring squad, Mike Hawthorn, a jovial, fun-loving Brit, retired at age twenty-nine. Returning to England, he stopped at a pub for a few pints with a friend. Speeding home on rain-slicked roads, Hawthorn hit a tree with such force that his car was bent nearly in half. He died instantly.

Ferrari added yet another black-framed portrait to his wall of "champions and martyrs." "Each time I shake hands with one of them and give him a car," he mused, "I wonder: Will I ever see him alive again?"

The constant risk of dying—swiftly, without suffering, without warning—added to the Ferrari mystique. Phil Hill, a young Californian who joined the *scuderia* in 1958, compared racers to soldiers who charge into battle even in the face of certain death: "If you think there's a great difference between them and an impassioned race driver because the latter has the ability to quit any time, you don't fully understand the pull of being impassioned."

AS FERRARI GREW OLDER, the Italian press began referring to him as "the Pope of the North." Behind his back, workers called him Il Grande Vecchio (the Great Old Man). The aging lion had one more battle to fight—not for a victory on the track, but for his entire company.

In 1963, deciding to focus exclusively on racing, Ferrari looked for a partner to buy out the production side of his business. The Ford Motor Company, headed by the patrician Henry Ford II, was eager to expand into the glamorous realm of racing. Their negotiations spurred a duel between two automotive titans with equally ferocious passions for winning.

At the time, no international race matched the cachet of the twenty-four-hour marathon at Le Mans, a punishing test of survival of the fastest. After five consecutive victories, Ferrari practically

owned the course and its aura of sex, speed, money, and fame. Henry Ford II wanted his company to bask in this glow—and reap millions in car sales.

After months of calculations and negotiations, Ferrari sat down in Modena with lawyers from both firms. According to the proposed agreement, Ford would own 90 percent of the company and make cars under the Ford-Ferrari brand. Ferrari would own 90 percent of the Ferrari-Ford racing team—with, he assumed, full autonomy. As he read the final document, Ferrari erupted into a volcanic rage.

"Where is the freedom I demanded right from the start?" he roared. At 10:00 p.m., he turned to his associates, said, "Let's get something to eat," and left, never to return to the negotiating table.

Henry Ford II responded with equal fury. "We're going to kick his ass," he swore. "We're going to race him." When his aides asked how much he was willing to invest, he replied, "I didn't say anything about money."

Ford would spend the equivalent of $40 million to race at Le Mans in 1965. American drivers did indeed win that year—but they were driving Ferraris, the sixth triumphant year in a row for the Prancing Horse. One paper called the race "the greatest defeat ever suffered by a team in the history of motor racing." A headline in *Sports Illustrated* blared MURDER ITALIAN STYLE.

The following year, Ford came after Ferrari with all the speed his millions could muster, rolling out the fastest cars the company had ever manufactured. On the day of the 1966 race, he handed a note to his top executives: "You'd better win."

By this time, Ferrari had entered negotiations with another of Italy's great automotive patriarchs, Fiat owner Gianni Agnelli (who drove to work in a Fiat with a Ferrari engine under the hood), to take over production. Legendary for his style, womanizing, and charm, Agnelli requested that his nephew, rather than Ferrari's

fastest driver, start the race. Speeding into a blind turn, the neo-phyte racer crashed into a wrecked car. The other frontline Ferraris all broke down along the track.

The monster Fords won first, second, and third places at the fastest speeds anyone had ever clocked at Le Mans. Henry Ford II leapt triumphantly onto the winners' platform with his drivers—as he did when his team won the following year. Scuderia Ferrari blasted back at Daytona in 1967, when three Ferraris crossed the finish line together. An almost life-size photo of the trio speeding past the checkered flag covers a wall in Ferrari's classic car restoration shop.

WHEN FIAT ACQUIRED 50 percent of Ferrari in 1969, an era ended, with more mass production, fewer custom touches, and more driver-friendly accessories. Life changed for the Ferrari family as well as the company.

In 1978, Ferrari's wife, Laura, whose physical and mental health had deteriorated over the years, died. Despite their contentious relationship, their fifty-five years of marriage had cemented an enduring bond. Laura was laid to rest in the vast family mausoleum, next to the space reserved for her husband alongside their son, Dino.

After a respectful interval, Ferrari took the legal steps to adopt Piero and give him his name. Piero, his wife, their daughter, and his mother, Lina, moved into Ferrari's enormous house, invariably described as dark and dismal. At the factory, Ferrari and Piero quarreled loudly and publicly. Ferrari demoted his son from his position as team boss, causing a rift that never completely healed.

In 1961, Ferrari had told a reporter, "One day I want to build a car that's faster than all of them, and then I want to die." With his last project, a winged 200-mph coupe with an interior similar to

that of a racing car, he realized this dream. "This car is so fast," he told a friend, "it'll make you shit your pants."

At ninety, the carmaker could no longer walk without assistance. His kidneys were failing. He seemed depleted by his team's losses. Yet he remained a national icon and an international power broker in the world of motor sports. Crowds would line up in the morning to watch and wave as a car drove him to the Ferrari factory.

"How do I want to be remembered?" Ferrari responded to a reporter. "I'd prefer silence."

When he died on August 14, 1988, the family held a private funeral service. Three weeks later the Formula One team revved their engines at the Italian Grand Prix. Despite low expectations in a lackluster season, Ferrari racers finished in first and second places. The *tifosi* (fans) rushed the field in a sea of red, yellow, and black, unfurling a banner that read: FERRARI, WE FOLLOWED YOU IN LIFE AND NOW IN DEATH. Their victory shouts may have been the only sound he would have preferred to silence.

WAS FERRARI'S PASSION EVER SATED? I think not.

Asked which of his cars was his favorite, he would always answer, *"La prossima"* (The next one).

Which victory was his greatest? *"La prossima."*

If the goal seemed impossible, if the price in human life too high, he would still press on. The passion that had chosen him wouldn't let him stop—or even slow down. "There is a piece of Enzo Ferrari in every car," says Ferrari Museums director Michele Pignatti Morano di Custoza, "his passion for speed, for power, for beauty, for excellence."

The Ferrari racing division spun off from Fiat Chrysler Automobiles as a wholly independent, publicly traded entity in 2016.

But even as ownership has changed, the cars have remained true to Ferrari's initial vision: powerful, beautiful, and intrinsically sexy.

At the Ferrari Museums, a Futuristic stadium-size structure with walls like giant waves showcases more than seven decades of automotive superstars. As I enter the cavernous space, I feel like Clara in *The Nutcracker,* as if all the toys under a Christmas tree have grown life-size. Dozens of Ferraris—different colors, makes, years—are casually parked on gleaming white platforms.

They are indeed magnificent beasts. I want to stroke every hood, slide onto the driver's seat, grasp the steering wheel, turn the key, and, as Ferrari would say, "feel its heart beat." A guide asks which car I would choose if I could have any Ferrari in the world.

The words of the Great Old Man immediately spring to my lips: *"La prossima."*

14

THE TRIUMPH OF ITALIAN STYLE

I t was the dress seen 'round the world: a princess bridal gown fashioned from fifty yards of satin, seventy yards of lace, and more than one thousand pearls. On January 27, 1949, in Rome's Church of Santa Francesca Romana, Linda Christian, a stunning young actress dubbed the "Anatomic Bomb" for her shapely figure, married the international heartthrob Tyrone Power. Eight thousand Italians craned for a glimpse of the star-kissed pair. When the newlyweds posed in the Forum, photographers snapped pictures and videos that graced front pages and newsreels on every continent.

The marriage officially ended seven years later, but the three sisters who created the fantasy dress reigned as queens of Italian fashion for almost half a century. Le Sorelle Fontana (the Fontana Sisters), three dressmaker's daughters from a small town near Parma, defined *alta moda* (high fashion) before anyone else,

including the Italians, realized that a homegrown form of haute couture even existed.

Hollywood royalty, along with actual queens, princesses, and duchesses, came like pilgrims to stand before the trio called "the three-sided mirror." Bacall brought Bogie; Ava Gardner, her then-husband Frank Sinatra. Senator John F. Kennedy bounded up the stairs and picked out three outfits for Jackie. Kirk Douglas bought an entire wardrobe for his wife.

"Our clients used to say that they needed three days for Rome—one for the Forum, one for the Vatican, and one for the Sorelle Fontana," recalls Luisella Fontana, a daughter-in-law who worked with the designers for forty years. "They joked about throwing a few coins in the Trevi Fountain but leaving their wallets with the Fontana sisters."

Only a single suite of rooms remains of the three-story atelier that was once a Roman landmark. Here the Fondazione Micol Fontana, created by the longest-surviving sister in 1994, displays mannequins costumed in some of the house's most memorable designs.

As enthralled as a little girl playing dress-up in her mother's closet, I marvel at a hand-embroidered bodice laced with a bounty of beads and a satin bridal train that seems to stretch for a city block. A skintight lipstick-red sheath with no visible buttons, snaps, or zippers intrigues me.

"How do you put it on?" I ask.

With help, Luisella explains, showing me how the strapless dress, custom-molded around a woman's body during multiple fittings, would be wrapped in graceful folds and attached with hidden fasteners.

"And to get out of it?"

Luisella dramatically begins unwinding the soft fabric, as if unfurling the wrapping from a priceless statue.

Could there be a more seductive way of dressing—or undressing?

AMERICANS, PARTICULARLY ON VACATION in shorts and tee-shirts, often look ready for a day at Disney World. Italians, even as they go about daily chores, primp for an *avventura,* a word that can translate into either "adventure" or "romance" and ideally combines a bit of both. This isn't surprising: a passion for fashion is woven into the fabric of Italian history.

In ancient Rome, aristocratic wives and daughters robed themselves in such extravagant finery that the Senate passed a law restricting gold jewelry and varicolored dresses. Women took to the streets to demand—and eventually win—its repeal. The sybaritic rulers of third-century Rome installed a silk factory in an imperial palace to manufacture the delicate fabric—forbidden to commoners—for their togas, trimmed with dyes more expensive than the costliest gems.

In the Renaissance, artisan tailors, furriers, haberdashers, embroiderers, tanners, cobblers, braiders, weavers, and button makers crafted the most dazzling fashion statements the West had ever seen. Women—who, according to an early fashion chronicler, changed styles "even more than the shape of the moon"—vied to parade the longest trains, the fullest skirts, and the most extravagant brocades. Their peacock men strutted in fur-trimmed cloaks and jewel-encrusted caps.

When the teenage Catherine de' Medici (1519–1589), great-granddaughter of Lorenzo il Magnifico, demanded additional stature for her wedding to the future king of France, Italian cobblers invented the high heel. And women owe another fashion first to this wife and mother of kings: underpants.

When riding a horse *all'amazzone* (sidesaddle)—to show off her legs, her detractors hissed—Catherine donned a prototype pair of knickers. The fashion police of the day endorsed this practical garment for two reasons: it shielded "those parts that are not for male eyes" in case of a fall, and it protected women from "dissolute young men, who put their hands under women's skirts."

Over the following centuries, Parisian designers reigned as style setters for the world. Italians served mainly as suppliers of fine fabrics, butter-soft leathers, and intricate lace and embroidery. Then a peasant's son from a poor town outside Naples elevated the humblest sartorial art—shoemaking—beyond mere craft to couture.

I CAME ACROSS THE TALE at an exhibit called "The Amazing Shoemaker: Fairy Tales and Legends About Shoes and Shoemakers" at the Salvatore Ferragamo Museum in the company's flagship store on via Tornabuoni in Florence. This is how it begins:

"Once upon a time there was a boy named Salvatore. The eleventh of fourteen children, he was born in Bonito, a small village near Naples, with a handful of houses, one main road, and a lot of countryside. His parents were farmers, and their life consisted of waiting and praying for a good harvest."

The story's young hero would cross the ocean to the United States, open a small custom shop, and design shoes for the movie stars who reigned as "the princesses and sorceresses of the twentieth century"—all before turning twenty.

Salvatore Ferragamo (1898–1960), who had left school after the third grade to help support his family, made his first pair of shoes when he was just nine. Unable to borrow white shoes for his younger sister's first Communion and too poor to buy them, the family faced the public disgrace of the girl's appearing in worn wooden clogs.

Working all night with nails, glue, lasts, cardboard, and some thick white canvas from the local shoemaker, Ferragamo cobbled shoes so stunning that the entire village marveled. His father, who had opposed his son's apprenticing in what he considered the lowliest of trades, relented. Soon young Ferragamo mastered every technique of the cobbler's craft.

After his father died of appendicitis, the eleven-year-old boy borrowed money from an uncle who was a priest and set up a shoe shop just inside the front door of his family home. Women from surrounding villages snapped up his stylish and well-priced footwear. The precocious shoemaker soon hired six assistants.

By sixteen, Ferragamo had saved enough for a third-class ticket on a ship to Boston, where he had lined up a job at a shoe company. After one glance at the clumsy shoes with "points shaped like potatoes and heels like lead," he quit. Heading west to California, he joined four of his brothers, who were doing odd jobs for the American Film Company.

Ferragamo wrangled a contract to make boots for Westerns, sandals for biblical epics, and one-of-a-kind footwear for stars like Mary Pickford, Douglas Fairbanks Jr., and Rudolph Valentino (who regularly stopped by for pasta). "The West would have been conquered sooner if they had boots like these," the Hollywood director Cecil B. DeMille exclaimed. The charming immigrant quickly became known as "shoemaker to the stars."

WHEN HE WAS TWENTY-TWO, a car accident left Ferragamo with a permanent limp and a commitment to ensuring "that others should know the pleasure of walking freely." Enrolling in an evening anatomy class, he learned the biomechanics of arch support, balance, and the musculature of the foot—and applied these lessons in custom designs. But when the Depression devastated the American

economy, a disheartened Ferragamo lost his clientele and returned to Italy to open a shop in Florence.

In 1933, Ferragamo declared bankruptcy. Working frantically, he managed to repay his debts within a few years, buy the Palazzo Spini Feroni on via Tornabuoni, and open boutiques throughout Italy. When leather became scarce, he made "uppers" with almost anything he could get his hands on: rope, raffia, braided cellophane from candy wrappers. For soles and arches, he used cork—and invented the wedge heel in the process. He also found the love of his life: Wanda, the daughter of the village doctor in Bonito.

World War II damaged Ferragamo's palazzo in Florence and destroyed his shop in Venice. But with top-quality leather salvaged by a local tanner, he rebuilt his business—pair by pair. Designing "Over the Rainbow" platform sandals for Judy Garland and gold stilettos for Marilyn Monroe, he regained his star status and opened boutiques around the world.

"I love feet. They talk to me," the shoemaker wrote. "I am consumed with anger and compassion: anger that I cannot shoe all the feet in the world, compassion for all those who walk in torment." Wanting every woman to feel the magic of Cinderella's glass slippers, Ferragamo produced more than twenty thousand shoe styles, many displayed in art and design museums around the world today.

Since Ferragamo's death in 1960, his wife, children, and grandchildren have shepherded his vision of a "Ferragamo woman"—sporting his house's eyeglasses, watches, and handbags as well as shoes—into a global empire, still under family control.

And so, as Ferragamo wrote in his autobiography, the fairy tale "continues—like life itself."

WHILE FERRAGAMO WAS FASHIONING footwear for Hollywood stars, the Fontana sisters were mastering the exacting techniques of needlework, design, cutting, and beading in the village of Traversetolo near Parma. As young teens under their mother's unyielding discipline, they sewed and embroidered from morning until late at night, with only brief breaks for lunch and dinner and occasional outings on feast days.

The oldest sister, Zoe (1911–1979), with a passion bigger than her tiny hometown could contain, was determined to break into the fashion business in either Milan or Rome. Unable to decide which, she and her husband hopped on the first train that pulled into the local station. It carried them to Rome, where her two younger sisters, Micol (1913–2015) and Giovanna (1915–2004), soon joined them to work as seamstresses.

Zoe's "golden scissors" impressed Gioia Marconi, the fashionable and well-connected daughter of Guglielmo Marconi, inventor of the radio. She commissioned an entire wardrobe and recommended the sisters to her style-setting friends. Fueled by a potent mix of passion and determination, the Fontana sisters launched the first fashion house in Rome in 1943.

With raw materials scarce during wartime, they bartered fresh produce from their parents' garden for fabric and kept stitching even as artillery boomed in the distance. Based on fashions popular during the Renaissance, their ultrafeminine dresses featured narrow bodices, cinched-in waists, and full skirts—along with lighthearted touches of pure whimsy, such as a huge ribbon bow, a cascade of pleats, or a rainbow of ruffles.

Linda Christian's bombshell wedding gown, heralded as a "beacon of style," catapulted the sisters to instant celebrity status. Brides everywhere—from Egypt's future queen to President Harry Truman's daughter—clamored for Fontana gowns. Audrey Hepburn rushed in for fittings between takes of *Roman Holiday*—then

fell in love with Mel Ferrer, canceled her planned wedding to a British aristocrat, and gave the gorgeous dress to one of the Fontanas' young seamstresses for her own walk down the aisle.

AMERICAN MOVIEMAKERS SHOOTING IN ROME hired the sisters to design wardrobes for stars like Myrna Loy, Grace Kelly, Deborah Kerr, Loretta Young, and Barbara Stanwyck. "Every Sunday, *mamma* would cook, and celebrities would come for dinner," Roberta, the daughter of the youngest sister, Giovanna, tells me. "The movie stars became part of the family."

With a Fontana workshop and salon in Manhattan, Micol spent so much time in the United States that she became known as "the American sister." On one of her many Hollywood sojourns, Cary Grant took the starstruck Italian for a moonlight spin in his convertible.

In Italy, the sisters emerged as celebrities in their own right, playing themselves in an Italian movie about a young girl working for the atelier. Their brand branched into ready-to-wear, shoes, perfume, luggage, and linens, with factories outside Rome, hundreds of employees, and boutiques throughout Italy.

Pope Pius XII honored the family and their employees in 1957 with a private audience and a blessing—the first time, the official Vatican newspaper noted, that a pontiff had ever discussed fashion. For *La dolce vita*, Fellini outfitted Anita Ekberg in Fontana creations, including the striking "priest dress," a severe but sexy frock inspired by a cardinal's scarlet robes. The sisters again played themselves in an American film, *Gidget Goes to Rome,* and, decades later, inspired an Italian *fiction* (television movie).

But the Fontana sisters did more than create a legendary name. They helped propel the entire Italian fashion industry into the forefront of haute couture with just three English words: "made in Italy."

FEBRUARY 12, 1951, marks the birthday of modern Italian fashion. On that date, Marchese Giovanni Battista Giorgini (1898–1971), an aristocratic entrepreneur who had exported Italian products to the United States before the war, organized the first-ever showing of Italian designs in the elegant Villa Torrigiani, his family home in Florence. The designers included the Fontanas, tailors from Rome and Milan, jewelers, and accessory makers. The audience consisted of buyers from the toniest American department stores. The sole journalist in attendance filed a front-page story for *Women's Wear Daily* under the headline ITALIAN STYLES GAIN APPROVAL OF U.S. BUYERS.

The next year almost two hundred American buyers and reporters flocked to Giorgini's fashion show, which had to be moved to the city's Grand Hotel. In an article headlined ITALY GETS DRESSED UP, *Life* magazine commented that "just like Chianti, Italian fashions are becoming as well-known as its table wine."

Aiming for a more upscale vintage, the presentations relocated to the glittering Sala Bianca, or White Room, of the Palazzo Pitti. The fifth annual show astonished attendees with a torchlit, trumpet-sounding reenactment of a sixteenth-century wedding, with actual nobles from Florence's families modeling Renaissance costumes made by Italian designers.

The coalition fractured several years later, with some houses showing in Rome and others in Florence. Eventually Milan, an industrial center and transportation hub, would emerge as the capital of *la moda italiana*. By 1961, *Life* declared that Italian design had "changed the way the world looks—the cars, buildings, furniture, and, most universally, the women."

With the same élan long associated with the "fine Italian

hand," the pioneers of *alta moda* combined traditional craftsmanship, fresh new styles, and modern technology. In their comfortable, effortlessly elegant designs, men would break out of the stiff suits that served as twentieth-century armor. Women would shed wired bras and elastic girdles to slip into outfits that flowed over their curves. And the world would sit up and take notice.

AMONG THE EARLY STYLE SETTERS, another family of strong women established the Fendi name at the forefront of luxury furs and accessories. I heard their backstory several years ago from Anna Fendi, one of five sisters who propelled the brand to international fame. We met at the Villa Laetitia, a palazzo on the Tiber that she bought as a near ruin and lovingly restored as a hotel, each room as artfully tailored as her family's trademark bags.

Retired from the daily operations of the Fendi business, this "fashion artisan," as she describes herself, recalled how her parents started a leather and fur shop in Rome in 1925 and struggled to survive during the dark days of Fascism and German occupation. After the war, they took over a dilapidated movie theater that was about to be torn down on via Borgognona, now one of the chicest streets in Rome.

As the Fendi daughters came of age, they joined the family business and resolved to preserve their parents' passion for high-quality design. In 1965, the sisters hired Karl Lagerfeld, long before his association with the house of Chanel made him a fashion icon. He revolutionized fur and leather clothing by perforating, weaving, and pleating the materials—and designed the double *F* (one inverted) Fendi logo, a symbol of style the world over.

The sole Fendi still involved in design is Anna's daughter, Silvia Venturini Fendi. *The New Yorker* compared one of her handbags, the Baguette, to a Petrarchan sonnet because, while its form always

remains the same, "within it the variations are unending." Fendi has produced more than one thousand different Baguettes since its creation in 1997—about three times the number of Petrarch's compositions.

FAMILIES LIKE THE FONTANAS AND FENDIS designed their way into fashion's nobility, but Emilio Pucci, the Marchese di Barsento (1914–1992), was born royal—the first person in his blueblood Florentine family, he often joked, to work for a living in a thousand years. With typical aristocratic *sprezzatura* (which roughly translates as nonchalance disguising often-strenuous effort), he claimed that his career sprouted from his passions for sports and pretty women rather than fashion itself.

While studying in the United States in the 1930s, Pucci stumbled into a job coaching the ski team at Reed College in Oregon. In order to free skiers from thick winter coats, he designed snug jackets and stretchy tights with stirrups to keep them in place. With what seemed a snap of his fingers, modern skiwear was born.

While he was vacationing in Capri after World War II (he served as a bomber pilot in the Italian Air Force), a lady friend arrived with nothing he deemed suitable to wear. With an innate flair for design, he whipped up playful shorts and swimsuits. A journalist snapped some eye-catching beauties in his colorful clothes and sold the photos to *Harper's Bazaar*. Soon sunseekers along the Italian and French Riviera were clamoring for his eye-popping outfits.

In his signature styles, Pucci—the first designer to sign his name (Emilio) to the exterior of garments—swirled a kaleidoscope of vibrant colors into scarves as striking as abstract paintings and paired ankle-kissing capri pants with bold-patterned silk shirts. "The prince of prints," as the fashion press crowned him, created wearable but chic sportswear that blended the allure of couture

with the ease of ready-to-wear. As his tony clients morphed into the international jet set, Pucci lightened their suitcases with feather-weight, wrinkle-proof synthetics—the precursors of an active modern woman's wardrobe.

ANOTHER ITALIAN DESIGNER WOULD LIFT *alta moda* to a level of refine-ment that once was exclusive French turf. Born in 1932 in a small city in Lombardy, Valentino Garavani was obsessed with glamour from the time he was a teenager.

"I was always a big dreamer," he told an interviewer. "Vivien Leigh, Hedy Lamarr, Lana Turner, and Katharine Hepburn—I am a designer today because I would dream of those ladies in fox coats and lamé, coming down those grand staircases they had in the movies. That was what I thought about. That was what I wanted."

This dream led Valentino to apprenticeships with top couturi-ers in Paris. His distinctive style would combine the elegance and worldliness of French fashion with the sensuality and high craft of Italy.

In 1960, at age twenty-eight, Valentino opened a *maison de couture* near the Piazza di Spagna in Rome but struggled to make a name for himself. Then, in a café along the via Veneto, he met Giancarlo Giammetti, six years younger, who recalled that "Valen-tino was incredibly seductive, with his deep tan, blue eyes, and soft but intense way of speaking." The two became lovers and then lifelong companions and business partners.

Valentino rose to the heights of haute couture, blazing as a star among stars. Elizabeth Taylor, friend and fan, regularly appeared in his designs. Jackie Kennedy wore Valentino for her wedding to Aristotle Onassis. Julia Roberts and Jodie Foster accessorized their Valentinos with Oscars at the Academy Awards.

"Valentino was the last true couturier," says Matt Tyrnauer, di-

rector of the documentary *Valentino: The Last Emperor.* "He was one of the first designers to make himself the inspirational figure at the center of the story he was telling."

Valentino acquired a villa in Rome, a mansion in London, a penthouse in Manhattan, a castle in France, a chalet in Gstaad, a private jet, a vast collection of museum-quality art, platoons of servants, and half a dozen pugs that traveled everywhere with him. "People say I am insane, this is not the world anymore, nobody lives this way," Valentino conceded. "But I want these things in my life. My eyes want to see perfection."

In Rome in 2007, I joined the crowds at the Ara Pacis Museum oohing and aahing through an exhibition meeting Valentino's high standards while honoring his career. The stark Futuristic setting provided a dramatic backdrop for pyramids of intense Valentino red, mountains of white, and long, stately rows of black dresses and gowns. A bridal train cascaded from a ceiling-high pedestal like a waterfall. A jewel-toned harlequin design, surrounded by mirrors, shimmered like a kaleidoscope. Yet as much as I admired the stunning silhouettes and intricate detail, I couldn't imagine wearing Valentino—or any other high-fashion designer's clothes—in my far-from-jet-set life.

THE MAN WHO CHANGED my mind—the first to "get" what working women really want—was a former medical student, window designer, and buyer in Milan. Born in 1934, Giorgio Armani grew up in Piacenza, which was heavily bombed during World War II.

"Because of the war," he wrote in his autobiography, "I sometimes think I never had a childhood or adolescence. I had no connection at all to fashion—I never even breathed in the air of an atelier." But he had the movies, which he described as his "real education": "They shaped my imagination, my culture, and my tastes."

Recognizing Armani's cinematic style sense as so rare that "even the blind" could recognize it, the designer Nino Cerruti hired him to "create a new image for men." Armani would launch a "whispered revolution"—not by blowing anything up but by tearing apart the most fundamental piece in a man's wardrobe.

Deconstructing the traditional jacket, Armani removed the stiff lining and traditional padding. With softer fabrics and a new approach to buttoning and hanging, he coaxed the lapels to fall a bit forward in a relaxed way. "I made the jacket come alive on the body," says Armani, who opened his own design house in the 1970s.

Then the movies—his boyhood passion—gave him his big break. The Hollywood superstar John Travolta, an early client, suggested that Armani provide the wardrobe for a sensuous thriller called *American Gigolo*. A relative unknown named Richard Gere ended up with the starring role—and the wardrobe. From the opening scene, when Gere assembles shirts, ties, and jackets from his well-stocked closet into subtly sexy ensembles, Armani almost stole the movie.

"Who's acting here?" Gere quipped while shooting. "The jacket or me?" The film, released in 1980, catapulted both the actor and the man who dressed him to stardom.

As his supple men's suits shouldered aside London tweeds, Armani sensed another change in the air. His sister, an actress and model at the time, was always borrowing his jackets. Like her, he realized, other liberated women wanted a more professional look.

"Women couldn't be credible dressed like dolls," he told a journalist. They needed clothes that would allow them "not simply to be noticed but to be remembered." Armani tried something radical: adapting men's jackets for women's bodies, using classic male tailoring that offered a sense of stature and security.

His new jackets featured wide shoulders, elongated lapels, an

air of casualness, and a gentle drape. "Giorgio's Gorgeous Style," as *Time* acclaimed it in a cover story, would adorn singers like Lady Gaga and Madonna, movie stars like Cate Blanchett and Diane Keaton, professional athletes and Olympic teams.

As he has evolved over the decades, Armani, many believe, has risen to the level of an artist—a designation he rejects. "I stubbornly remain convinced that fashion is not an art form," he insists. "Art—real art with a capital A—is made to last. It transcends time and sums up a society's highest aesthetic and cultural values. Fashion is created, used up, and renewed in a quick and endless cycle."

Accused of being a "maniacal perfectionist," Armani admits to "an obsessive relationship with my work. . . . I don't have much time for literature, for music, for art. I live with my work. I make love to my work." Perhaps this explains the seductiveness of his clothes.

"What's sexy is not a body laid bare before everyone's eyes," he contends. "Sexy is suggestion, veiling and unveiling. . . . Seduction should be a game that brings people closer rather than shouting, 'Look how beautiful I am!'"

MY SEDUCTION STARTED DECADES AGO during weekly walks past an Emporio Armani store (far less pricey than his couture salon) to Italian classes in San Francisco. After months of admiring the garments in the windows, I was lured inside by a semiannual sale. The first time I tried on a natty pin-striped blazer—stylish but not showy—I felt both elegant and at ease. Since then, I've worn Armani's statement jackets, crisp but comfortable pants, and the best little black dress ever for book tours, lectures, television interviews, presentations in Italian palazzi, and the formal ceremony of being knighted at the Italian Consulate in San Francisco.

Armani's impact has extended far beyond occasional buyers like me. "If you so much as glance in a mirror as you dress each morning, Giorgio Armani has influenced your wardrobe," observed Martha Nelson, the founding editor of *InStyle,* in a tribute to an Armani exhibition at New York's Guggenheim Museum. His enduring legacy: "his passion for simplicity in all forms of dressing."

I never appreciated the scope of Armani's fashion vision until my last visit to Milan, where I toured the Armani/Silos. Built in 1950 as giant food storage bins, four levels showcase the clothes that changed the way the world dresses. I wandered through room after room of understated daywear, ultraglamorous evening gowns, variations on "greige" (a blend of gray and beige that Armani invented), Persian-inspired tunics, Asian sarongs, tuxedos for women, slouchy coats for men, layers and layers of sheer fabric creating skirts, in a critic's words, "as delicate as the flap of a butterfly's wing."

Over the decades Armani's design empire, the most successful Italy ever produced, has extended beyond fashion. The city-block-size Palazzo Armani in Milan houses boutiques for furniture, flowers, pets, children's clothes, sportswear, shoes, books, chocolates, and accessories, plus a café that offers the best people-watching in town. In addition to shops around the world, Armani hotels in several major cities cocoon guests in understated luxury. In 2017, at age eighty-two, Armani opened a private, invitation-only club that quickly became the must-be-seen-in destination for Milan's trendsetters.

"We don't have military power in the world," a businessman told me at a reception in Milan. "We don't have political or financial influence. But we have the pope and Armani. One represents the Church, and the other represents style."

Other stars also have lit up Italy's ever-expanding fashion galaxy. Gianni Versace and, after his murder, his sister Donatella amped

the erotic energy in sexually expressive clothes with a Fellini-like sensuality. Miuccia Prada, a political science major and professionally trained mime before surrendering to her passion for design (and self-confessed "obsession" with nylon), emerged as fashion's "punk and radical thinker," as a *Vogue* writer described her.

In their theatrical designs, Domenico Dolce and Stefano Gabbana have mined every vein of Italian passion, drawing inspiration from *"molto sexy"* Sicilian widows, bad-boy bandits, soccer players, and classic Italian icons. The theme for a recent collection was "Italia Is Love," but as a reporter noted, "the message might better have been summed up as 'Italia is loved.'"

TAKING STYLE TO A NEW DIMENSION, Italian designers have been showing their love for their country by helping to preserve its endangered treasures. In 2010, Diego Della Valle, head of Tod's, a luxury shoe and leather goods firm, donated 25 million euros to restore the time-battered Colosseum, Rome's emblematic landmark. Bulgari, the upscale jewelry brand, funded the cleaning and repair of the Spanish Steps, just down the street from its flagship store. The Salvatore Ferragamo Group has underwritten the upgrading of air and security systems in Florence's Uffizi Gallery. Gucci has paid for refurbishing Renaissance tapestries in that city's Palazzo Vecchio. Prada is investing in restorations in Bologna, Padua, Bari, Florence, and Milan.

Generous tax breaks have provided an undeniable financial incentive, but corporate donors also voice a genuine passion for their country and culture. "My father chose Florence for its beauty—it inspired his creations," says Ferruccio Ferragamo. "We feel it is our duty to maintain and contribute to the beauty of our city. Florence gives to us every day. Now it is time we give back."

The house of Fendi gave back to Rome with a 2-million-euro

cleaning and refurbishment of the Trevi Fountain. For its ninetieth anniversary, the atelier displayed its 2016 collection literally *on* the famous fountain—with models strutting on a temporary Plexiglas catwalk that created the illusion that they were walking on water. Fendi also is partnering with the Galleria Borghese as a sponsor of the digital Caravaggio Research Institute, the most complete searchable database chronicling the artist's life and works.

LATE ON AN AUTUMN EVENING IN ROME, I take a solitary walking tour of some of the fashion-sponsored restorations. The Colosseum, once a somber gray hulk, glows with newfound majesty. The Spanish Steps, chipped and grimy for as long as I can remember, sparkle in the lamplight. I approach the Trevi Fountain through a maze of narrow streets and listen for the splashing sound of cascading water that always precedes a first glimpse.

As I turn a corner and enter the Piazza di Trevi, I stop in my tracks. The water god Oceanus and his luminous winged horses seem to glow from within. (The effect, I later learn, comes from LED lights.) Turquoise waters spill over and around the gleaming stones. A mist rises in the night air to envelop onlookers with its magic spell.

I immediately realize that I am looking at more than a monument. Once again, I am seeing *la passione italiana,* timeless in its beauty—and its style.

15

SEDUCING
THE WORLD

About three decades ago, I descended into Milan's grim train
station and emerged hours later in a maritime Oz, half sea
and half land. The "streets" of Venice ran with water, rows of
crenellated palazzi soared above me, and seagulls swooped low over
my head. Appearing from nowhere, a *facchino* (porters abounded
then) asked the name of my hotel, grabbed my suitcase, and trun-
dled off. I rushed to keep up, scrambling onto long wooden ramps
above the *acqua alta* (high water) that lapped just beneath my feet.
In the swoon of the moment, I would not have been surprised to
sprout wings like Venice's emblematic lion and take to the air.

After returning several times to glide on Venice's canals and
get lost in its labyrinth of lanes, my husband and I ventured off to
other Italian destinations. Decades passed, and Venice blurred into
memory. But as soon as I began researching this book, I knew I
had to return to the city that embodies *la passione* itself.

"Great," my husband said, pausing a moment. "But not for Carnevale—right?"

I hesitated.

I wasn't thinking of the Disneyfied Carnevale of elaborate costumes and expensive balls that draws tens of thousands of visitors. But I'd heard of a simpler, smaller, sweeter celebration held just before the official festivities in Cannaregio, the working-class neighborhood where the highest percentage of native Venetians live. It begins with a spectacular parade along the oldest waterway in Venice.

And so, on a chilly night in February, we find ourselves watching a gigantic silver balloon rise above the Cannaregio canal like a moon lassoed from the sky. Dangling below, an acrobat gyrates into a spinning star. Sky ballerinas with huge butterfly wings flutter around her. Giant ten-feet-high anemones unfurl long filmy tendrils. Fire dancers on gondolas juggle flaming torches.

Once the parade has run its course between the canal's two bridges, it doubles back to the starting point and, to the delight of onlookers, presents a full-length encore. Booming from loudspeakers, an announcer describes the crowd as *veneziani fra veneziani* (Venetians among Venetians), celebrating the creativity, the dedication, and, most of all, the passion they have for their city.

During this magical evening, we hear no languages other than Italian and Venetian. Children scamper in Harlequin costumes (with a few galactic superheroes in the mix). Women swirl in the flowing robes of another age; men don the long-beaked masks of plague doctors. Confetti falls like snowflakes. And I realize that although Venice has harbored every sort of passion, the one that still burns brightest in the hearts of Venetians—once numbering two hundred thousand, now only about fifty-three thousand—is their intense love for their hometown.

While other Italians may cherish their cities and villages, Venetians see themselves, first and foremost, as sons and daughters of a unique nation-state. Venice preserved its independence longer than any republic in history, ruled a colonial empire larger than Great Britain's, sent the first diplomats into the world, and drenched daily life in music and laughter.

"The Venetians were magnificent by nature," the historian William Thayer observed a century ago as he wandered through its labyrinthine lanes, asking, "What poets dreamed these marvels? What romancers dwelt in these enchanted halls?" The city's dreamers and romancers would master every art of seduction, but the first Venetians had no such fanciful aspirations. They were simply running for their lives.

IN THE FIFTH CENTURY AD, waves of barbarians burned and looted their way across northern Italy. In the final death blow in 452, Attila and his scavenger Huns razed the once-proud city of Aquileia, a thriving cosmopolitan trading center. Pushed to the edge of the sea, the survivors retreated to their only refuge: the lagoon.

On marshy islands fringed in reeds, the refugees constructed makeshift homes like seabirds' nests afloat on the waves. Driven from their old ways of living, the accidental islanders invented new ones. They flooded rough paths to form watery roads. They learned to build and sail agile boats, to fashion rainwater collectors that served as wells, and to organize a community—with no small amount of bickering and bloodshed—that ultimately united "rich and poor under equal laws."

Pounding countless pilings through the squelchy marshes into a solid layer of earth, the Venetians lined the canals with palazzi, joined islets with humpbacked bridges, and crowned every *sestiere*

(neighborhood) with cupolaed cathedrals. Their fleet, the most formidable in Christendom, sailed forth to conquer the waters beyond the lagoon.

In the twelfth century, in a ritual reenacted every year, Venice "married" itself to the sea with a golden ring dropped from the doge's festooned galley. As choirs chanted, he pronounced, "Oh Sea, we wed thee in a sign of our true and perpetual dominion."

From East and West, exotic treasures poured into Venice: silks, coffee, mosaics, spices, gold, silver, gems. The city called La Serenissima (the Most Serene One) grew rich, as a historian recounts, on "man's craving for luxury, for ostentation, for self-indulgence, on the pride of life and the lust of the eye."

Its delights enticed the senses—from rhapsodies of color in its paintings, to operatic spectacles on its stages, to tasty *frittelle* (culinary cousins of fritters) on its tables. Its ruling elite of about two hundred families, registered in the *Libro d'oro* (Golden Book), draped themselves in lace and velvet and glorified the city with their splendor.

FREEWHEELING AND TOLERANT, Venice granted (relative) freedom to women, sanctioned illicit liaisons, indulged in sensual pleasures, and tolerated libertines like Giacomo Casanova. Masters of illusion, Venetians reveled in masks, costumes, theater, and games of chance. Mad for music, they delighted in gondoliers' ballads and violin concerti. Connoisseurs of luxury, they sprinkled actual gold dust on the holiday cake known as *pandoro*.

Some of the city's fairest maidens—often lacking the requisite dowries for marriage—entertained in mirrored drawing rooms. Men of means came to drink, gamble, discuss arcane topics, and enjoy songs, dances, witty conversation, and more intimate pleasures with Venice's famed courtesans. The city boasted not one but

two overpasses called Ponte delle Tette (Bridge of the Tits) leading to red-light districts where slanted blinds revealed glimpses of the enticements available in local brothels.

The days of privilege and decadence spun to an end when Napoleon threatened "to obliterate the Venetian name from the face of the earth." With tears streaming down his face, the last doge formally proposed abolishing the Venetian constitution and surrendering to the French. On May 12, 1797, after more than thirteen centuries, the Republic of Venice ceased to exist. Yet even under the crushing rule of the French and then the Austrians, the city's unofficial live-and-let-love slogan—"*Siamo a Venezia!*" (We are in Venice!)—affirmed the joys of living in the magnificent moment.

Venice's overheated sensory microclimate created a "permanent state of romantic excitement," according to a Russian psychoanalyst named Isaak Abrahamowitz. The "constant erotic frenzy" of living amid Venice's nonstop stimulation, he contended, kept "desire forever inflamed, but at a mild level, without sudden fluctuations." As a result, the sexual impulse "melts into all the limbs [and] smoothly penetrates the recesses of the soul."

Tourists as well as natives succumb to this intoxicating sensuality. "Other cities have admirers," the nineteenth-century French essayist Paul de Saint-Victor observed. "Venice alone has lovers." Peggy Guggenheim, who lived for three decades among her modern art treasures on the Grand Canal, cautioned against choosing Venice for a honeymoon or romantic tryst: "To live in Venice or even to visit it means that you fall in love with the city itself. There is nothing left over in your heart for anyone else."

IS LA SERENISSIMA still as seductive?

Not in some of the ways it once was. When I applaud a colorful regatta from a canal-side restaurant, a waiter scans the twenty or

so brightly decorated gondolas and shrugs. *"Poche!"* (Just a few!), he mutters. Once, he tells me, so many boats jostled for position that you could barely see the lagoon. Now, he says, everywhere you look, all you see are tourists.

Venice is undeniably reeling under the crush of foreign invaders. Massive cruise ships loom over the Piazza San Marco. Tourists jam by the half dozen into gondolas, their selfie sticks bristling upward like porcupine quills. Summer brings choking heat, an inescapable stench, shoulder-to-shoulder mobs, and overcrowded cafés and museums.

Venetians voice additional complaints: Groceries and bakeries are closing. As rents rise, many natives can no longer afford to live in their hometown. There are fewer children, fewer old people, fewer cats. The once-glorious epicenter of power and wealth has become a bejeweled corpse, its beauty fading, its parapets crumbling, its canals flooding.

And yet . . .

At night the streets are strung with tiny lights that glimmer like stars snatched from the heavens. From our terrace at the Gritti Palace, we watch a full moon rise over the Basilica of Santa Maria della Salute and glaze the Grand Canal in silver. Snatches of song sail on the breeze. Palazzi glow from within, their lights shimmering on the inky canals.

Venice may indeed be dying—as it has been for centuries. But until its final breath, this fantasy of a city on water will continue to do what it has always done: seduce those who dream of marvels and seek romance in its enchanted halls.

THE SAME MIGHT BE SAID of Italy, which also has been seducing foreigners since its history began. Century after century, in peace and war, despite pirates and plagues, over perilous passes, stormy seas,

and rutted roads, they have come—explorers, adventurers, traders, sailors, soldiers, writers, musicians, poets, painters, sculptors, penitents, pilgrims of every sort—to the promised land of their imagination.

For a veritable who's who of Western civilization, Italy served as the essential finishing school, a required destination for any person of refinement. "The Italians had all Europe for their pupils, both theoretically and practically in every noble bodily exercise and in the habits and manners of good society," the nineteenth-century historian Jacob Burckhardt observed. Yet even cultural acolytes who came to learn from dead Italians found themselves enchanted by living ones—and infected with *la passione italiana*.

"At last—for the first time—I live!" Henry James wrote in his diary when he arrived in Italy in 1869. "Who has been in Italy can forget all other regions," the Russian writer Nikolai Gogol gushed. "Who has been in Heaven does not desire the Earth." Elizabeth Barrett, a virtual invalid dominated by her family, fled England for Italy after secretly marrying Robert Browning and exuberantly embraced writing, motherhood, and Italian nationalism. "Open my heart and you will see / Graved inside of it, 'Italy,'" her equally besotted husband wrote.

Wagner, Bizet, Debussy, and a chorus of musicians, along with legions of artists, architects, and sculptors, found inspiration in Italy—as did generation upon generation of writers: John Keats, Alfred Tennyson, Charles Dickens, Thomas Mann, Herman Melville, Mark Twain, William Faulkner, Ernest Hemingway, Tennessee Williams, Erica Jong, and John Grisham among them. I've stayed in the building on via Margutta where Truman Capote rented a loft in the 1950s, a few steps from the studio where Pablo Picasso painted when he came to Rome with his friend Igor Stravinsky in 1917.

Martin Scorsese filmed *Gangs of New York* on a back lot at

Cinecittà. Francis Ford Coppola converted a grand villa into a luxury hotel in his grandfather's village in Basilicata. (The soundtrack of *The Godfather* still echoes continuously through Sicilian towns.) In his bachelor days, George Clooney presided over a latter-day Hollywood on Lake Como. He and Amal Alamuddin (among a star-studded roster of celebrity brides and grooms) married in Italy—in a Venetian fantasy of a wedding.

Yet Italy's spell extends beyond historical figures and contemporary headliners. On book tours across the United States, I've met dozens of men and women who found unexpected passions in Italy—for weaving, ceramics, Etruscan caves, Catholic shrines, Sicilian mosaics, Neapolitan folk songs. In heartwarming e-mails, readers of *La Bella Lingua* write that my book also has inspired new passions: to trace their Italian heritage, enroll in Italian classes, learn beading or mask making from Italian artisans, write memoirs and novels based in Italy, even quit a job and move halfway around the world from Australia to start a new life in Milan. (I breathed a sigh of relief when this daring move turned out to be a happy one.)

But in recent years, Italian seductiveness, no longer confined by mere borders, has extended its reach farther than ever before to infiltrate every corner of the world. Federico Rampini, a distinguished author and the US bureau chief for *La Repubblica,* encapsulates this phenomenon in what he terms "the globalization of Prosecco."

WHEN HE MOVED to San Francisco in 2000, Rampini ordered the light sparkling Italian wine at an upscale restaurant.

"Pro . . . what?" the waiter stammered. He'd never heard of Prosecco. It seemed that no one had. Rampini couldn't find his favored aperitif anywhere in his sophisticated new city. Then two years passed.

"Prosecco arrived—not on tiptoes, but like the landing in Normandy in the Second World War," he recalls. Almost overnight every bar and restaurant in the Bay Area had capitulated. Prosecco appeared on wine lists in high-end and moderate-priced restaurants, with bartenders and sommeliers chatting knowingly about various brands and their home regions.

The Prosecco invasion didn't stop in California. Wherever Rampini traveled—from the cosmopolitan cities on both coasts to smaller towns in Texas and Louisiana—he found Prosecco. After its conquest of America, the Italian bubbly took on the world, with sales rocketing to more than half a billion bottles a year. Yet its success represents just part of a much larger trend.

IN THE LAST TWO DECADES, the entire planet has become more Italian. From Boston to Berlin, Sydney to Singapore, people of all ages and income levels nibble on biscotti, sip espresso, drive Fiats, zip up Diesel jeans, and snuggle in Cucinelli sweaters. The farm-fresh quality of Italian *cucina*, once snootily dismissed by gourmands, has dethroned haughty French cuisine. Chefs in top-tier restaurants are likely to be Italian born or trained. The Mediterranean diet—practically a synonym for the cooking of southern Italy—has won over legions of health professionals, nutritionists, athletes, environmentalists, and foodies.

Italian products that I once crammed into suitcases like contraband to bring to the States—amaretti cookies, Lavazza coffee beans, arborio rice—line the shelves of American stores. Eataly, the all-Italian emporium, has morphed into a culinary juggernaut. Even mainstream supermarket chains stock Italian pasta, olive oil, Parmesan cheese, and peeled tomatoes.

Italian fashions have become just as ubiquitous. The upscale salons of big-name designers line the chicest shopping streets of

major cities on every continent. Available online as well as in department stores and outlet malls, the "made in Italy" label lures millions of customers with a sophistication that blends elegance with exuberance.

Italian itself, with only an estimated 63 million native speakers (compared to 1.8 billion who claim at least a little English), has become trendy. Years ago, Stefania Scotti, Rampini's wife (and one of my first Italian tutors), started teaching Italian to the youngest pupils at San Francisco's French American International School. The popular classes now enroll students from kindergarten through grade twelve.

Italian courses at American colleges and universities attract ever-increasing numbers. Worldwide, Italian ranks fourth—after English, Spanish, and French—among the most studied languages. People of all ages, in all sorts of places, take Italian, often not for academic credit or pragmatic purposes, but for personal pleasure and edification—just as they might enroll in piano or ballet classes without planning to become musicians or dancers.

"I suspect it is because Italy and the Italian language are perceived as beautiful, fun, and sexy," Stephen Brockmann, a professor at Carnegie Mellon, opined in an essay called "A Defense of European Languages," adding, "And why not? I can't see anything wrong with that."

Neither do I.

THE ALLURE OF "BEAUTIFUL, fun, and sexy" also may explain the global passion for Italy's most popular export: its way of life, which Rampini describes as his country's "equivalent of China's Great Wall."

When he transferred to Beijing in 2004, Rampini found that

the fascination with anything and everything Italian had saturated the Far East. Descendants of the great "tea civilizations" of the world craved Italian espresso. Countries that rarely indulged in desserts embraced gelato with unabashed delight. When genuine made-in-Italy merchandise was not available, manufacturers gave their knockoffs Italian-sounding names. *"Siamo copiati perché siamo amati,"* says Rampini. We are copied because we are loved.

With *una corrente di italianizzazione* (a current of Italianization) running throughout the developed world, Italy has emerged as one of the economic and cultural winners of globalization. As Rampini reports in his recent book, *Le linee rosse* (*Red Lines*), "Italian products have shown an unsurpassable capacity to conquer markets on all continents."

Yet "Italy fever" reflects more than the popularity of vibrant ceramic platters and hand-sewn wallets. "People around the world are attracted to what's inside these objects," says Rampini, "to the universe of values that they sense: the importance Italians give to creativity, our respect for history and traditions, our capacity for adapting the beautiful to the useful, the ancient to the modern."

As Italians readily concede, their nation is struggling with complex issues: immigration, unemployment, corruption, political upheavals. Yet people outside Italy's borders pay little heed. "Regardless of Italy's problems, wherever I've traveled—Shanghai, Bangkok, Marrakech, St. Petersburg," Rampini reports, "I've met people who aspire to live like Italians. What seduces them is the culture of knowing how to live that Italy has raised to a level of perfection."

AT THE HEART OF THIS CULTURE pulses *la passione italiana,* often sparked by what Lord Byron called Italy's "fatal charm" of beauty but sustained by something far deeper. Italy, as philosophers have

noted, stands apart as the place where human beings first grew souls. In what was once a land of shepherds and soldiers, coarse and brutal, the full range of human experiences and emotions played out over thousands of years. Passionate and proud, tender and tough, creative and cunning, Italians—a mongrel race mixing conquerors and conquered—learned all the lessons life can offer and defined what it means to be fully human.

"How could Italians have produced the art that we have created had we not been consumed with the beauty that surrounds us? If we had not been in awe of the majesty of the divine?" asks William Giovinazzo, author of *Italianità: The Essence of Being Italian and Italian-American.* "How could we have written the poetry and literature had we not burned with the revelations that could inspire others? How could we have given birth to a culinary tradition that has conquered the world had we not found delight in even the most common of meals shared with friends and family? How could we have composed the music and operas had we not wished to stir hearts with this joy?"

Even today, in a world expanding and exploding into the future, Italy still reminds us of essential truths about who we are and what we can rise toward. "Nothing, above all, is comparable to the new life that a reflective person experiences when he observes a new country," wrote Goethe, who believed that in Italy "whoever looks seriously about him and has eyes to see is bound to become a stronger character; he acquires a sense of strength hitherto unknown to him. . . . Though I am still always myself, I believe I have been changed to the very marrow of my bones."

La passione italiana has had a similar effect on me. Like other pilgrim souls, I've absorbed its simple but profound lessons: Appreciate your senses. Express your feelings. Cultivate empathy and compassion. Hold family close. Share food and laughter with friends. Tune in to the rhythm of the ever-changing seasons. Enjoy

the abundance of the earth and give back to it with generosity. Choose the *bello* over the *brutto*. Let fantasy inspire reality (not the other way around). Honor the divine. Love without limits. Let the human spirit soar.

Even at its most ardent, *la passione italiana* cannot substitute for genius, talent, or sheer hard work, nor can it transform any of us into a Dante or a Michelangelo. However, it can infuse a richer dimension into daily life—not just through its masterpieces but through something as humble as the dish that has won over people of all ages in all places: pizza.

THIS WAS THE TAKEAWAY LESSON of a recent trip to southern Italy. On a boat off the Amalfi coast with some local friends, I casually mentioned that my husband would be celebrating a big birthday in the spring.

"Facciamo una festa!" (We'll throw a party!), they immediately volunteered. When I pointed out that the date was six months away, they shrugged off this minor detail as irrelevant.

"We will not be with you then, so we must celebrate now."

And so, on the seaside terrace of the Hotel Transatlantico in Naples, our group of five gathered to enjoy the classic "pies," baked by the master *pizzaiolo* Luciano Forte (father of one of our group). We sampled the two officially designated as cultural treasures by UNESCO: a *marinara* and a *Margherita*. Then one scrumptious pizza after another, with various toppings on smoky, chewy crusts, appeared before us—and just as quickly disappeared.

Despite protests that we could not eat another bite, we rallied our appetites for a decadent but delectable chocolate layer cake that Luciano himself had baked for the occasion. *"Buon divertimento!"* (Enjoy yourself!), the icing inscription read.

Indeed we did—with a truly spectacular display of *la passione*

italiana: fireworks organized by our friends that filled the starry night with bursts of color and drew cheers from the crowds along the waterfront. Cars slowed. Open-air discos stopped the music as dancers gazed heavenward. Diners on restaurant terraces lifted their glasses in a toast.

"Che bello!" I exclaimed.

"Sì," one of our companions replied, offering an apt Italian compliment: *"bello come un film"* (beautiful like a movie).

I thought of Federico Fellini, master of cinematic magic, who would have delighted in the jubilant scene.

"There is no beginning; there is no end," he once observed. "There is only the infinite passion of life."

What could be more seductive?

ACKNOWLEDGMENTS

I am grateful to the experts, guides, scholars, and friends who assisted me over the last few years and to the many others whose passion impressed and inspired me.

From the beginning of my research, Lisa Pieraccini, an archaeologist and the director of the M. Del Chiaro Center for Ancient Italian Studies, and Christopher Hallett, a professor of classics and art history at the University of California, Berkeley, provided essential background on the Etruscans and ancient Romans.

In Rome, the archaeologists Clementina Panella of La Sapienza and Livia Galante brought the earliest eras of human history to vivid life. The passion of our friend Dr. Massimo Biondi of La Sapienza for Etruscan history and life enriched my appreciation of this remarkable culture.

I thank Marco Spagnoli, the movie director and critic, for his insights and his wonderful films, and Professor Valeria Della

Valle of La Sapienza, a distinguished author and dear *amica,* for providing a wealth of information on Italian cinema, culture, and language. I extend great appreciation to Tracy Roberts and Jessica Edwards of LoveItaly, a nonprofit organization dedicated to preserving Italy's treasures, and to the art historian Sara Magister, who guided me through Caravaggio's Rome.

I am grateful to the endlessly resourceful Barbara Lessona of Countess Concierge, who specializes in making Rome feel like home for every client. She introduced me to worlds I'd never glimpsed, including the Sorelle Fontana atelier. I extend fond thanks to Luisella and Roberta Fontana for their memories of a glamorous golden age of Italian fashion and to Anna Fendi for the story of her family's passion for elegance and design.

In Sicily, Lorenzo Capraro of Agrigento Experience, Claudio and Pina of La Mattina Travel in Palermo, and Frank Cappa of Siracusa guided me through three millennia of history. Verona brought special joy because of Maurizio and Antonella Barbacini and their passion for music and romance.

In Venice, the exceptional Cristina Gregorin of Slow Venice helped me navigate the long, complex, and ever-so-passionate history of La Serenissima. I appreciate the skill and knowledge of its accomplished artisans, including Gloria d'Este of Tessitura Luigi Bevilacqua, the glassblowers of Seguso Vetri d'Arte, and the delightful sisters, jewelers Susanna and Marina Sent. A special thanks to master glass artist Lucio Bubacco of Murano, who melds passion into every piece.

I extend my gratitude to several of Perugia's fine artisans, including Marta Cucchia of Museo Atelier Giuditta Brozzetti; Maddalena Forenza of the Museo Laboratorio di Vetrate Artistiche Moretti Caselli; Maria Antonietta Taticchi of Materia Ceramica; and Giordano Mangano of Cioccolato Augusta Perusia. My wonderful guide Daniela Maria Paci led me into some of Umbria's love-

liest settings to meet the weavers of Tela Umbra in Città di Castello and the jeweler Francesca Trubbianelli of Gioielli Raku in Assisi. I thank the ceramicist Maurizio Tittarelli Rubboli of the Museo Opificio Rubboli in Gualdo Tadino, who shared his family's rich legacy with me, and Roberta Niccacci, who embodies the warm heart of Umbria.

Writing about food in Italy never seems to be anything but a pleasure. Gustatory delight reached a new height at the Spagnoli Confiserie du Chocolat in Sant'Enea, and I extend *grazie di cuore* to Luisa Spagnoli, not just for her exquisite confections, but also for her generosity in sharing her family history and photos. A special thanks to our mutual friends, the author and chef Silvia Buitoni and her sister (another distinguished chef) Viola Buitoni, for making my visit possible.

Emilia-Romagna more than lived up to its reputation as Italy's well-fed "belly." I thank Marcello and Raffaella Tori of Bluone Food and Wine Tours in Bologna for taking me behind the scenes of Italy's signature flavors. I appreciate the hospitality of Stefano Tondelli of Salumificio Santo Stefano in Parma and Davide Lonardi of Acetaia Villa San Donnino in Modena.

I also thank the chefs, restaurateurs, and hoteliers who've contributed so much to my Italian culinary education, particularly Alessandro Camponeschi and Costantino Rossi of Camponeschi in Rome; Robert Sciò and Federico Morosi of Il Pellicano in Porto Ercole; Michelin chef Antonio Guida of the Mandarin Oriental in Milan; *pizzaiolo* Luciano Forte of the Transatlantico restaurant in Naples; Alberto Gaido of Assaggia in Rome; Gabriella Ganugi of Apicius and Florence University of the Arts; and several wonderful private chefs, including Marina Cerchi of Rome and Porto Ercole, Jeannine Salomons of Bellaria Catering in Monticchiello, Valentina Bardi of San Quirico, and Giancarlo of Le Cesarine in Bologna.

I cannot separate my passion for Italy's wines from my deep affection for its winemakers. Many years ago, the extended family of Monte Vibiano Vecchio in Umbria—Maria Camilla, Lorenzo, and the greatly missed Andrea Fasola Bologna—welcomed us into their home and their hearts. We have treasured our times with them.

In Piedmont, thanks to our outstanding guide Paolo Ferrero of Buon Gusto Tours, my husband and I enjoyed the hospitality and the wines of several remarkable vintners: Beppe Dosio and Marco En. Dotta of Dosio Vigneti; Flavio Meistro of Azienda Agricola BUT; Augusto Olearo of Castello di Razzano; Enrico Orlando of Cà Richeta; Giorgio Pelissero of Pelissero wines; and Aldo and Milena Vaira of G.D. Vajra. In Val d'Orcia, we made the delightful acquaintance of Simonetta and Nicolò Magnelli of Le Chiuse, Annibale Parisi of NostraVita, and Giulitta Zamperini of Poggio Grande.

We greatly appreciated the wine and the art of the magnificent Castello di Ama in Chianti, and we thank our hosts, Lorenza Sebasti and Marco Pallanti, and our friend Dr. Stefano Pallanti for his assistance.

I thank Michele Pignatti Morano di Custoza, the head of the Ferrari Museums, for his gracious welcome; Gina Chinchilla, who helped arrange my tour of Armani/Silos; and the art historian Morena Ghilardi, my guide in Milan. Over the years, the journalist and author Federico Rampini, the educator Stefania Scotti, the cinema scholar Gianfranco Angelucci, the composer and conductor Mario Ruffini, the art historian Ludovica Sebregondi, and the singer Lua Hadar have greatly enhanced my appreciation of Italian passion.

Grazie di cuore to our wonderful companions on sea and land: Capitano Tonino Palumbo, Salvatore Forte, Giusy Iaccarino, Giorgia Messina, and Nicolà Iacono of Silver Star Yachting. The

d'Ambrosio brothers of Pallenberg Travel—Crescenzo, Simone, and Andrea—have taken the very best care of us in Rome and beyond for many years.

Thanks to John and Brigid Ash in Val d'Orcia and to Hamish and Carolina Tabor of Isola Rosa in the Maremma, I was able to complete the final draft of *La Passione* in two idyllic writing retreats. *Grazie infinite* to Samuela, Nicolà, and Angela for their many kindnesses and to Alessandro Pierangioli of Montalcino Travel, Fabio Spigarelli of Autonoleggio Spigarelli of Assisi, and Iuri Nutarelli of Capital Chauffeur Service.

I am deeply grateful to many who offered ideas, read early drafts, and provided unswerving encouragement, including Frances Mayes; Simone Schiavinato and the editorial staff of *L'Italo-Americano;* JoAnn Locktov of the *Dream of Venice* book series; Kathleen Gonzalez, author of *A Beautiful Woman in Venice;* Kathy McCabe of *Dream of Italy;* Rita Morgan Richardson, founder of the Friends of San Filippino; Ann Reavis, author of *Italian Food and Life Rules;* and Donna DiGiuseppe, author of *Lady in Ermine.* Heartfelt thanks to Paolo Barlera and Franca Cavallaro of the Italian Cultural Institute in San Francisco for their support and enthusiasm.

I am always thankful for my career-long agent and cherished friend Joy Harris and the invaluable Adam Reed. I owe a great debt of gratitude to my Italian guardian angel and consultant, Valentina Medda, and to my brilliant web designer Madeira James and the ever-helpful Jen Forbus of xuni.com.

My thanks to Tricia Boczkowski and Jon Darga, my editors at Crown, who embraced *La Passione* with a passion of their own. Jon's perceptive insights and deft editing shaped my draft into a more compelling and cohesive narrative. I applaud the beautiful cover by Gary Redford, and I offer admiration and appreciation

to every member of the Crown team, including Cathy Hennessy, production editor; Maureen Clark, copyeditor; Elena Grivaldi, art director; and Jen Valero, designer of the interior layouts.

My heart spills over with love and gratitude for my *adorati*—my husband, Bob, and my daughter, Julia—the sunshine of my soul and the inspiration for every passionate pursuit.

BIBLIOGRAPHY

1. LA PASSIONE ITALIANA

Barzini, Luigi. *From Caesar to the Mafia*. New York: Library Press, 1971.
———. *The Italians*. New York: Simon & Schuster, 1964.
Bianchi, Matteo, ed. *Dizionario affettivo della lingua italiana*. Rome: Fandango Libri, 2008.
Cahill, Thomas. *Mysteries of the Middle Ages*. New York: Anchor Books, 2008.
D'Epiro, Peter, and Mary Desmond Pinkowish. *Sprezzatura: 50 Ways Italian Genius Shaped the World*. New York: Anchor Books, 2001.
Duggan, Christopher. *A Concise History of Italy*. Cambridge: Cambridge University Press, 1984.
Durant, Will. *Caesar and Christ*. New York: Simon & Schuster, 1944.
Esposito, Russell. *The Golden Milestone*. New York: New York Learning Library, 2003.
Gilmour, David. *The Pursuit of Italy: A History of a Land, Its Regions, and Their Peoples*. New York: Farrar, Straus and Giroux, 2011.

Hooper, John. *The Italians*. New York: Viking, 2015.

Larner, Monica. *In Love in Italy*. New York: Rizzoli, 2006.

Murray, William. *The Last Italian*. New York: Prentice Hall Press, 1991.

Norwich, John Julius. *The Italians: History, Art, and the Genius of a People*. New York: Portland House, 1983.

Pizzorusso, Ann. *Tweeting da Vinci*. New York: Da Vinci Press, 2014.

Powers, Alice Leccese, ed. *Italy in Mind*. New York: Vintage Books, 1997.

2. SWIMMING WITH THE GODS

Augias, Corrado. *The Secrets of Rome: Love and Death in the Eternal City*. New York: Rizzoli International Publications, 2007.

Benjamin, Sandra. *Sicily: Three Thousand Years of Human History*. Hanover, N.H.: Steerforth Press, 2006.

Etruscans: Italy's Lovers of Life. Alexandria, Va.: Time-Life Books, 1995.

Lawrence, D. H. *D. H. Lawrence and Italy*. New York: Penguin Books, 1997.

Martinelli, Maurizio, and Giulio Paolucci. *Etuscan Places*. Florence: Scala Group, 2006.

Pieraccini, Lisa. "Etruscan Wall Painting." In *A Companion to the Etruscans*, Sinclair Bell and Alexandra Carpino, eds. New York: Wiley-Blackwell, 2016, 247–60.

Simeti, Mary Taylor. *On Persephone's Island*. New York: Vintage, 1986.

Simeti, Mary Taylor, and Maria Grammatico. *Bitter Almonds*. New York: Bantam Books, 1994.

Vivere da etrusco. Siena: Associazione dei Musei e Parchi Archeologici Toscani, 2009.

3. FROM WARRIORS TO LOVERS

Angela, Alberto. *Amore e sesso nell'antica Roma*. Milan: Mondadori Libri, 2015.

———. *A Day in the Life of Ancient Rome*. New York: Europa Editions, 2010.

Beard, Mary. *SPQR: A History of Ancient Rome*. New York: Liveright, 2015.

Brittain, Alfred. *Roman Women*. Philadelphia: George Barrie & Sons, 1907.

Cantarella, Eva. *Dammi mille baci*. Milan: Giangiacomo Feltrinelli, 2011.

Chrystal, Paul. *Women in Ancient Rome*. Gloucestershire, U.K.: Amberley, 2014.

Duggan, Christopher. *A Concise History of Italy*. Cambridge: Cambridge University Press, 1984.

Goldsworthy, Adrian. *Antony and Cleopatra*. New Haven, Conn.: Yale University Press, 2010.

———. *Caesar*. New Haven, Conn.: Yale University Press, 2006.

Hibbert, Christopher. *Rome: The Biography of a City*. London: Penguin Books, 1985.

Johnson, Boris. *The Dream of Rome*. London: HarperPerennial, 2007.

Lefkowitz, Mary, and Maureen Fant. *Women's Life in Greece and Rome*. Baltimore: Johns Hopkins University Press, 2005.

Montanelli, Indro. *Romans Without Laurels*. New York: Pantheon Books, 1959.

Schiff, Stacy. *Cleopatra: A Life*. New York: Little, Brown, 2010.

Tavassi La Greca, Antonella. *La pedina di vetro*. Rome: Di Renzo Editore, 2008.

Zanker, Paul, and Björn Ewald. *Living with Myths: The Imagery of Roman Sarcophagi*. Oxford: Oxford University Press, 2012.

4. THE GREATEST LOVE STORY EVER TOLD

Cammareri, Giovanni. *I misteri*. Trapani: Il Pozzo di Giacobbe, 1998.

Celano, Thomas of. *The First Life of Saint Francis of Assisi*. Newton, Mass.: Triangle, 2000.

Heater, James, and Colleen Heater. *The Pilgrim's Italy*. Nevada City, Calif.: Inner Travel Books, 2003.

Niola, Marino. *I santi patroni*. Bologna: Il Mulino, 2007.

Vardey, Lucinda. *Traveling with the Saints in Italy*. Mahwah, N.J.: Hidden Spring, 2005.

Woods, Thomas E., Jr. *How the Catholic Church Built Western Civilization*. Washington, D.C.: Regnery Press, 2012.

5. THE RISE OF ROMANCE

Alighieri, Dante. *The Divine Comedy*. Translated by John Ciardi. New York: New American Library, 1954.

Alison, Jane. *The Love-Artist*. New York: Picador, 2001.

Bergreen, Laurence. *Casanova: The World of a Seductive Genius*. New York: Simon & Schuster, 2016.

Boccaccio, Giovanni. *The Decameron*. New York: Penguin Classics, 2003.

Bondanella, Julia Conaway, and Mark Musa, eds. *The Italian Renaissance Reader*. New York: Penguin, 1987.

Brand, Peter, and Lino Pertile. *The Cambridge History of Italian Literature*. Cambridge: Cambridge University Press, 1996.

Casanova, Giacomo. *The Many Loves of Casanova*. Los Angeles: Holloway House, 2006.

Della Valle, Valeria, and Giuseppe Patota. *L'Italiano: Biografia di una lingua*. Milan: Sperling & Kupfer, 2006.

Dunn, Daisy. *Catullus' Bedspread: The Life of Rome's Most Erotic Poet*. New York: HarperCollins, 2016.

Fabiani, Barbara. *Fare l'amore a Roma*. Castel Gondolfo (Rome): Infinito, 2009.

Fei, Silvano. *Casa di Dante*. Florence: Museo Casa di Dante, 2007.

Ferrigni, Mario. *Ginevra degli Amieri*. Milan: R. Bertieri e P. Vanzetti, 1923.

Gallagher, Joseph. *A Modern Reader's Guide to Dante's "The Divine Comedy."* Liguori, Mo.: Liguori/Triumph, 1999.

Hales, Dianne. *La Bella Lingua: My Love Affair with Italian, the World's Most Enchanting Language*. New York: Broadway Books, 2009.

Lewis, R. W. B. *Dante*. New York: Lipper/Viking, 2001.

Manacorda, Giuliano. *Storia della letteratura italiana*. Rome: Newton & Compton, 2004.

Montanelli, Indro. *Dante e il suo secolo*. Milan: Rizzoli, 1974.

Ovid. *The Art of Love*. http://www.sacred-texts.com/cla/ovid.

———. *The Erotic Poems*. New York: Penguin Books, 1982.

Summers, Judith. *Casanova's Women*. New York: Bloomsbury, 2006.

6. PASSIONS IN BLOOM

Bargellini, Piero. "The Ladies in the Life of Lorenzo de' Medici." In *The Medici Women,* Franco Cardini, ed. Florence: Arnaud, 2003, 13–24.

Bayer, Andrea Jane, ed. *Art and Love in Renaissance Italy*. New Haven, Conn.: Yale University Press, 2009.

Bell, Rudolph. *How to Do It: Guides to Good Living for Renaissance Italians.* Chicago: University of Chicago Press, 1999.

Besdine, Matthew. *The Unknown Michelangelo.* Garden City, N.Y.: Adelphi University Press, 1964.

Brinton, Selwyn. *The Golden Age of the Medici.* London: Methuen, 1925.

Bronowski, J. "Leonardo da Vinci." In *The Italian Renaissance,* J. H. Plumb, ed. Boston: Houghton Mifflin, 1989. 222–237.

Brucker, Gene. "Florence and Venice in the Renaissance." *American Historical Review* 88, no. 3 (June 1983): 599–616.

———. *Florence: The Golden Age, 1138–1737.* Berkeley: University of California Press, 1998.

———. *Living on the Edge in Leonardo's Florence.* Berkeley: University of California Press, 2005.

———. *Renaissance Florence.* Berkeley: University of California Press, 1969.

———, ed. *The Society of Renaissance Florence.* Toronto: University of Toronto Press, 2001.

Bull, George. *Michelangelo: A Biography.* New York: St. Martin's Griffin, 1998.

Buonarroti, Michelangelo. *Poems and Letters.* Translated by Anthony Mortimer. New York: Penguin, 2007.

Cesati, Franco. *The Medici.* Florence: Mandragora, 1999.

"Chi vuol esser lieto, sia." Florence: Accademia della Crusca, 2006.

Clark, Kenneth. "The Young Michelangelo." In *The Italian Renaissance,* J. H. Plumb, ed. Boston: Houghton Mifflin, 1989, 192–205.

Cohen, Thomas. *Love and Death in Renaissance Italy.* Chicago: University of Chicago Press, 2004.

Cole, Michael, ed. *Sixteenth-Century Italian Art.* Malden, Mass.: Blackwell, 2006.

Condivi, Ascanio. *The Life of Michelangelo.* Translated by Alice Wohl. University Park: Pennsylvania State University Press, 1976.

da Vinci, Leonardo. *The Notebooks of Leonardo da Vinci.* 2 vols. New York: Dover, 1970.

de Tolnay, Charles. "Michelangelo and Vittoria Colonna." In *Sixteenth-Century Italian Art,* Michael Cole, ed. Malden, Mass.: Blackwell, 2006.

Durant, Will. *The Renaissance*. New York: MJF Books, 1953.

Fortune, Jane. *Invisible Women: Forgotten Artists of Florence*. Florence: Florentine Press, 2014.

Hales, Dianne. *Mona Lisa: A Life Discovered*. New York: Simon & Schuster, 2014.

Hartt, Frederick. *History of Italian Renaissance Art*, 4th ed. Upper Saddle River, N.J.: Prentice Hall and Harry N. Abrams, 1994.

Hibbert, Christopher. *The Rise and Fall of the House of Medici*. New York: Penguin, 1974.

Kaborycha, Lisa. *A Short History of Renaissance Italy*. San Francisco: Pearson, 2010.

Lazzi, Giovanna, and Paola Ventrone. *Simonetta Vespucci*. Florence: Polistampa, 2007.

Lewis, R. W. B. *The City of Florence*. New York: Farrar, Straus and Giroux, 1995.

Melver, Katherine. "Art and Love in Renaissance Italy and Love and Marriage in Renaissance Florence." *Renaissance Quarterly* 62, no. 3 (Fall 2009): 918–21.

Montanelli, Indro, and Roberto Gervaso. *Italy in the Golden Centuries*. Chicago: Henry Regnery, 1967.

Nicholl, Charles. *Leonardo da Vinci: The Flights of Mind*. New York: Penguin, 2004.

Nuland, Sherwin. *Leonardo da Vinci*. New York: Lipper/Penguin, 2000.

Palazzo Strozzi. *Florence, Money and Beauty*. Florence: Giunti, 2011.

Plumb, J. H. *The Italian Renaissance*. Boston: Houghton Mifflin, 1989.

Spadolino, Giovanni. *A Short History of Florence*. Florence: Le Monnier, 1992.

Summers, David. *Michelangelo and the Language of Art*. Princeton, N.J.: Princeton University Press, 1981.

van Loon, Hendrik Willem. *The Arts*. New York: Simon & Schuster, 1937.

Vasari, Giorgio. *The Lives of the Artists*. Translated by Julia Conaway Bondanella and Peter Bondanella. London: Oxford University Press, 1991.

Winspeare, Massimo. *The Medici: The Golden Age of Collecting*. Florence: Sillabe, 2000.

Zöllner, Frank. *Leonardo da Vinci*. Cologne: Taschen, 2005.

———. *Leonardo da Vinci: The Complete Paintings and Drawings*. Cologne: Taschen, 2012.

7. SACRED AND PROFANE

Bernardini, Maria Grazia. *Bernini: The Sculptures*. Rome: Gebart, 2013.

Bissell, R. Ward. "Artemisia Gentileschi—A New Documented Chronology." *Art Bulletin* 50, no. 2 (June 1968): 153–68.

Caravaggio. New York: Rizzoli, 2004.

Christiansen, Keith, and Judith Mann. *Orazio and Artemisia Gentileschi*. New Haven, Conn.: Yale University Press, 2001.

Cohen, Elizabeth. "The Trials of Artemisia Gentileschi: A Rape as History. In "Gender in Early Modern Europe," special issue, *Sixteenth Century Journal* 31, no. 1 (Spring 2000): 47–75.

Contini, Roberto, and Francesco Solinas, eds. *Artemisia Gentileschi: The Story of a Passion*. Milan: 24 ORE Cultura, 2011.

Graham-Dixon, Andrew. *Caravaggio: A Life Sacred and Profane*. New York: W. W. Norton, 2010.

Harris, A. S., et al. *Women Artists: 1550–1950*. New York: Knopf, 1977.

Langdon, Helen. *Caravaggio: A Life*. London: Chatto & Windus, 1998.

Mormando, Franco. *Bernini: His Life and Work*. Chicago: University of Chicago Press, 2011.

Murray, William. *City of the Soul*. New York: Crown Journeys, 2003.

Pescop, Claudio, ed. *Artist's Life: Caravaggio*. Florence: Giunti, 2010.

Vreeland, Susan. *The Passion of Artemisia*. New York: Penguin Books, 2003.

8. FATTO A MANO (MADE BY HAND)

Belozerskaya, Marina. *The Arts of Tuscany*. New York: Abrams, 2008.

Caiger-Smith, Alan. *Times and Seasons: Umbrian Writings*. Perugia: Aguaplano, 2012.

Hockemeyer, Lisa. "Manufactured Identities: Ceramics and the Making of (Made in) Italy." In *Made in Italy*, Grace Lees-Maffei and Kjetil Fallan, eds. London: Bloomsbury, 2014, 127–44.

Lazzarin, Paolo. *One Hundred and One Beautiful Towns in Italy: Shops and Crafts*. New York: Rizzoli, 2007.

Mentasti, Rosa. *I vetri di Archimede Seguso*. Turin: Umberto Allemandi, 1999.

Minchelli, Elizabeth. *Deruta: A Tradition of Italian Ceramics*. San Francisco: Chronicle Books, 1998.

Sims, John Ferro. *Handmade in Italy*. New York: Watson-Guptill, 2003.

9. THE FLAVORS OF ITALY

Artusi, Pellegrino. *Science in the Kitchen and the Art of Eating Well*. Toronto: University of Toronto Press, 2006.

Capatti, Alberto, and Massimo Montanari. *Italian Cuisine: A Cultural History*. New York: Columbia University Press, 2003.

de' Medici, Lorenza. *Italy: The Beautiful Cookbook*. Los Angeles: Knapp Press, 1988.

Dickie, John. *Delizia! The Epic History of the Italians and Their Food*. New York: Free Press, 2008.

Ehlert, Trude. *Cucina medioevale*. Milan: Guido Tommasi, 1995.

Field, Carol. *Celebrating Italy*. New York: HarperPerennial, 2007.

———. *In Nonna's Kitchen*. New York: HarperCollins, 1997.

Giacosa, Ilaria Gozzini. *A Taste of Ancient Rome*. Chicago: University of Chicago Press, 1992.

Hazan, Marcella. *Amarcord*. Detroit: Gale Cengage Learning, 2008.

———. *Marcella Cucina*. New York: HarperCollins, 1997.

———. *Marcella Says*. New York: HarperCollins, 2004.

Kostioukovitch, Elena. *Why Italians Love to Talk About Food*. New York: Farrar, Straus and Giroux, 2009.

Martino of Como. *The Art of Cooking: The First Modern Cookery Book*. Berkeley: University of California Press, 2005.

Nestor, Brook. *The Kitchenary: Dictionary and Philosophy of Italian Cooking*. New York: iUniverse, 2003.

Parmigiano Reggiano: The Only Parmesan. Parma: Consorzio del Formaggio Parmigiano Reggiano, 2011.

Piras, Claudia, and Eugenio Medagliani, eds. *Culinaria Italy*. Cologne: Konemann, 2000.

Putti, Maria, and Roberta Ricca. *La signora dei Baci: Luisa Spagnoli*. Rome: Graphofeel, 2016.

von Peschke, Hans-Peter, and Werner Feldmann. *La cucina dell'antica Roma*. Milan: Guido Tommasi, 1997.

——— *La cucina del rinascimento*. Milan: Guido Tommasi, 1997.

10. GRAPES OF PASSION

Bastianich, Joseph, and David Lynch. *Vino Italiana: The Regional Wines of Italy*. New York: Clarkson Potter, 2005.

Castello Monte Vibiano Vecchio. *When Life Becomes Passion.* Marsciano: Castello Monte Vibiano Vecchio, 2005.

Esposito, Sergio. *Passion on the Vine.* New York: Broadway Books, 2008.

Fasola Bologna, Lorenzo. *Vigna Lorenzo: La storia.* Marsciano: Castello Monte Vibiano Vecchio, 2011.

Ferrero, Paolo. *When Barbera Was Black.* Asti: Diffusione Imagine, 2009.

Fois, Marcello, Philip Larratt-Smith, and Marco Pallanti. *Growing and Guarding.* Mantua: Maurizio Corraini, 2015.

Gannon, Megan. "Well-Aged: Oldest Traces of Italian Wine Discovered." *Live Science,* September 1, 2017. https://www.livescience.com/60295 -oldest-italian-wine-discovered.html.

Hoffman, Suzanne. *Labor of Love.* Vail, Colo.: Under Discovered Publishing, 2016.

Kramer, Matt. *A Passion for Piedmont.* New York: William Morrow, 1997.

O'Keefe, Kerin. *Barolo and Barbaresco: The King and Queen of Italian Wine.* Berkeley: University of California Press, 2014.

———. *Brunello di Montalcino.* Berkeley: University of California Press, 2012.

11. DIVINE VOICES

Bello, John. *Enrico Caruso: A Centennial Tribute.* Providence, R.I.: Universal Associates, 1973.

Berger, William. *Puccini Without Excuses.* New York: Vintage Books, 2005.

———. *Verdi with a Vengeance.* New York: Vintage, 2000.

Breslin, Herbert, and Anne Midgette. *The King and I.* New York: Broadway Books, 2004.

Caruso, Dorothy. *Enrico Caruso: His Life and Death.* New York: Simon & Schuster, 1945.

Caruso, Enrico, Jr., and Andrew Farkas. *Enrico Caruso: My Father and My Family.* Portland, Ore.: Amadeus Press, 1990.

Cascella, Marco. "The Illness and Death of Enrico Caruso: A Medical Chorus Out of Tune?" *Journal of Religion and Health* 55, no. 1 (February 2016): 217–25.

Conrad, Peter. *A Song of Love and Death.* Saint Paul, Minn.: Graywolf Press, 1987.

Da Ponte, Lorenzo. *Memoirs.* Translated by Elisabeth Abbott. New York: Dover, 1967.

Desler, Anne. "'The Little That I Have Done Is Already Gone and For-gotten': Farinelli and Burney Write Music History." *Cambridge Opera Journal* 27, no. 3 (November 2015): 215–38.

Gattey, Charles Neilson. *Queens of Song*. London: Barrie & Jenkins, 1979.

Gossett, Philip. *Divas and Scholars: Performing Italian Opera*. Chicago: University of Chicago Press, 1996.

Key, Pierre. *Enrico Caruso: A Biography*. London: Hurst & Blackett, 1923.

Kimbell, David. *Italian Opera*. Cambridge: Cambridge University Press, 1995.

Landon, H. C. Robbins, and John Julius Norwich. *Five Centuries of Music in Venice*. New York: Schirmer Books, 1991.

Pavarotti, Luciano, and William Wright. *Pavarotti: My World*. New York: Crown, 1995.

Plotkin, Fred. *Opera 101: A Complete Guide to Learning and Loving Opera*. New York: Hyperion, 1994.

Potter, John. *Tenor: History of a Voice*. New Haven, Conn.: Yale University Press, 2009.

Rosselli, John. "From Princely Service to Open Market: Singers of Italian Opera and Their Patrons, 1600–1859." *Cambridge Opera Journal* 1, no. 1 (March 1989): 1–32.

———. *The Life of Verdi*. Cambridge: Cambridge University Press, 2000.

———. *Singers of Italian Opera*. Cambridge: Cambridge University Press, 1992.

Serra, Ilaria. "Teaching Italy Through Its Music: The Meaning of Music." *Italian Cultural History* 88, no. 1 (Spring 2011): 94–114.

Servadio, Gaia. *The Real Traviata*. London: Hodder & Stoughton, 1994.

Shackelford, Rudy. *Dallapiccola on Opera*. Milan: Toccata Press, 1987.

Smith, Patrick. *The Tenth Muse: A Historical Study of the Opera Libretto*. New York: Schirmer, 1970.

Verdi, Giuseppe. *Verdi: The Man in His Letters*. New York: Vienna House, 1970.

12. CINEMA IN THEIR BLOOD

Angelucci, Gianfranco. *Federico F.* New York: Bordighera Press, 2008.

Biagi, Enzo. *La bella vita: Marcello Mastroianni racconta*. Rome: BUR, 1996.

Bondanella, Peter. *The Cinema of Federico Fellini*. Princeton, N.J.: Princeton University Press, 1992.

———. *The Films of Roberto Rossellini*. Cambridge: Cambridge University Press, 1973.

———. *Italian Cinema from Neorealism to the Present*. New York: Continuum, 2004.

Brunetta, Gian Piero. *Guida alla storia del cinema italiano 1905–2003*. Turin: Piccola Biblioteca Einaudi, 2003.

———. *The History of Italian Cinema*. Princeton, N.J.: Princeton University Press, 2003.

Comand, Mariapia. *Sulla carta: Storia e storie della sceneggiatura in Italia*. Turin: Lindau, 2006.

Della Valle, Valeria. *L'Arma più forte*. Rome: Istituto Luce, 2017.

Dewey, Donald. *Marcello Mastroianni*. New York: Birch Lane Press, 1993.

Fellini, Federico. *Fellini on Fellini*. Translated by Isabel Quigley. New York: Da Capo Press, 1996.

Gundle, Stephen. *Mussolini's Dream Factory*. New York: Berghahn, 2013.

Hochkofler, Matilde. *Marcello Mastroianni: The Fun of Cinema*. Rome: Gremese, 2001.

Hotchner, A. E. *Sophia Living and Loving: Her Own Story*. New York: William Morrow, 1979.

Iannucci, Amilcare, ed. *Dante, Cinema and Television*. London: University of Toronto, 2004.

Incontri Internazionali D'Arte Roma, eds. *The Fabulous Thirties: Italian Cinema 1929–1944*. Rome: Electra International Publishing Group, 1979.

Kezich, Tullio. *Federico: Fellini, la vita e i film*. Milan: Feltrinelli, 1990.

———. *Primavera a Cinecittà*. Rome: Bulzoni, 1999.

Levy, Shawn. *Dolce Vita Confidential*. New York: W. W. Norton, 2016.

Maddoli, Cristina. *L'italiano al cinema*. Perugia: Guerra, 2004.

Malerba, Luigi, and Carmine Siniscalco, eds. *Fifty Years of Italian Cinema*. Rome: Carlo Bestetti, 1959.

Mastroianni, Marcello. *Mi ricordo, sì, io mi ricordo*. Milan: Baldini & Castoli, 1997.

Reich, Jacqueline. *Beyond the Latin Lover: Marcello Mastroianni, Masculinity, and Italian Cinema*. Bloomington: Indiana University Press, 2004.

Rondi, Gian Luigi. *Italian Cinema Today (1952–1965)*. New York: Hill and Wang, 1966.

Scorsese, Martin. *My Voyage to Italy*. DVD (2001).

Sorlin, Pierre. *Italian National Cinema: 1896–1996*. London: Routledge, 1996.

Wood, Mary. *Italian Cinema*. New York: Berg, 2005.

13. PASSION ON WHEELS

Baime, A. J. *Go Like Hell: Ford, Ferrari, and Their Battle for Speed and Glory at Le Mans*. Boston: Mariner Books, 2009.

Clark, Jennifer. *Mondo Agnelli: Fiat, Chrysler, and the Power of a Dynasty*. New York: John Wiley & Sons, 2012.

Ferrari, Enzo. *My Terrible Joys*. London: Hamish Hamilton, 1963.

Malin, Luca. *Indomita: La straordinaria vita di Maria Antonietta Avanzo*. Rovigo: Malin Communication Obliviomachia, 2014.

Rogliatti, Gianni. *Ferrari: Design of a Legend*. New York: Abbeville Press, 1990.

Williams, Richard. *Enzo Ferrari: A Life*. London: Yellow Jersey Press, 2001.

Yates, Brock. *Enzo Ferrari: The Man, the Cars, the Races, the Machine*. New York: Doubleday, 1991.

14. THE TRIUMPH OF ITALIAN STYLE

Argano, Bonizza. *Lo stile dell'alta moda italiana*. Rome: Promograph Communication, 2005.

Armani, Giorgio. *Giorgio Armani*. New York: Rizzoli, 2015.

Bianchino, Gloria, et al., eds. *Italian Fashion: The Origins of High Fashion and Knitwear*. New York: Electra Rizzoli, 1987.

Bosoni, Giampiero, ed. *Il modo italiano*. Milan: Skira, 2006.

Caratozzolo, Vittoria. *Italian Style in Fashion*. Venice: Marsilio, 2006.

Contini, Mila. *Fashion: From Ancient Egypt to the Present Day*. New York: Odyssey Press, 1965.

Fontana, Micol. *Specchio a tre luci*. Torino: Nuova ERI, 1991.

Frick, Carole. *Dressing Renaissance Florence*. Baltimore: Johns Hopkins University Press, 2002.

Guggenheim Museum. *Giorgio Armani*. New York: Harry N. Abrams, 2001.

Herald, Jacqueline. *Renaissance Dress in Italy, 1400–1500*. Atlantic Highlands, N.J.: Humanities Press, 1981.

Landini, Roberta, and Bruna Niccoli. *Moda a Firenze 1540–1580*. Florence: Pagliai Polistampa, 2005.

Martin, Richard, and Harold Koda. *Giorgio Armani: Images of Man*. New York: Rizzoli, 1990.

Reinach, Simona. "Italian Fashion: The Metamorphosis of a Cultural Industry." In *Made in Italy*, Grace Lees-Maffei and Kjetil Fallan, eds. London: Bloomsbury, 2014, 239–54.

Steele, Valerie. *Fashion, Italian Style*. New Haven, Conn.: Yale University Press, 2003.

Vecellio, Cesare. *Vecellio's Renaissance Costume Book*. New York: Dover, 1977.

White, Nicola. *Giorgio Armani*. London: Carlton Books, 2000.

15. SEDUCING THE WORLD

Giovinazzo, William. *Italianità: The Essence of Being Italian and Italian-American*. Staffordshire, U.K.: Dark River, 2018.

Gonzalez, Kathleen. *A Beautiful Woman in Venice*. Venice: Supernova, 2015.

———. *Seductive Venice: In Casanova's Footsteps*. Venice: Ca' Specchio, 2012. www.seductivevenice.com.

Guggenheim, Peggy. *Confessions of an Art Addict*. Hopewell, N.J.: Ecco Press, 1960.

Hale, Sheila. *Titian: His Life*. New York: HarperCollins, 2012.

Locktov, JoAnn. *Dream of Venice*. Mill Valley, Calif.: Bella Figura, 2014.

Madden, Thomas. *Venice: A New History*. New York: Viking, 2012.

McCarthy, Mary. *Venice Observed*. San Diego: Harcourt, 1963.

Morris, Jan. *The World of Venice*. Orlando, Fla.: Harcourt Brace, 1993.

Norwich, John Julius. *A History of Venice*. New York: Vintage Books, 1989.

Palmer, Hugh. *Best Kept Secrets of Venice*. New York: Fall River Press, 2009.

Rampini, Federico. *Le linee rosse*. Milan: Mondadori, 2017.

Thayer, William Roscoe. *A Short History of Venice*. New York: Macmillan, 1905.

INDEX